BUFFALO RIVER HIKING TRAILS

#5

TIM ERNST

EMERGENCY CALL
<u>888-692-1162</u>
OR 911

<u>www.TimErnst.com</u>

The cover photo is of a black bear cub in the Upper Buffalo Wilderness near Hawksbill Crag (momma was nearby, watching both her cub and the photographer). Photo by Tim Ernst

Wilderness publications by Tim Ernst:

Arkansas Waterfalls guidebook
Arkansas Nature Lover's guidebook
Arkansas Hiking Trails guidebook
Arkansas Dayhikes For Kids guidebook
Buffalo River Hiking Trails guidebook
Ozark Highlands Trail guidebook
Ouachita Trail guidebook
Arkansas Greatest Hits picture book (2020)
Arkansas Splendor picture book (2019)
Arkansas Beauty picture book (2017)
Arkansas In My Own Backyard picture book (2016)
A Rare Quality Of Light picture book (2015)
Arkansas Nightscapes picture book (2014)
Buffalo River Beauty picture book (2013)
Arkansas Landscapes II picture book (2012)
Arkansas Portfolio III picture book (2011)
Arkansas Autumn picture book (2010)
Arkansas Wildlife picture book (2009)
Arkansas Landscapes picture book (2008)
Arkansas Waterfalls picture book (2007)
Buffalo River Dreams picture book (2006)
Arkansas Portfolio II picture book (2004)
Arkansas Wilderness picture book (2002)
Buffalo River Wilderness picture book (2000)
Arkansas Spring picture book (1998)
Wilderness Reflections picture book (1996)
Arkansas Portfolio picture book (1994)
The Search For Haley
The Cloudland Journal

Tim's Fine Art Prints, Pam's Original Pastels,
and Arkansas Scenic Calendars

Order autographed items direct from Tim:
TIM ERNST PUBLICATIONS
Jasper, Arkansas
Phone: 870–446–2382
Online store & info: www.TimErnst.com

This guidebook is dedicated to Dr. Neil Compton, who passed away in February 1999. Without Neil, his love of wild places, and willingness to share them with others, there would be no trails to lead us into the Buffalo River wilderness.
You will be following his bootprints every step of the way...

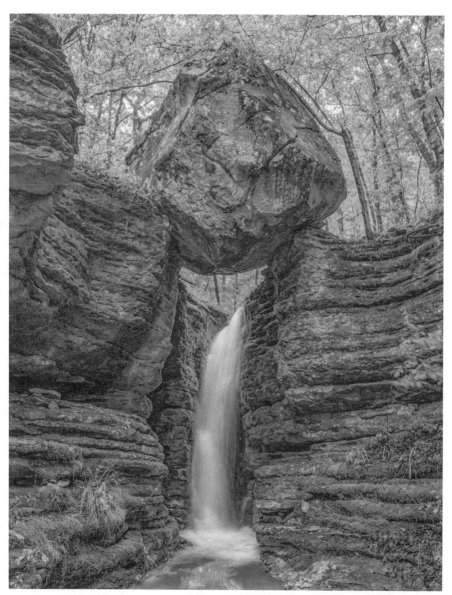

Balanced Rock Falls near Ponca—see page 46 for the map and description

TABLE OF CONTENTS/INDEX

FOREWORD

In the beginning, those of us who strived to stop the strangulation of Arkansas' Buffalo River were obliged to resort to the canoe and paddle in order to see, know, and describe the beauty of that unmatched stream. Access, provided by nature, required no labor to realize the Buffalo River experience. The route was already there, an ever moving surface to carry the visitor on with only the effort of paddles to see this gift of creation.

That was good enough in the beginning. But we floaters on the stream were left to wonder what marvels might lie hidden, back away from our course, in those many tributary hollows. Or what grand vistas might await whomever was ambitious enough to climb the towering cliffs that line the course of the Buffalo. Some of us did elect to seek out a few such places, often tramping through tangled undergrowth, and over dangerous ledges. But in the process we sometimes discovered such breathtaking features as the Hawksbill Crag, the Bowers Hollow Waterfall, Indian Creek Canyon, and the Penitentiary Gorge. We knew that there were so many such places along the Buffalo, and on the Boston Mountain Crest that we would never have time to see them all if we had to bushwhack our way in and out.

I, for one, yearned for something like the long established Appalachian Trail to make available, to those who didn't mind the walking, our Boston Mountains and the Buffalo River Country. Good hiking trails here in our uplands would draw attention to, and encourage measures to protect, scenic areas. At least there would be observers on those trails to report heavy handed development which now plagues our back country.

Fortunately, progress has been made. We have a respectable trail system here in the Ozark area which will eventually link up with those in the Ouachitas and in Missouri, and which will rival others in the U.S.

One of the first to undertake the task of getting an Ozark trail plan underway in Arkansas was Richard "Dick" Murray, who, when he retired from the U.S. Army Corps of Engineers, settled in Fayetteville and joined the Ozark Society. His early exploration of trail routes inspired others to carry on after age and infirmary prevented his continuing the work.

One of these was Tim Ernst, who founded the Ozark Highlands Trail Association. His tenacious energy, and his inspiration of others to volunteer time and labor, has led to the completion of the Ozark Highlands Trail from Lake Ft. Smith State Park to the Buffalo River—an incredible accomplishment, considering how hard it is to get people to perform such work.

Tim Ernst is not just a trail builder. He is also the best photographer of the outdoor scene and the natural world now active in the Ozarks. (Take a look at his many coffee table picture books and you can see that.) His pictures are, and were, an important factor in bringing in those determined diggers who constructed those pathways that we are now pleased to tread, unimpeded by brush, briars and downed tree-tops.

One who learned from Tim Ernst is Ken Smith, a longtime battler to save the Buffalo. Ken is now in the employ of the U.S. Park Service, with a small crew constructing the Buffalo River Trail, which will eventually extend from Boxley to the White River. When integrated with the Ozark Highlands Trail and others, we will have in the Interior Highlands, a system to rival that in Appalachia.

Hence there awaits the outdoorsman, the day hiker or the backpacker, a different dimension in the Buffalo River experience. The River and its spectacular palisades may now be seen in a new light every bit as satisfactory as from the shoreline below. Those of us who have stood on the precipice across the River from Big Bluff, seeing it for the first time full face, know that this is so.

Neil Compton

Neil Compton

Dr. Compton was the man most responsible for saving the Buffalo River from destruction. He founded the Ozark Society in the 1960's. This organization led the successful fight to save the River from the "progress" that threatened it. The result was the creation of the nation's first National River. Dr. Compton, an excellent outdoor photographer and writer, as well as one of the most important conservationists in the region, was recognized by then President George Bush in 1990 as a "Point of Light" for his lifetime of dedication to the environment. Neil passed away in 1999 after leading one last hike a few days before to his beloved Buffalo River.

INTRODUCTION

ABOUT THIS GUIDE

Welcome to this updated edition of my *Buffalo River Hiking Guide*. Most of the information here is the same as in the previous edition, with a few important changes here and there. A portion of the proceeds from the sale of all my guidebooks go towards the protection, management, construction, and maintenance of hiking trails in Arkansas, so thanks for using this guide!

This book was written *by* a hiker, *for* hikers. It was intended to be used as your step-by-step guide to having a safe and enjoyable hiking experience in the Buffalo River area. For most of the hikes described in the book, it is the only piece of information that you will need.

The Buffalo River has long been known as one of the premier floating streams in the United States. Only recently has a good trail system been developed, and now the area is attracting hikers from all over the country. Quite frankly, the trails, and the scenery along them, are as remarkable as the River itself.

The guide covers most of the "official" hiking trails in the area. And a few unofficial ones too. It also describes how to get to a lot of "access" points. These are great jumping off spots that will get you into some pretty nice country. In addition to these trails and access points, there are literally hundreds of miles of old roads, horse trails, and other "routes" in the area that are suitable for hiking.

This book is not intended to be a complete history of the area, or a canoeing guide. Nor do I pretend to tell you about every wonderful place to visit. In fact, I'm sure that there are a thousand times more SSS's in the area than the ones that I tell you about (an "**SSS**" is a *Special Scenic Spot* along the trail).

This book was written in a first-person format. I am not a writer. I'm a hiker. The descriptions in this book were edited down from tapes that I made while hiking the trails. My goal was to put something in your hands that was as close as I could get to a real person standing there giving you information. In the process, the "flavor" of my speech was retained. Sorry about that. I spend the majority of my time in the woods, not learning correct grammar.

The information is as accurate and as up-to-date as possible. Most of the mileage figures listed are my own—a measuring wheel was my constant companion on all hikes.

Before you go hiking, you should at the very least read the rest of this introduction—some of the stuff you really do need to know. The remainder of the book contains detailed descriptions of the trails—a personal guided tour by someone who has been there. It is divided up into three major hiking areas—"Upper," "Middle," and "Lower" Buffalo

Area Trails. Most of the trails are in the upper River area, but there are many great trails downstream as well.

All of the trails have a separate map that goes with them, which is located at the beginning of the description. If you are in a hurry, and want to find a particular trail, just check the reference chart on the back cover. It lists all of the trails, and tells where the description and map of each is located (or see the table of contents).

Also located on the back cover of this book is a checkoff box for each trail. Throughout the years I meet a lot of you on the trails that are toting one of my guidebooks. I always want to look at the back cover to see how many trails you have done—and I am surprised at how many of you are not only using this checkoff list, but how many of them you have checked off.

There is a great deal of information in this introduction that deals with other stuff, like the weather, bugs, camping, water, low impact use, etc., that I hope you will find useful. Plus a special section on equipment. Of course all the reading in the world won't help if you don't get out and kick up a little dust, so I hope that you are able to use this book and do some hiking!!!

BUFFALO NATIONAL RIVER

The Buffalo National River was established in 1972 as America's first National River. What that means is that it is actually a National Park, and is administered by the National Park Service. It contains 95,730 acres. There are a few trails in this guide that are not in the park, but instead are located in the nearby Ozark National Forest. Throughout this guide, when I use the word "River" (with the "R" capitalized), I am referring to the Buffalo River.

The River itself is quite simply one of the most scenic, free-flowing rivers in the United States. With the exception of a small section of its headwaters, the entire course is protected by either the national park, or by the Upper Buffalo Wilderness. There are exceptions, but generally, any lands within these areas are protected from future destructive practices by man. Of course, what we do as visitors can have a drastic impact on the River too, so be sure to take care of the land as you visit.

The River begins high up in the Boston Mountains near Red Star and Fallsville. It flows down out of the hills and onto the Springfield Plateau, which in this area is not really a "plateau" at all. It continues carving its way until it reaches the White River at Buffalo City. The total length is about 150 miles. The mountains in northern Arkansas and southern Missouri are commonly referred to as "The Ozarks."

No one really knows for sure how the River got its name. The most popular theory, is that it was named after the bison that used to roam the area. Some think is was named after the buffalo fish, which is a

sucker. My feeling, is that it was named after the little known rock face that looks like the head of a buffalo, complete with horns and a hump.

And where does the River get that wonderful turquoise color in the winter? It is because of the zillions of tiny rock particles that are suspended in the water. They get ground up when the water is high, and actually act like a kind of prism, and separate the blue-green wavelengths from the white light and reflect them back. It's the same thing that causes those terrific red sunsets, with dust particles doing the separating.

Although the River is a first-rate whitewater floating stream, I think what really brings people to it is the scenery. It is an area of towering limestone bluffs, thunderous waterfalls, and places so remote and rugged and magical, you may just come for a visit, and never go home.

HISTORY OF THE RIVER AREA

The limestone, sandstone and shale rock beds of the area were laid down 3–4 hundred million years ago beneath a giant sea that covered much of the earth. The "Ozark Dome" was uplifted out of that sea much later, cracking those rock beds, and the erosion process that created the hills and canyons began. The Ozarks are some of the oldest mountains in the United States, much older than the Rockies.

White man moved in and started cutting the huge timber and building houses in the 1830's. Many of these old homesteads are still around, and can be seen along the trails. But it wasn't until the 1950's and early '60's that man really threatened to have an impact. There were several "flood control hydroelectric" dams that were on the drawing board, and slated to be built on the River. These would have silenced the mighty Buffalo, and covered up much of the priceless wilderness that we now hike through.

Enter Dr. Neil Compton. He founded the Ozark Society, and the rest, as they say, is history. Now obviously he didn't just show up, wave his hand, and save the Buffalo all by himself. But, in my opinion, if Neil had lived in North Dakota instead of Arkansas, we would be water-skiing right on top of the tallest waterfall between the Rockies and the Appalachians, instead of enjoying this breathtaking wonder from below. Enough said. Except maybe that the next time you see him, say, "Thanks."

The Park Service took over management of the River in the early '70's. Like the vast new national parks in Alaska, this one was not like any other park. The Park Service had to invent new ways to look at and manage the Park. They have done, and are doing, a splendid job of it too. Unlike most national parks for instance, at Buffalo River you are allowed to camp pretty much anywhere in the back country that you want to, and hunting is allowed.

REGULATIONS

I don't want to give you the long list of federal regulations that apply to parks—although they are posted at trailheads, and you should take the time to read them some day. There are a few specific things about this park that you should know.

There are *no permits required* to hike, camp, or build fires. You are allowed to camp almost anywhere (except around Hemmed-In Hollow Waterfall and Big Bluff), as long as you stay at least 100 feet from any trail or water source (it is OK to camp on gravel bars on the River though), and are a half mile from any developed recreation areas. **Pets are not allowed on most park trails except the Mill Creek Trail, and those in the Tyler Bend Recreation Area—Buck Ridge, River View, Rock Wall, and Spring Hollow trails.** (this may change soon)

Glass containers are not allowed. *Mountain bikes* aren't legal on any of the trails. There will be some old roads open to biking in the future, however. The *historical sites* that are scattered throughout the area are national treasures, and should not be disturbed (no camping!). *Artifacts, like arrowheads, are also protected*—leave them where you found them!

And that is about it. All of the other things that you need to comply with, are common sense things. Don't build fire rings. Or dump *anything* into the water. Or cut *any* living plant or tree. Bury your waste (away from water sources). Be a clean camper. Be considerate of your fellow hikers who are also out there for a little solitude. *Pack It In— Pack It Out.* I'm sorry, this IS a must. Littering is just not done in the backcountry. Don't leave anything behind, and pick up what you see that shouldn't be there. Always carry a trash bag when you hike, and leave the trail cleaner than you found it.

Park Watch is a program similar to a Neighborhood Watch that encourages visitors to take an active roll in protecting and preserving the park. You should be alert to uncontrolled fires, safety hazards, vandalism and crime. If you observe any of these situations, report what you see to a park employee, or stop at the nearest park office. Or call one of the Park Service stations—numbers are listed on the next page.

NATIONAL PARK SERVICE

The National Service is a part of the Department of Interior. They manage most of the major parks in the country—like Grand Canyon, Yellowstone etc. Their mission is to preserve the resource, while providing recreation to the visiting public. They also do a great job of interpreting the natural and historical features of the park.

The Buffalo National River Headquarters is located in Harrison. They have several Ranger Stations located along the River, with the main ones being at Tyler Bend and Buffalo Point (maps, books, River and hiking information, emergencies). There are also information sta-

tions and/or Ranger's residences located on the upper River at Lost Valley, Steel Creek, near Erbie and at Pruitt. There isn't always a Ranger available, though, and they don't really keep regular hours—that's because they spend a great deal of time out in the field. In fact, you'll probably get a note attached to your vehicle once in a while when you park at one of the trailheads—"Hi, hope you enjoyed your hike," or something to that effect. They are around, and are looking out for you, and the Park.

The Park publishes an annual information publication called *Buffalo National River Currents*, that has a lot of good information in it, and is available free at any park office. For questions or information about the River, please contact:

<div align="center">

National Park Service
Buffalo National River
P.O. Box 1173
Harrison, AR 72602–1173
870–741–5443

Steel Creek Ranger, 870–861–5511
Erbie Ranger, 870–446–5145
Tyler Bend Visitor Center, 870–439–2502
Buffalo Point Information Station, 870–449–4311

</div>

NATIONAL FOREST SERVICE

Several of the trails, and three of the wilderness areas that are described in this book, are located in the Ozark National Forest. These lands are managed by the U.S. Forest Service, which is part of the Department of Agriculture. I worked for the Forest Service for several years (still work with them on a lot of projects), and I know first hand that most people just simply don't know the difference between the Forest Service and the Park Service, which is considerable. The general philosophy of the Forest Service is to use the land (as opposed to just protecting it), to produce a variety of products, one of which is recreation.

The Supervisor's Office for the Forest is in Russellville. The two district offices that manage the trail areas described in this book are:

<div align="center">

Big Piney Ranger District
Hwy. 7 N., Jasper, AR 72641, 870–446–5122
Sylamore Ranger District
1001 E. Main St., Mountain View, AR 72560, 870–269–322

</div>

MAPS AND MILEAGES

There are a couple of dozen maps in this guide. They were created on computers by master map maker Ken Eastin (Eastin Outdoors). Elevation profiles are attached to the maps for most of the backpacking trails (where big hills are more critical!), and will give you a quick reference to the elevation gains and losses. These don't show every bump and valley, but do show all of the major gains and losses, and will give you a good idea of what lies ahead. The description will pretty much walk you through your hike, and the map is there for your overall reference.

The mileages are shown/listed in several different ways. In the description for each trail, there is a running log of the accumulated mileage. These were wheeled off on the ground (by me) with a measuring wheel and are very accurate (more accurate than GPS). For those longer trails that I felt needed more information, I have included a mileage log at the beginning of the description, and also listed distances on the maps between certain points along the way. There will be times when my mileages and the posted mileages that you see elsewhere aren't the same. Usually the differences will be slight. If you don't know which to believe, just average the two, and go enjoy the trail.

When you feel the need to hike cross-country, without the aid of trails, then you might want to pick up a topo map of the area. These are mentioned throughout the description. The Park Service and Forest Service offices sell topo maps, and many of the major outdoor stores in Arkansas carry them too. Currently you can find topo maps with many of the trails shown on them online at www.compulsivehiker.com.

You can get individual maps for some of the wilderness areas, which are available direct from our online store (**www.TimErnst.com**). There are two maps available that show most of the trails in the Buffalo area that are published by *Trails Illustrated,* also the Ozark Highlands Trail North map by *Underwood Graphics* is great. They are printed on plastic paper, and are very good maps. They show contours, and usually much more detail than the maps contained here. See all the available maps in our online store— **www.TimErnst.com**. The maps in this guidebook, along with the descriptions, are all that you really need to find your way around.

HIKING PACE

The question that I get asked most often is "how far can I hike in a day?" That is a good question, and no one knows the answer to that except *you.* How far or how fast you hike is determined by many different factors, the least of which is the trail. The trails in the Buffalo area are usually built to standards which enable most folks to hike them with no problem. However, there are some pretty steep climbs, and even

areas where the trail is extremely rough, and should not be hiked by the novice. *Be sure to read through the descriptive text **before** you head out*—you may discover that you should visit a different trail!

Generally speaking, if you are an average hiker, including rest stops and lunch, you can probably average about a mile an hour when you are carrying a backpack. Most people who don't **backpack** much, *and there is a big difference between backpacking and just hiking with no weight on your back,* can hike six to ten miles a day without too much trouble. Although it's been my experience that for most people less miles and more time to look around is best.

If you are in good shape, hike a lot, and aren't interested in spending a great deal of time messing around, sure you can hike fifteen or more miles a day. When I go out and get serious I average about three miles an hour, and typically cover twenty plus miles a day. But, of course, it hurts.

For dayhikers, one mile an hour or less is about right. If the area is especially scenic, and/or you plan to have lunch, then think about spending a couple of hours per mile or so. I've gone into places and spent all day just checking out the first mile.

A word of caution. When it is cold out you tend to start hiking with too many clothes on, and soon break out in a sweat. *This can kill you*, and you may not even realize what is happening! Of course I'm talking about hypothermia. I'm not going to tell you all about it or how to treat it—you should read up on it, though, before you go into the woods. I will say this—use the "layering method" when you hike, i.e. remove clothing as you get warm, and always hike so that you don't work up a sweat (slow down your pace if you have to). In fact, I always start off feeling slightly chilled in colder weather, knowing that my motor (and the hill ahead!) will heat things up soon enough.

TRAIL INFORMATION, HISTORY, FUTURE

Many of the trails in the Buffalo area are old roads that were built by the original settlers of the area. In 1987 the National Park Service published the "Trail Plan" for the River. This document became the blueprint for a trail system that would be developed in the Park. This system would incorporate many of the old roads, as well as lots of new trail construction, into a system that is one of the finest in the United States. The Park Service is going through with this development plan, and has already constructed a lot of new trails and facilities.

The Buffalo River Trail (BRT) is the main artery of this system. It was originally planned to run the entire length of the River, however those plans have been scaled back quite a bit in recent years. There are currently two parts to the BRT—the Upper Section that runs from South

Boxley to Pruitt (36.5 miles), and the Lower Section that runs from Woolum to Hwy. 14/Dillards Ferry (47.6 miles). Perhaps someday it will continue downstream through the Lower Buffalo Wilderness and connect with the Sylamore Section of the Ozark Highlands Trail that runs around the Leatherwood Wilderness Area. All of this will eventually connect with a trail system in Missouri (the Ozark Trail) and the combined trail (called the Trans-Ozark Trail) will run from near Ft. Smith, Arkansas to St. Louis, Missouri—over 1000 miles of trail!

The Park relies a great deal on volunteers to do trail work. In fact, much of the trail that you walk on right now was built by volunteers. The Ozark Society and Ken Smith have led the way. Crews from the American Hiking Society, the Student Conservation Association and the Sierra Club have all built trail in the Park. And so have local organizations like the Boy Scouts. *You* can be a part of this effort too—contact the **Volunteer Coordinator** at the NPS headquarters in Harrison to see how you can help. Right now, the main volunteer project is to extend the Buffalo River Trail downstream from Gilbert—there is some really neat stuff down there, and you should be a part of it. Sign up now.

As the development goes on, and things change, you can keep up by checking with any Park Ranger, or at the information stations located around the Park. I will always be happy to answer your questions too— **www.TimErnst.com**.

WILDERNESS AREAS

Most people think of "wilderness" as anything outside of town. There are certain places in this country that have been set aside by Congress, and forever protected from man. These are the truly wild places, our most remote, rugged and beautiful. In a "designated wilderness," no vehicles of any kind are allowed (including bicycles), no timber may be harvested, no roads built, no motors of any kind—essentially, no unnatural changes by man. There is one exception. Trails. They are used to transport man and beast, and are used to keep man and beast from causing damage to the resource. Thank goodness we have wilderness areas, and trails. By the way, hunting, fishing and most any other type of activity that doesn't impact the land, *is allowed.*

There are six designated wilderness areas in the Buffalo River Drainage—three Park Service areas, and three Forest Service areas, for a total of about 77,000 acres. That's a pretty good chunk of land. But just barely enough (only 9% of the Buffalo River watershed). There are two Upper Buffalo Wilderness Areas, (one Park Service, one Forest Service); the Ponca Wilderness (Park Service); Richland Creek Wilderness (Forest Service); Lower Buffalo Wilderness (Park Service) and the Leatherwood Wilderness (Forest Service).

As you visit these special places, please pay extra attention to the

impact that you may have on them. As more and more people seek solitude in these pristine areas, it will be increasingly difficult to keep from "loving them to death." Practice no trace ethics whenever possible. In fact, here is an idea. To get the most out of a wilderness area, and maybe even get the most out of yourself, spend a couple of days in one, with very little provisions. No tent, no stove, no sleeping pad. Just you and mother nature, on her terms. You might discover a lot about the woods. And yourself.

CAMPING

There are numerous Park Service campgrounds up and down the River, which are available to hikers. These are detailed along with the trail descriptions. They have "walk in" sites, toilets, water and usually a telephone (no phone at Kyles Landing). For the remainder of the trail areas, including all of the land in the national forest, camping is permitted anywhere along the trail, with a few exceptions: Camping is not allowed around the Hemmed-In Hollow Waterfall, on Big Bluff (not a good idea to camp on any bluff), in any of the historical structures, on private property, or within 100 feet of any trail or water supply (the exception to this is that you are allowed to camp on the gravel bars).

Camping probably does more damage to the forest areas than anything else we hikers do. You need to be especially aware of this, and do your best to minimize the impact of your stay in the backcountry. And the bottom line here is this: these areas are constantly studied to see what impact we are having on them. If an area begins to get impacted too much by our use, then our use will have to be limited—and this means *permits*, and none of us want that.

LOW IMPACT USE

As more and more of us use our trails, we need to be especially careful that we don't impact the special areas that we visit. It's easy to destroy a fragile spot, but it's just as easy to tread lightly and keep from messing up the things that we came out to see in the first place. All it takes is a little common sense. If we all do our part, this "Natural State" of ours will stay that way so that generations to follow will be able to enjoy the raw scenic beauty that we do.

Stay on the trail. Our trails were designed to carry you from one point to another in the most efficient (and/or scenic) way. When folks cut switchbacks, erosion begins, and soon the trail is messed up and there is an ugly scar. It is not rude to ask someone that you see doing this to kindly get back on the trail.

Hike in small groups. It's fun to go out with a large gang, but that doesn't always work too well in the backcountry—it destroys the

character and solitude of the place. Not to mention increasing the possibility of damage to the trail and surrounding areas. We always limit our group size to 10 or less when we're going to be camping. Fewer is generally better. Besides, you'll have more campsite selection if you only have one or two tents to set up! Have your parties at home—come to the woods to enjoy nature, not Billboard's top ten. Speaking of noise, be considerate of others—they just might be out on the trail to get away from all the hustle and bustle of city life. Enjoy the peaceful solitude, and let others do the same.

Camp in established sites when possible. If everyone camped in a new location every night, the damage would be much more wide spread. By concentrating this damage to several sites, the area will stay more primitive. If you must set up in a new spot, choose a site at least 100 *feet away from the trail* and any water source, and preferably out of sight (and please, *please* don't build a new fire ring). I hate to hike down a nice trail and see tents scattered along the way. Don't you?

Protect our water. Clean water adds so much to the outdoor experience, not to mention our quality of life in general. Here is a simple guideline to remember when in the backcountry—don't put *anything* into the water. Period! I know, I know, you use "biodegradable soap." What if the guy just upstream is using it too, and takes a bath in the creek that you're getting your kool aid water out of? You'll have suds in your punch! Oh yea, it will be biodegradable punch, but suds just the same. Yuk! Think about downstream—we all live there. Use biodegradable soap if you have to, but use it *away* from the stream. Or better yet, don't use soap of any kind.

Keep bathroom duties out of sight. This seems rather obvious, but not everyone seems to understand. You need to get completely *out of sight* of the trail and any water supply to do your business. Dig a small hole, fill it in and cover it up when you're done. Why do people still leave their mess next to the trail?

Cook with a stove. We haven't reached a firewood shortage yet here in Arkansas, but if we all built big fires every day we would have. Do all of your cooking with one of the lightweight stoves available—they're quicker and a whole lot cleaner anyway. Campfires are OK, but keep them small, *don't* build a fire ring, and only use dead branches that are on the ground and that you can break with you hands—if you have to saw it, it's too darn big! (The reason for this is that large wood seldom ever burns up completely, and what you have left over is an ugly black stick.)

Leave No Trace. This should be your goal on any trip on a trail—when you leave there should be no sign of your ever having been there.

It really seems silly to even mention this, but because there are still a few stupid people in the woods, I will. *Pack It In, Pack It Out.* Don't litter! Don't carve up trees. Don't cut or destroy *any* living thing. Leave it as you found it. In fact, leave it cleaner than you found it—carry a trash bag for not only your own stuff, but for other litter that you see along the way, too.

FIRES

Open fires are allowed, and permits are not required. But as just discussed, limit your use of campfires. Here are a few points to remember. New fire rings are *not* allowed. If you aren't camping in an area that already has a fire ring, then please don't build one. It isn't really necessary (cook on your stove), and the blackened rocks will be an ugly scar for a long time.

To build a low-impact fire, first clear away all of the leaves and other duff, down to bear dirt. Build a small fire in the middle of the cleared-out area. Use dead branches that are on the ground, *not* broken from tree trunks. I usually build a "pile fire"—add alternate layers of leaves and small twigs. As the leaves burn, the twigs will too. Gradually add bigger twigs 'till they will burn each other. It's not too pretty, and does get a little smoky, but it's the fastest and easiest way that I know to build a small fire.

When you are finished, and this is the most important step of all, make sure that your fire is *completely out.* Drown it, stir it, drown it, and stir it again. You've all seen those Smoky the Bear commercials. He isn't kidding. It's a shame to burn down a wonderful forest. And guess what, if you accidently start a forest fire, *you* may have to pay to get it put out! You should be able to lay your hand on the fire and not feel *any* heat. Once you're convinced that it's dead out, cover the area with leaves and twigs so that you can't tell you've built a fire there.

WATER

If you are going to dayhike, be sure to take enough water with you to last the day, plus a little more, just in case. If you will be spending the night in the backcountry, water becomes a little more critical. Most folks tend to camp somewhere near water (but at least 100 feet away, remember), so getting it is usually no problem. However, many of the trails in the Buffalo area are "high and dry," especially during the summer months, so you will need to think a little more about it. Consult the maps—what is the last creek shown before your intended campsite? Is it likely to have water in it at that time of the year? If so, then when you get to it, you need to fill up. Many streams that go dry do have a pool of water here and there—I usually find that it is better to go *up*stream to

find it. If all else fails, you may need to hike down to the River and fill up—it always has some pools in it during the summer.

The water in the Ozarks is generally clean and free of pollution. But that doesn't mean that it won't make you sick. There are lots of tiny critters (including the giardia beast) that are swimming around in there, and they may not match what your system is used to. Be sure and treat all the water that you get from creeks, and *especially* springs (bats like to roost above water). You have a lot of options these days, from tablets, to iodine crystals to all kinds of filters, so go ahead and treat and be safe.

SEASONS

Spring. An excellent time to hike. It's very magical here in March and April as everything comes to life. There's usually lots of water too, creating thundering waterfalls. Of course we've got lots of wildflowers, but the trees flower wildly as well. Especially the dogwoods, redbuds and serviceberry. Popular trails get crowded sometimes.

Summer. It gets pretty hot and muggy towards July and August. Everyone heads to the lakes. Which leaves many of the trails deserted. There is usually water in the Buffalo River, in fact some terrific swimming holes. Did someone mention skinny dipping in the warm moonlight? One of my favorite things is getting caught out in a summer thunderstorm.

Fall. Each season has a certain smell to it, but none so nice as the scent of a crisp October day in the woods. Forget about all the blaze of color. Forget the deep blue sky. Forget the craft fairs. Fall just *feels* good!

Winter. This is the longest hiking season here. Some years we have long stretches of 60–70 degree days, with brilliant sunshine. Many of the trails that run through endless tunnels of heavy forests the rest of the year, are now open to the world—with no leaves on the trees you can see deep into the hills and hollows, and out across the countryside. There are no bugs or snakes, and seldom other hikers. Of course it can get down right nasty, too!

WEATHER

The weather in the Ozarks is just like everywhere else—difficult to predict and constantly changing. Here is a breakdown by month of the type of weather that you are likely to see while hiking. There are certainly no absolutes, 'cause it is just as likely to be 70 degrees on Christmas Day as it is to be 0. But here are some averages.

January. This is a great month to hike. Lots of nice, clear views, and probably some ice formations too. It is one of the coldest months. Daytime highs in the 30's and 40's, with some days in the 50's and even

60's. Nighttime lows may be in the teens and twenties, but often down to zero, and once in a while below zero for a short period. It may snow some, but not too much, and it probably won't stay around for long. Rain is likely too. But the real killer is an ice storm. They don't happen too often. When they do, the forest is just incredible!

February. Expect weather just like January. Possibly a little colder. Witch hazel bushes will pop open on sunny afternoons along the streams, and the fragrance will soothe the beast in you. I wish that they made a perfume that smelled like this!

March. Things are beginning to warm up, and get a little wetter. Daytime highs in the 50's and 60's, sometimes up into the 70's. Nighttime lows are milder, in the 30's and 40's, with a cold snap down into the 20's once in a while. Some snow, but not much. There are often long, soaking rains. Wildflowers begin to pop out. Serviceberry, wild plum and redbud trees come out and show their colors too. There are lots of "spring break" people on the River, and on the trails.

April. One of the best months of the year. Daytime temps reach into the 70's and even some 80's. The mild nights are in the 40's and 50's, with still a cold snap once in a great while. Sometimes a heavy, wet snow, but this is rare. There can be some great spring thunderstorms. It's a wet month, and all of the waterfalls usually are running at full tilt. Wildflowers are everywhere. And the dogwoods pop out in full bloom, and they are the most common understory tree so it is quite a sight! They will linger around some into May. The rest of the trees begin to green up too. And, as a photographer I notice this, the new growth is just a brilliant kind of green that you don't see any other time. This is the perfect month to try some of those lesser-used trails, as the main ones, like the River, are usually crowded.

May. Another great month, and it is the wettest month of the year. It may rain for days on end. The daytime temps reach into the upper 80's, and the nights seldom get below 60. Wild azaleas are in full bloom now. And there are still lots of wildflowers around. And waterfalls, and more waterfalls. And plenty of sunshine. The trees are all leafed out.

June. Still good hiking weather. Less rain, and warmer temperatures. The days may reach 90, and it will drop into the 70's at night. This is the last really good month to hike for a while. The bugs start to come out, trails get grown up with weeds, and the humidity goes up a little. Swimming holes become really inviting!

July. This is an "ify" month. It could be cool and wet, but most of the time it is pretty dry and beginning to get hot, up into the 90's, with nights still down into the 70's, or even 60's. When it does rain, it usually does so with lots of power. It's a wonderful experience to hike in the warm rain. Put on your tennis shoes and try it sometime.

August. This is a good month to go to the beach or lake. Not a good time to be out hiking. Daytime highs can reach 100, with humidity read-

ings to match. Sometimes it doesn't get below 80 at night. And there are lots of ticks, chiggers and other assorted bugs just waiting for you. And lots of spider webs strung across the trail. So if you do go hiking, remember to take that tall friend with you and let them lead.

September. This is also a good month to stay home. It is often a worse month than August. Everything is pretty much the same except that horseflies come out, and they are really a pain! Towards the end of the month, it does begin to cool off a bit. That's a good sign that better hiking is just around the corner, so you had better dust off that equipment, and maybe get into shape. Try doing some early morning hikes. You'll be surprised at who else you'll find out there with you.

October. This is the other best month of the year. The first part of it is usually still quite warm, dry and buggy. But towards the middle the nights get cooler, down into the 50's, 40's and even 30's, and then it frosts. Yet the days are in the 70's and some 80's. By the end of the month it's crisp, clear days and nights, and the forest transforms from the dull green that you have gotten used to since May, into one of the most incredible displays of color anywhere. It can be just as pretty as New England or Colorado. And out on the trails the last week of the month is always best. The bugs are pretty much gone too.

November. Early in the month is still kind of like October, with some warm days and a few fall colors hanging on. But it can change quickly. The leaves die and fall off the trees. This turns everything the same color of brown, but also opens up lots of views that have been hidden since April. The days get cooler, down into the 40's and even 30's, with some nice warm days in the 60's. The nights fall into the 20's and 30's more often, and once in a while there will be a cold snap. Rain is more frequent, and once in a great while, some snow. *This is the month when hunters are most active, and hunting is allowed in the River area.*

December. A good month to hike. The days are usually in the 30's and 40's, but are often in the 50's and above. The nights get cold, and can drop down to zero once in a while. Snow is more likely, but not too much. And it can rain a lot. This is a typical flood month, though it is usually pretty dry, with some rain now and then and, once in a while, some ice. The ice begins to accumulate on some of the bluffs. A campfire, a mug of hot chocolate and a warm friend feel great!

EQUIPMENT

If you do a lot of hiking, you probably already know what to take with you. For those of you new to the sport, here is a bare-bones list of gear that you should probably take with you. Begin with the first list, then add on as needed. You can always take other stuff that you think you might want, but just don't go overboard—remember, you'll be carrying all of it. One good way to keep track of all this stuff is to make up a list of everything that you take on your hike. When you return, take a look at the stuff you thought was useless, and maybe remove it from

the list. Use the same list to add items that you wish you had taken. Do this every time that you go hiking. Eventually, your list will be just the items that you really need.

If you are just going to hike a very short trail, and be out for an hour or two, you can pretty much get by with a set of comfortable clothes that you are wearing, plus:

❏ Map or guidebook (always have with you!)
❏ Fanny pack or daypack
❏ Small first aid kit
❏ Waterproof matches and / or bic lighter
❏ Water, a liter
❏ Pocket knife (folding Swiss-Army type)
❏ Comfortable footwear—tennis shoes are OK
❏ Small trash bag for the "collectibles" that others left behind
❏ Warm clothes, if winter
❏ Sunscreen, if summer
❏ Rain jacket, if it looks like rain
❏ Insect repellant, if it looks like bugs
❏ A snack
❏ A whistle
❏ Optional— camera, hiking stick, binoculars, note or sketch pad

For more of an extended dayhike, one that may last most of the day, add the following items to your daypack:

❏ Lunch, plus another snack
❏ More water
❏ Lightweight boots instead of tennis shoes
❏ Small flashlight, the kind that takes AA batteries
❏ Whistle
❏ Extra film
❏ Rain gear, if winter, no matter what the sky looks like
❏ Hat
❏ Light jacket or sweater, if chilly
❏ Warm jacket, if cold
❏ Plastic trowel for toilet duties
❏ Toilet paper
❏ ID books for flowers, birds etc.

For an overnight stay in the woods, you'll need to carry all of your gear on your back. The general rule is *keep it simple*, i.e. *light*. If you

hike with someone else, you can save a lot of weight by sharing group equipment (tent, stove etc.). You should have all of the items on the other lists plus:

- ❏ Backpack instead of daypack
- ❏ Sturdy boots, broken in
- ❏ Sleeping bag
- ❏ Sleeping pad
- ❏ Stocking cap
- ❏ Tent, w/ground cloth
- ❏ Small cook stove
- ❏ Cook pot
- ❏ Cooking/eating utensils
- ❏ Cup (insulated plastic mug works great)
- ❏ Two small trash bags
- ❏ Rain cover for backpack
- ❏ Rope, 25 feet
- ❏ Water filter/tablets/iodine crystals
- ❏ Polypropylene or similar underwear, if the weather is cool
- ❏ More food, including snacks and drink mixes
- ❏ Personal stuff like toothbrush, small towel, etc.
- ❏ Spare batteries for flashlight
- ❏ Zip lock bags, assorted sizes
- ❏ Aspirin, or equivalent
- ❏ Spare socks
- ❏ Change of clothes
- ❏ Tennis shoes for around camp
- ❏ Sewing kit
- ❏ Stuff sacks for organizing stuff
- ❏ A large stuff sack to "bear bag" your food, plus extra rope

People always want to know what kind of gear I use. Since I work and generally live out on the trails much of the year, my stuff has to be pretty good. Of course, equipment is purely a personal choice—and there are lots of great products out these days. But here are a few thoughts on some of the major equipment that I carry into the woods, and rely on to work day in and day out.

But first let me say something about buying equipment. I feel that it pays to shop at your local outdoor store, if possible, and buy name brand gear. If you use your stuff much, you'll come out ahead in the long run. Besides, most likely your local outdoor store supports the

trail activities in your area, and you should shop there. My local "candy store" is the *Pack Rat Outdoor Center* here in Fayetteville. It seems like I spend more time in there than I do at home when I'm in town. I'd be lost without them. There is one mail-order store that is worth supporting too, and that's *Recreational Equipment Incorporated* (REI). They give a great deal of support to trails at the national level, as well as to local groups, like the Ozark Highlands Trail Association.

Boots. I've worn lots and lots of boots and have had many blisters to prove it. Don't get a pair of boots that are too heavy, or your feet will suffer. There are a lot of lightweight nylon/leather combos out these days—they are good for dayhiking and short backpack trips. The weight you intend to carry on your back, and the rougher the terrain you plan to hike, the heaver your boots should be. The most important thing about boots, is to get a pair that is comfortable and that fits, and break them in!

Tents. I own and use several different tents—one is very small and light for my quick solo trips in fair weather; another one is roomy enough for my wife and camera gear; and a third one that is pretty heavy but will withstand gale-force winds. My main advise here is this: If you are only going to be a fair–weather camper, then a Wal–Mart variety will be just fine. But if you plan to do some serious backpacking, and want your tent to last a long time, spend a few bucks and get a name brand. The two most important factors to me are that the tent must be freestanding, and have a vestibule with lots of room to stash gear outside of the tent.

Daypack. Everyone has a daypack/bookpack these days that will carry lots of stuff and these will probably work just fine for your shorter dayhikes. If you plant to be out all day and/or carry a lot of gear then spend some time at your local outdoor store and find one that is comfortable and well made.

Backpack. I have both an external frame pack and an internal frame pack. The external is great when the temps are high so my sweaty back can keep cool; but I use an internal pack at all other times—they just seem to fit better and feel more comfortable under heavy loads. Two things about selecting a backpack—one is to be sure that it fits right when fully loaded. If the outdoor store that you are buying it from won't let you load it up with 40 pounds of gear, then help you fit it, walk out of the store and go somewhere else. And two, remember that no matter how large a pack you buy, you will always bring along enough junk to fill it up—don't get a pack that's too big, or you won't be able to pick it up!

Sleeping bag. I've used two high-quality goose down bags for more than 25 years, and have never had any problems taking care of them. One is a lightweight "summer" bag that has kept me warm down

to 20 degrees, while the other is a monster down bag that I've used in twenty below zero weather. Down is the best, but there are some great imitation down bags out these days that seem to be a pretty good deal, although I doubt that they can stand up to years and years of constant use like down does. All sleeping bags are "rated" for their minimum temperatures. Take this figure with a grain of salt—not only is everyone different, many environmental factors come into play when determining just how warm a bag will keep you on any given night. A pad, tent, midnight candy bar, stocking cap, and tentmate will all keep you warmer.

Sleeping pad. I'm getting to be a wimp in my old age I guess, so I finally broke down and bought a Therm-a-Rest *Ultralight* pad. It's got one of those covers that make into a chair, and it's the first thing that is loaded into my backpack before a trip. The "blue foam" type pads are cheap, light weight and pretty effective.

Stove. Nothing beats my MSR *WhisperLite*. It just keeps on going and going, like that stupid bunny on TV. And it heats in a hurry. A good, basic stove (this is the stove that I loan out) is the Coleman *Peak I*—it's pretty simple to operate, and a good performer. If you are only going to camp during warm weather, and not do too much cooking, one of those cheap "gaz" cannister stoves work fine.

Water filter. For short trips, I use iodine crystals. But for longer trips, I use the *First Need* pump. It's simple, effective, and reasonably light weight. There are a number of excellent filters on the market of late—made by PUR, Katadyn and MSR, but they are a bit heavy and pricey. The Katadyn *minifilter* is light, but slow.

WILDLIFE, INCLUDING BEARS AND SNAKES

There is an abundance of wildlife along the trails, both large and small. I have seen everything from colorful lizards and hummingbirds, to bald eagles, bears and elk. The Park Service has a "Checklist of Mammals" that they'll give you, and it lists 54 species of them! Most of these critters will flee at the first sign (or noise) of a hiker, so you probably won't see many while you are hiking. But when you stop and take time out, that is another story.

One of the special treats of the Buffalo area, not found anywhere else in the state, is the elk herd. The Arkansas Game and Fish Commission stocked part of the area with elk several years ago. The elk just love it here in Arkansas, 'cause they have been doing well. What a joy it is to be walking through the wilderness, look out across the field, and see an elk. They are big, about the size of a cow or horse. You will see their droppings, and the trees that they scrape, all around the area. The Erbie area and the fields around Steel Creek and Ponca low-water bridge are the best spots to find them. Although you are likely to see them just about anywhere. Some friends of mine that frequent the area tell me

that they were startled one day, when they looked up from Hemmed-In Falls, and spotted a huge bull elk. He was just hanging out on the bluffline, surveying all of his kingdom.

Yes, there are bears. Black bears too were stocked by the Commission for many years. They are not the huge grizzlies that you hear and see so much of, though. Most are pretty small, actually, about the same size as you and me. And, they aren't really much of a problem. I have been hiking in the woods in Arkansas for 30 years, and I have only seen a few bears in all that time. The best place to find a bear is in the Horn Mountain area, which overlooks the Richland Creek Valley. A section of the Ozark Highlands Trail (which joins the Buffalo River Trail at the mouth of Richland Creek) goes right through the middle of it, and you often see their footprints.

Even though bears have not been much of a problem in the past, that doesn't mean that you can ignore them. They are strong, and under the wrong circumstances, can be quite dangerous. I only hear reports of bear sightings once in a while. Although it's probably not a necessity to "bear bag" your food when you camp, it's a good idea. *Do not keep food in your tent with you.* And be a clean and neat camper, and you shouldn't have any problems. Most of them will take off just as fast as they can, if they see or scent you. Any loud noise will usually send a curious one off into the woods in a hurry. If you see a bear, and it is obvious that he has seen you, shout at the top of your lungs.

And, yes, there are snakes. Lots of snakes. Copperheads. Rattlesnakes. And cottonmouths. And they do bite. But snake bites are rare, and are usually the result of someone playing with one. Bees kill more people nationwide than snakes do, so it's not a real serious problem. But they are there. Watch out for them. Look at them. But for goodness sakes, don't play with them. A snake will not seek you out and bite you. If you reach down and pick one up, or happen to step on one, sure it will bite you. What else can it do? Watch your step, mind your own business, and you shouldn't have any problems.

If you do happen to get bit, the best thing that you can do is relax, you aren't going to die. And get to a doctor as soon as you can. Snakebite kits don't work very well. But I do recommend that you carry a device called "*The Extractor*"—it does work (on bee stings too!). The main thing is to just try and stay out of their way.

I'm not much of a bird person, but I can tell you that there are lots and lots of birds out there. The Park Service has a bird checklist too—it lists 189 species! My favorite ones are the eagles of course. They come down from the north and spend the winter here. Just like an elk, seeing one will make you stop whatever you are doing, and stare, breathless, at this incredible living thing.

There is one more checklist that you can get from the Park Service that I should mention—it is of what I call "ground wildlife"—wild-

flowers. There are 62 species on the list, and these are only the spring flowers. If you love this kind of stuff, then you should be sure to carry a wildflower book into the woods with you too.

HUNTING AND FISHING

Unlike almost all other national parks, hunting is allowed in Buffalo National River. There are few conflicts between hunters and hikers. A lot of folks are afraid to hike during the hunting season. There is a hunting season of one sort or another going on from September through the middle of June. Why would you want to stay home during all of the best hiking seasons? The most popular game species are squirrel, deer, turkey and bear. The Arkansas Game and Fish Commission has a great management program, and game populations are high.

Fishing is a popular sport in the Buffalo area. One reason might be the many different kinds of fish to catch. The Park Service fish list has 59 species. Good grief! At times the fishing can be quite good. But with all of this success comes a potential problem. As more and more people visit the area and fish, the game fish population is in danger of getting "fished out." To make sure that there will always be plenty of fish for you and your grandchildren to catch, *practice catch and release*. Enjoy your sport, play the fish, admire it, then carefully release it to fight another day.

Hunting and fishing licenses are required of all resident and non-resident sportsmen over the age of 16. For info contact:

Arkansas Game and Fish Commission
2 Natural Resources Drive
Little Rock, AR 72205
501–223–6300

BUGS

We have all kinds of bugs in Arkansas. Mosquitoes start to come out near the end of April and May. Ticks too. And chiggers like to show up during the summer. And just about the time that they are all getting burned up by the dry weather and heat, horseflies and gnats come out and really bug you!

There is no surefire way to keep them all from bothering you. A good 100% DEET repellant will help. Avon *Skin-So-Soft* works great for some people, not at all for others. In addition to repellants, a couple of other things will help too. First, don't smell good. Take a shower before you go into the woods, but don't *add* any sweet scents to your body. And campfire smoke really knocks down the bugs. It smells a lot better than perfume anyway. Campfire smoke is trail perfume!

In August and September, sometimes the spider webs across the

trails just drive you nuts. A headnet will usually do the trick, but then of course you don't get as much protein that way—the net will keep you from accidentally eating those fat rascals! This is a good time of the year to hike with a tall friend—let them lead.

By late October most of the bugs should be gone 'til spring. Although I have seen ticks out all winter before. And speaking of ticks, they have been getting a lot of press lately. If you find a tick on you, just reach down and pull it off. No big deal. *However*, since Lyme disease is becoming more prevalent, if you suspect a problem (especially a bullseye rash), go to a doctor and tell him that you've been in the woods and to consider ticks as a culprit (it's easily treatable if caught in time).

SHUTTLE SERVICES

There are several nice loop trails that you can hike in the Buffalo area. But for a lot of the trails you will want to do, you'll either have to turn around and hike back to your car, leave another car at the other end, or arrange for a shuttle. Fortunately, there is already a terrific system in place that makes this an easy task. Most of the folks who run canoe operations in the area will also shuttle a hiker. The Park Service has a list of all those folks that are licensed to run shuttles within the Park. Do keep in mind that during spring weekends these folks are swamped with business—hike during the winter or during the week if you can. A shuttle will cost you $25 or more, depending on how far you've got to go, and is well worth the cost. For a list of the current concessionaires who are licensed by the park service, see their web page—
http://www.nps.gov/buff/index.htm.

CABINS AND MOTELS

After a long day on the trail, there is nothing quite like settling back in front of a fireplace, in a log cabin in the Ozarks. To swipe a phrase from Mazda, "it just feels right." It is great to sleep out under the stars, but you should treat yourself to a cabin once in a while.

There are now quite a few cabin rentals and B&B's in the Buffalo River area, and most of them will have a web page where you can go see what type of lodging they have. We maintain an "outdoor links" page on our web site (www.TimErnst.com) that has links for many of these rental cabins.

There are motels available in the area too. Check with the Jasper and Harrison Chamber of Commerce office's for a lodging list. And for a "Vacation Travel Kit," and other information about traveling in "The Natural State," call 1–800–NATURAL.

CAVING AND CLIMBING

NOTE that most all wild caves on federal land continue to be closed due to the spread of "white nose syndrone" in bats (as of 2019).

The massive limestone bluffs that are everywhere in the Buffalo country are the sources of potential danger, and adventure. Lots of folks try to climb the bluffs, and this usually isn't a good idea. There have been several fatal falls in the Park over the years. It takes special skill and equipment to safely negotiate a sheer bluff. They are great for standing on top of and enjoying the view from, but leave it at that.

The limestone also hides something—often the inside of these rock layers is honeycombed with caves. There are hundreds of small entrances and passageways, and a few really nice cavern systems, including the longest cave in Arkansas. Like climbing, safe caving requires a great deal of skill and special equipment. If you plan to explore any cave, be sure that you have at least three light sources with you.

A couple of other important things about caves. First, many of them have cave formations in them—stalactites that hang down from the ceiling, stalagmites that grow up from the floor, and flowstone or curtains that grow out from the walls. All of these are hard and made of rock (calcite), but are still extremely fragile. If you do enter a cave and see some, *please do not disturb*. And the other thing is about bats. They are really pretty nice guys. Especially if you consider that each one of them will eat up to 1,000 mosquitoes *every day*! There are a dozen species of bats in the Park, including a couple that are on the endangered species list. At certain times of the year, disturbing the bat colonies can kill a lot of the bats. For this reason, many of the caves in the Park are closed part of the year. So if you see a closed sign at a cave entrance, by all means stay away—you'll only be adding to the mosquito population if you go in!!!

CANOEING

If you are reading this book you probably want to hike. And you may already know a great deal about the wonderful floating that the Buffalo has. For those of you who don't, let me give you a small bit of info. The River is, of course, one of the great floating streams there is. Folks come from all corners to float. It's not all that difficult of a float. In fact, I suppose that half or more of the people on the River are just casual floaters, or it may even be their first time. There is plenty of challenging whitewater, especially in the upper section. And sometimes, during high water, the River gets pretty dangerous, and is even closed to floaters. There are also lots of nice, easy pools.

A good way to do a float is to go through an outfitter. They are licensed by the Park Service, and are usually a pretty good deal. Check with the Park Service for a current listing of the outfitters. You can pretty much write your own ticket with them—use them for just a shuttle of

your own boat, rent a boat from them, or even do a "dude" float—have the outfitter come along as a guide— even fix your lunch!

The floating conditions at the River vary greatly during the year, and it isn't always the same from year to year. In a typical year, the floating in the upper section will be good from January-May or June, but this really depends a lot on how much rain we've gotten. The middle section is usually floatable for a longer period. The lower section is pretty much floatable all year (not too much whitewater).

A great way to see the Buffalo is to combine a float trip and a hiking trip. Float for a day or two, then hike back upstream. The Buffalo River Trail is especially suited for this. There are several spur trails that lead from the River to trails into scenic or historical areas.

GLOSSARY OF TERMS

Here are a few words that I use over and over again in this guide that you may not be familiar with.

Bench. This is part of a hill, a section that is usually level and runs along the hill for a while. If there was a giant around he could sit on it, like a bench.

Leaf-off. This is the season after all the leaves on the trees fall off, and before they grow new ones in the Spring. There are always a lot more views out through the trees during leaf-off.

Leaf-on. The opposite of leaf-off.

Road trace. These are old roads that have not been used for a while, and are usually grown up with trees and other vegetation, and/ or covered over with deep duff. They often make great trails 'cause they are wide enough to allow two hikers to walk side-by-side .

Saddle. This is a low spot in a ridge. Trails like to pass through them 'cause it's easier than climbing all the way to the top!

SSS. This means *"Special Scenic Spot."* There are a lot of places along the trails that may or may not be well known, but are just neat little areas that I find very attractive. The better trails have more SSS's!

THANK YOUS

There are a few folks who helped me a great deal with one aspect or another in the production of this book that I'd like to thank. I'll start with Jim Liles, a former Assistant Superintendent of Buffalo National River. He had to endure hours of questioning from me about this and that, has spent many more hours checking my text and maps—I owe a great deal of the accuracy of this book to him. He has been involved with trail development at the Park since the beginning, and was the principal author of the Buffalo River Trail Plan. Jim has additionally spent many hundreds of hours doing volunteer work building trails in the Park (including the trail from Compton Trailhead down into

Hemmed-In Hollow, plus many miles of the Buffalo River Trail, all on his own time!). Others who helped with the book include: John Apel of the National Park Service, Marny Apel and George Rogers of the Forest Service, Ken Eastin for his great maps. And, of course, a special thanks to the late Neil Compton for contributing such an eloquent Foreword.

Folks who helped out with this newest edition include "Fireman Jeff" Davis, Cindy and Shane Jetton, Ranger Lauren Ray, Michael Reed, Jim Liles, and my lovely bride, Pamela.

And finally, I would like to thank the most important person, the one for whom this book was written—*you*. If there is no one to hike our trails, no one to revel in the splash of a waterfall, no one to sit on a bluff in tears because the sunset is so beautiful, then, there is no reason for a trail guide. So *thank you* for reading this book, for hiking the trails in the Buffalo River area, and for helping to take care of our natural world.

Now you have come to the end of the introduction to this trail guide. It's time to get out into the woods and use the rest of the book. The Buffalo River area is a terrific place to be, and I hope that this guide helps you enjoy it to the fullest. Please feel free to contact me at any time, with questions or comments about the trails, or this book. Good luck. Enjoy yourself. Be careful. See ya in the woods . . .

Tim Ernst

UPPER BUFFALO AREA TRAILS

Hawksbill Crag/Whitaker Point (3.0 miles round trip)

Hawksbill Crag is one of the most recognizable spots in Arkansas. It's an amazing rock outcrop that sticks out from the top of a tall bluff. It is located in the Upper Buffalo Wilderness Area. There is a primitive trail (marked with orange markers) that runs from a parking lot to the Crag. Since this is in the Ozark National Forest, DOGS ARE ALLOWED.

Camping is not allowed along the trail or at Hawksbill Craig. AVOID SPRING AND FALL WEEKENDS—too crowded. Probably best to hike it early in the mornings at any time to avoid crowds.

To get to the trailhead, begin at Boxley Valley in Buffalo National River, at the intersection of Hwy. 21 & 43. Head south on Hwy. 21, 1.2 miles. Just before the highway crosses the Buffalo River TURN RIGHT onto Cave Mountain Road (NC#9560, a terrible, bumpy, dusty, rough, dirt road), and soon it heads straight *up* the hillside. Follow this road 'till you pass Cave Mountain Church and cemetery on the right (5.4 miles from the Hwy.). Continue past the church for another .6 mile (*past* NC#9210) and PARK at the "Wilderness Access" parking lot. Boxley quad map.

From the parking lot, the trail begins across the road next to the Dale Bumpers monument and heads into the woods. It drops down the hill slightly, crosses a small stream, then switchbacks down a steeper hillside. It crosses the stream again, then runs level out to some blue blazes—these mark the wilderness area boundary. Red blazes (also purple) mean private property—steer clear of them. From here the trail continues out on the level, into the wilderness area, winding around as it drops down some. During leaf-off you can begin to see out into the Whitaker Creek drainage.

The trail swings back to the left, drops down to and across a small stream at 1.0. The trail splits here. Turn left to follow an old road trace that eventually leads to the Crag (shown as a dotted line on the map away from the blufftop—this is a safer route), or TURN RIGHT and go down the creek to an SSS waterfall just downstream (Haley Falls, named after six-year old Haley Zega who got lost here and was later rescued after the largest search mission in Arkansas history).

You will come to a bluffline at the top of the falls—the trail swings back to the LEFT and up and away from the bluff. This bluff-top trail (marked as the solid red line on the map) can be *very dangerous* since it runs close to the tall bluff, so be sure to remain on the trail and STAY AWAY from the edge of the bluff!

The trail continues mostly level along the top of the bluff with great views along the way looking down into the Whitaker Creek drainage (did I mention to *stay away from the edge?!*). You will eventually pass in between some giant sandstone blocks as the trail swings to the left.

Hawksbill Crag Trail

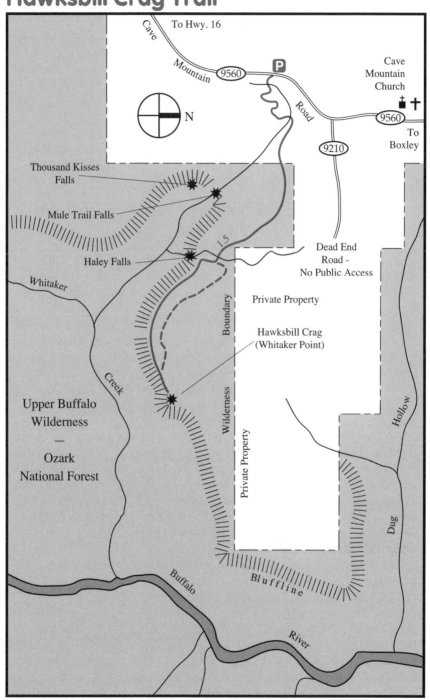

To Hwy. 16

Cave Mountain 9560

P

Cave Mountain Church

9560

To Boxley

9210

N

Thousand Kisses Falls

Mule Trail Falls

Haley Falls

Whitaker

1.5

Dead End Road - No Public Access

Private Property

Hawksbill Crag (Whitaker Point)

Boundary

Wilderness

Creek

Upper Buffalo Wilderness — Ozark National Forest

Private Property

Hollow

Buffalo

Bluffline

Dug

River

Just past this point you can look ahead and all of a sudden, there it is—Hawksbill Crag—one of the most major SSS's in Arkansas! The trail continues on to a point where you can access the Crag (the dotted line trail section joins from the left just before you reach the Crag). *Please be careful* in this area—if you go to the edge to have a look and slip, you may not survive the fall. (By the way, you may be able to see a barn and houses on the distant hillside, which are owned by an original 1800's homestead family and several others near the community of Mossville.)

The total length from the parking lot to the Crag is 1.5 miles (3.0 miles round trip).

To get back to the trailhead from the Crag you just hike back the same way that you came.The official trail does not continue past the Crag or loop around—it dead ends on private property.

Upper Buffalo Wilderness Area-Access Points
(no trails)

There are actually *two* Upper Buffalo Wilderness Areas—one administered by the National Park Service, and one by the U. S. Forest Service. The Park Service area is pretty small, and is located right next to the larger Forest Service area (access via the Buffalo River Trail trailhead at South Boxley—see page 66). The two together make up about 13,300 acres. Besides the Hawksbill Crag Trail described on page 32, there are four wilderness access parking areas that don't have official trails—Kapark Cemetery, Dixon Ford, the Jerry Dahl Monument, and Boen Gulf. All of these parking areas provide good access to a variety of destinations within the Wilderness. DOGS ARE ALLOWED.

The general rule about hiking here is that you should get a good map, use one of the access lots, and "bushwhack" your away around. We sell a special topo map for this wilderness, or you can use the Trails Illustrated West map (find both at www.TimErnst.com). Or you can use the two quad maps that cover the area—Boxley and Fallsville. There are a number of old log roads, many of which are shown on the maps, that can be used as trails. I prefer to go cross-country. By the way, this wilderness is filled with waterfalls—see the *Arkansas Waterfalls Guidebook* for directions and GPS data for some of them.

Kapark Cemetery Access

This parking lot is centrally located and provides good access to a large chunk of the Wilderness, including Bowers Hollow, Whitaker Creek and Pruitt Hollow, all great places to explore. To get to the trailhead, begin at Boxley Valley in Buffalo National River, at the intersection of Hwy. 21 & 43. Head south on Hwy. 21, 1.2 miles. Just before the highway crosses the Buffalo River TURN RIGHT onto Cave Mountain Road (NC#9560), which is dirt—it heads straight *up* the hillside! Follow this road untill you pass Cave Mountain Church and cemetery, and then past the Hawksbill Crag Trailhead, then continue on

Upper Buffalo Wilderness

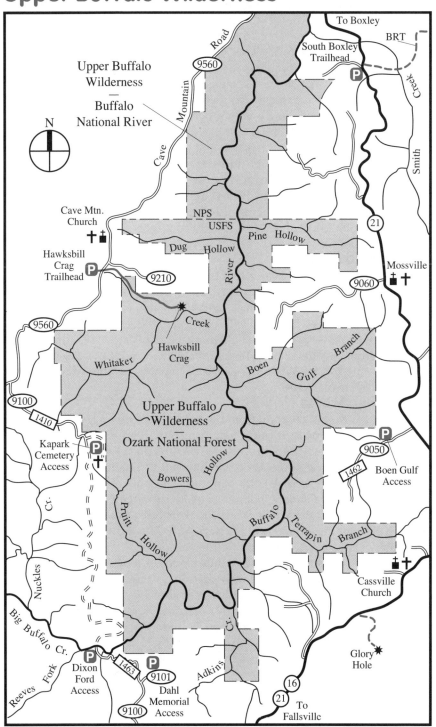

To Boxley

BRT

South Boxley
Trailhead

P

Upper Buffalo
Wilderness
—
Buffalo
National River

Road

9560

Cave Mountain

Cave

N

Smith Creek

21

Cave Mtn.
Church
✝ ‡ ■

NPS

USFS

Pine Hollow

Dug Hollow

River

Mossville
‡ ✝ ■

9060

Hawksbill
Crag
Trailhead

P

9210

Creek

9560

Whitaker

Hawksbill
Crag

Boen

Gulf

Branch

9100

1410

Upper Buffalo
Wilderness
—
Ozark National Forest

P

9050

Kapark
Cemetery
Access

P

✝

Hollow

1462

Boen Gulf
Access

Bowers

Cr.

Pruitt

Hollow

Buffalo

Terrapin

Branch

Nuckles

✝ ■

Big Buffalo Cr.

Cr.

Cassville
Church

Reeves Fork

P

1463

P

9101

Dixon
Ford
Access

Dahl
Memorial
Access

9100

Adkins Cr.

16

21

To
Fallsville

Glory
Hole ✳

Cave Mountain Road another 2.6 miles (a total of 8.6 miles from Hwy. 21), and TURN LEFT onto NC#9100/Forest Road #1410. (You can also get to this turnoff from Hwy. 16 near Red Star—drive six miles on Cave Mountain Road/CR#3595/NC#9560, then turn right onto NC#9100/Forest Road #1410.) Follow this road for a couple of miles until you come to the "Wilderness Access" sign on the left. Park here (road goes farther, but it is often a mess). The main road continues down to the Buffalo River at Dixon Ford—very rough road and not maintained.

Dahl Memorial Access

This access area is easy to get to and gives you access to Atkins Creek and across the River to Pruitt Hollow. To find it, go about 1.4 miles East from Fallsville on Hwy. 16/21 and TURN LEFT onto NC#9100/Forest Road #1463. Follow it for a couple of miles and TURN RIGHT onto NC#9101 just before the main road goes down a steep hill. The parking lot is just ahead (a jeep road continues past the parking area, but is not recommend.

Dixon Ford Access

This is the only access area that is located right on the River. To find it, follow the directions above to the Dahl Memorial Access, but instead of turning off of NC#9100/Forest Road #1463, remain on it and continue down the steep hill. This will take you to the River. The first time that I drove to this spot was just after an eight-inch snowfall. I drove all the way from Fayetteville and broke trail all the way! It was an especially magical trip, as the Wilderness Area was hushed for three days under the deep white blanket.

Boen Gulf Access

To get to the access point from Boxley, head south on Hwy. 21 to the community of Mossville, then stay on Hwy. 21 another 2.5 miles and turn right (west) onto dirt road NC#9050/Forest Road #1462, go .3 mile to the Wilderness Access sign, and turn RIGHT and park at a wide spot near the main road. An old road trace continues on another couple hundred yards to a bulletin board and Wilderness registration box, but you probably can't drive this. Be sure to register!!! (You can also reach NC#9050 from the intersection of Hwys. 16 & 21 at Edwards Junction— the turnoff is 1.9 miles north of this intersection.)

From the registration box, continue along the road trace past the wilderness boundary (marked with posts in the road), to flat area of big trees. The road trace continues straight ahead, but another old road bares off to the left (west). Follow this one down into the Boen Gulf drainage. You'll notice blue wilderness boundary blazes on the trees in a couple of places as you continue down, and will eventually bottom out at Boen Gulf. There are many waterfalls, blufflines and great things to explore in all directions!

Alum Cove Trail

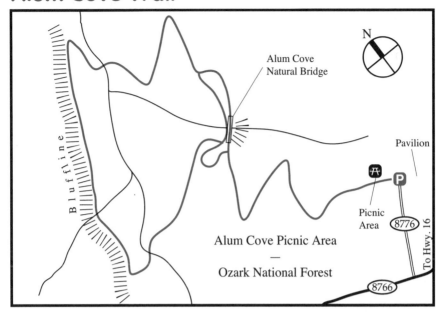

Alum Cove Natural Bridge Trail (1.1 miles)

This wonderful little trail visits one of the largest natural rock bridges in this part of the country. It loops around past a nice bluffline too. There are some tall trees around, and lots of wildflowers, including a rare variety of shooting star. This trail is located in the Ozark National Forest. There is a picnic area and pavilion, but no camping.

To get to Alum Cove, take Hwy. 7 south out of Jasper for 14 miles and turn right on Hwy. 16 towards the community of Deer. Go one mile and turn right onto NC#8766 (paved). There is a large sign at this intersection, so you can't miss it. Drive 3.1 miles and turn right at the sign and take the gravel road to the parking area.

The trail heads on down the hill, and switchbacks down *(stay on the trail—don't cut switchbacks)* 'til it reaches the natural bridge (there are several benches along the way, which you will appreciate on the way up!). You can walk right out on top of the bridge—it's 130 feet long and 12 feet thick. During the wet season there is a waterfall or two that pours into the open area behind it. The trail loops on down underneath the bridge too. This is where the bridge is most impressive. I took a photograph here one time of the *sun* rising underneath the bridge!

From the base of the bridge the trail continues on—it doesn't really matter which way you travel on it, but I usually go clockwise. It drops on down a little ways and crosses a little stream, then works its way up the other side to a wonderful bluffline. And the first thing that you see along the bluff is a cave entrance. It doesn't go in very far, but it does have two different entrances and is a neat little spot. By the way, all of this area is an SSS!

The trail turns right at the bluff and follows it along for a while. The

37

bluff is made of sandstone (so is the natural bridge), and so has been easily carved out by eons of wind and water. At one point the bluff splits and you can walk behind it. In many spots the bluff is covered with lots of lichens, mosses and ferns. During the wet season, there is a nice waterfall that pours over the bluff.

All too soon the trail leaves the bluff, drops back down to and across the small stream, and heads back up to the other end of the natural bridge. There are at least 18 species of trees here, including umbrella magnolia, and my old friend, the beech tree.

The hike out isn't too steep, but it does gain a bit of elevation, so be sure to use the benches! Total loop hike is just over one mile.

Round Top Mountain Trail (3.6 miles)

This is one of the most scenic trails in Arkansas, and also there is some rare history to go with it—fragments of a WWII bomber that crashed in 1948. To get to the trailhead, take Hwy. 7 south out of Jasper (uphill) a couple of miles and turn right at the hiker sign, then park at the small building at the top. The property is owned by the Newton County Resource Council, and their volunteers keep the trail up. There are composting toilets but no water.. DOGS ARE ALLOWED on leash.

The trail starts out by climbing the steep hillside in four winding switchbacks— there are benches at every switchback! In fact, there are more than 30 benches located all along the route. At .2 there is a trail intersection—TURN RIGHT to visit the entire trail. It is all level now as the trail goes along a flat bench that is located just below the massive sandstone bluff that is up to your left—ALL of this area from here on is an SSS. Not only is the bluff beautiful, but you'll find thousands of wildflowers here in March and April. At .4 there is a small trail that goes to the left up to the base of the bluff, and to a little tunnel cave. The main trail continues along the bench and comes to the crash site at .5. There is an old rock wall and a bronze plaque that lists the date and names of the crew. You may find bits and pieces of the B-25 bomber that smashed into the hillside—like the wildflowers, these are all protected. Remain quiet at this site, and remember the sacrifice that our military folks make in order for us to live free in this country. (The impact location was actually just above the bluff and is not marked.)

The trail continues along near the base of the bluff, past another little trail that drops down the hill to the right to a lookout point—if you are going to the top, the view is much better from up there. The main trail curves around the nose of the bluffline to the left, and comes to the Geology Viewpoint at .7, a special SSS area with giant moss-covered blocks of sandstone and a terrific view.

The trail remains level as it curves around to the left and to the back side of the mountain, past the 1.0 mile point. There are some views out towards the Little Buffalo Valley, and scores of wildflower fields on the forest floor. By 1.5 the trail has bumped up to a break in the bluffline known as South Gap, another great SSS! Once through the gap the trail turns to the left and remains close to the base of the bluff, going past a Native American campsite area, and through a split in the bluffline, all of it an SSS.

Round Top Mountain Trail

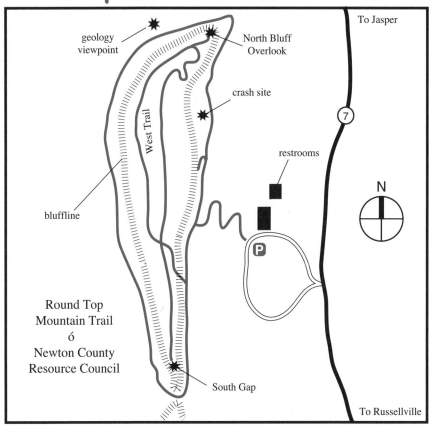

geology viewpoint

North Bluff Overlook

crash site

West Trail

restrooms

To Jasper

7

N

bluffline

Round Top
Mountain Trail
ó
Newton County
Resource Council

P

South Gap

To Russellville

There is a trail intersection at 1.7—TURN LEFT and go up a flight of stairs that will lead you to the top of the mountain. There is another intersection ahead—TURN RIGHT to head up to the main overlook (we will return to this spot via the West Trail). The trail eases up the hill some, following the top of the ridge, past milepoint 2.0, then tops out at the high point on the mountain. From there the trail begins to ease on down the hill to the right, and drops on down to another intersection—TURN RIGHT, then follow the trail on down to where it ends at the North Bluff Overlook at 2.3, a terrific SSS with a 200 degree view!

Now, take the trail back up to the last intersection and GO STRAIGHT, which will take you around the back side of the mountain on the West Trail. It is level and there are some great views. It will intersect with the main trail at 2.9—TURN RIGHT and take the short spur out to the top of South Gap, another great SSS, then return to the same intersection and TURN RIGHT and go back down the long flight of steps. TURN LEFT at the bottom of the steps, which will take you back to the last intersection at 3.4—TURN RIGHT and follow the switchbacks to the trailhead, a total hike of 3.6 miles.

Roark Bluff Overlook (no official trail)

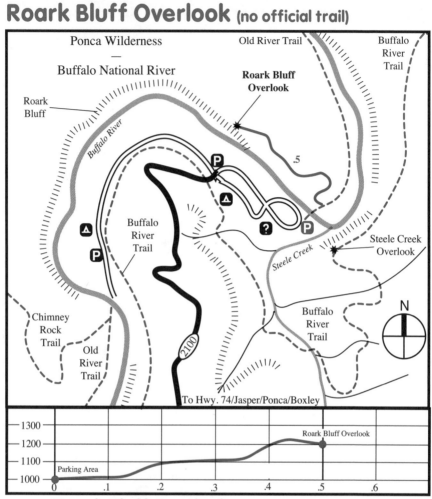

Roark Bluff Overlook (1.0 miles, round trip)

There's a great view from on top of this massive, mineral-stained limestone bluff. It's extremely dangerous up there though, and this trip is not for kids or anyone concerned about heights. Steele Creek Recreation Area is located between Ponca and Low Gap, and is one of the main canoe access points on the upper River.

Park at the canoe access (in red above, day parking only) and take the Old River Trail that goes across the Buffalo River headed downstream. Follow the trail into the woods just a short distance then TURN LEFT onto an unofficial trail. This trail swings UP to the right, then UP left, then straightens out, climbing all the way. Climb up through a broken bluffline, then veer to the LEFT and over towards the edge. Follow a social trail that will drop down to near the top of the bluff and the view will be obvious. STAY AWAY FROM THE EDGE though! And enjoy...

Steele Creek Overlook (Buffalo River Trail)

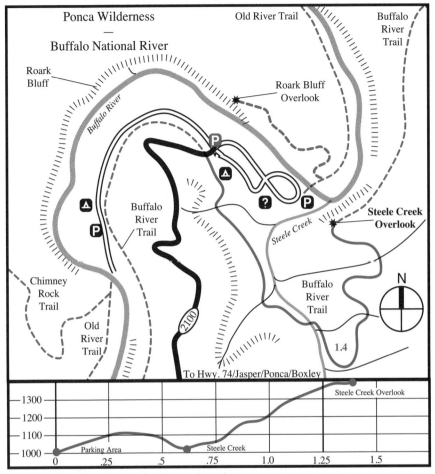

Steele Creek Overlook (2.8 miles, round trip)

Follow the Buffalo River Trail up to a wonderful view that looks down on the River, Steele Creek pastures, Roark Bluff, and Bee Bluff. The Steele Creek Recreation Area is located between Ponca and Low Gap, and is one of the main canoe access points on the upper River.

Park at the bottom of the hill next to the pay station/bulletin board (in red above) and head back up the paved entrance road 100 feet then TURN LEFT onto the Buffalo River Trail (blazed white). This is a great scenic hike that follows a bluffline up and away from the recreation area past some giant beech trees. It crosses a couple of seasonal creeks and eventually drops down to and across Steele Creek (often a wet crossing).

From there the trail heads uphill, then swings left and curves back towards the recreation area, up, and away, and views get better. As the trail heads steeply up hill and back to the right, you will come to the overlook—a perfect rest stop since you will be out of breath!

Smith Creek Nature Preserve (up to 4+ miles)

The Smith Creek Nature Preserve is a great 1316-acre scenic area at the south end of Boxley Valley that is protected by The Nature Conservancy. There are many beautiful cascades, moss-covered boulders, giant chunks of rock clogging the stream, and more wildflowers than you can count. Smith Creek runs throughout the heart of this area (and into the Buffalo River downstream) and during high water is a favorite of kayakers. But even when the creek is bone dry I find great beauty in the solid mass of boulders you'll often see covering the streambed. Sherfield Cave runs under the property, and is home to the largest hibernating colony of endangered Indiana bats in Arkansas (that's one reason why The Nature Conservancy is protecting the land). There are two main scenic destinations that I'll describe—QuiVaLa Elsie Falls and the Boulder Jumble Paradise. (*Pronounced "Ke-v[a'] -l[a']" and is a French-Indian word meaning "who goes there?"). Dogs are allowed. No camping.

To reach the parking area, from the south end of Boxley Valley take Hwy. 21 south up the steep hill for 1.2 miles and TURN LEFT onto the little dirt road and park near the gate at the tall sign (don't block gate). Or from the Mossville church head north on Hwy. 21 for 3.2 miles and TURN RIGHT to park. Begin both hikes at the locked gate.

QuiVaLa Elsie Falls. Begin your hike going past the gate and down the steep hill on the jeep road, then just as you get to the bottom of the first hill at .2, the main road will go to the right but you will TURN LEFT onto an old logging road/trail. Follow this trace as it winds on down the hill. Part of this old road is level, other parts are quite steep. It will eventually get to the very bottom of the drainage and come alongside Smith Creek at .7.

You will need to go downstream a little bit, but the left side is blocked by a small bluff, so you will have to get out into Smith Creek, which is normally dry. (If Smith Creek is up and running and you cannot see the bottom, do not enter it!) Just downstream you will see a little creek coming in from your LEFT at the far end of the small bluff—follow this watercourse upstream about 100 yards until you come to the base of the falls. Qui VaLa Elise Falls was named after Elise Roenigk, who along with her husband, Marty, were responsible for the area being protected.

The main trail continues back across Smith Creek and intersects with an upper and lower trail—these make their way upstream across steep hillsides then back down to Smith Creek near the picnic area and bridge. Either trail will add about 1.5 miles to your hike, then you can loop back to the parking area or follow the road farther upstream to the Boulder Jumble Paradise and spring.

Boulder Jumble Paradise and Spring. Begin this hike going past the gate and down the steep hill on the jeep road, then just as you get to the bottom of the first hill at .2 TURN RIGHT and continue along the road (left goes down to the waterfall). The road runs level for a while, then a

Smith Creek Nature Preserve

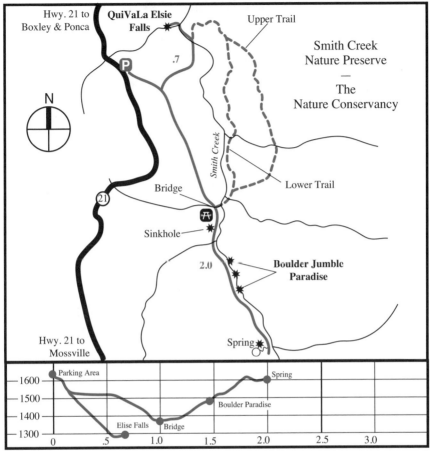

little up and down, then steeper down as it curves to the left and finally comes to a bridge and levels out at 1.0, a wonderful SSS!

You can turn left and cross Smith Creek to follow either the upper or lower trails downstream back to the waterfall. But we want to cross the bridge and continue STRAIGHT on the roadbed past the picnic table. You will soon come to a sink hole right next to the trail that is feeding water into the cave system beneath your feet—watch your step! This entire area is an easy, lovely walk with wildflowers and a few giant boulders.

At 1.3 you cross a creek and then head uphill and swing to the left, still on the old roadbed. Soon you will come to the beginning of what I call the Boulder Jumble Paradise, and you will soon discover why! Giant moss-covered boulders clogging the creek, and waterfalls pouring into emerald pools. The road continues on up the hill generally following above the creek, and there are several side trails that lead to the creek.

If you continue past the Boulder Jumble area you will eventually come to and across the outlet of the spring at 2.0. The spring will be just upstream, a lovely area of cold water pouring over moss-covered rocks.

Hedges Homesite (4.0+ miles round trip)

This is more of a modern historical homesite but interesting and beautiful all the same. Harold and Margaret Hedges were an important part of the battle to get the Buffalo National River established and were both river rats of the finest degree. Their amazing home in the wilderness was burned by arsons while they were away for Christmas in 1990.

The hike begins at the South Boxley Trailhead, which is located on Hwy. 21, 1.1 miles south of where it crosses the Buffalo River—turn right off of the highway and into the parking area just before the road climbs out of the valley (at the Boxley Valley Historic District sign). This is also the site of the original Whiteley Farmstead, one of the early pioneer families that settled Boxley Valley. The upper section of the Buffalo River Trail begins here too, and goes 36.5 miles downstream to Pruitt (see page 65 for descriptions and maps).

From the parking area follow the road back to a historic barn and Whiteley spring, where locals still get their water during dry periods. TURN LEFT just before the spring and follow an old road up the hill. It turns to the right while climbing, going past Whiteley Cemetery.

Stay on the old road trace as it climbs up, up, and up, and eventually the road will disappear and you will be on a horse trail, still heading up. There are some amazing giant beech trees, a rock wall or two, a pond, and a giant slab of moss-covered rock. It's mostly a steady climb to an intersection at .7 with an old road. A left turn would take you out to a gate just off of Hwy. 21. Straight ahead are the remains of the Whiteley School which was burned by arsons in 1997. You want to TURN RIGHT onto the "bench" road.

Follow this road downhill past another old homesite, and past a gate that marks the boundary of the Upper Buffalo Wilderness Area, National Park Service Unit. Soon the road will head downhill and cross a stream at 1.0, a wonderful SSS! Continue on the road uphill a little, then level. There are some pretty nice views during leaf-off all along this section.

At 1.5 there is a trail/old road that takes off to the left (it's actually the bench road, and it would take you farther into the wilderness area). We want to go STRAIGHT AHEAD at the intersection and continue on what is actually the Hedges driveway, it makes a run downhill all the way to the homesite. If there is high water you might be able to see Hedges Pouroff across the valley high up on the opposite hillside—it's one of the tallest waterfalls in Arkansas (113'), named after the Hedges. Harold told me they saw SEVEN waterfalls pouring off that spot on the bluff one rainy day!

The road levels out at 1.8 as you enter the homesite area—pond on the left—go straight ahead and curve to the right along a beautiful rock wall that Harold built. Stop and look around and you will see the Historical SSS homesite with stone chimney and more of Harold's handy stonework to explore.

Hedges Homesite (no official trail)

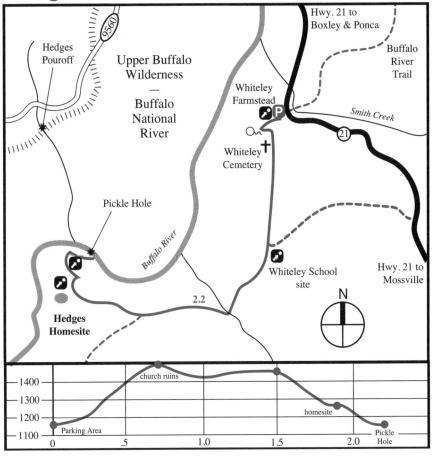

To see more, continue on the old road you came in on past a small work shed on the right, then downhill as it curves to the left and straightens out some. The old Pickle homestead will be off to the right. At the bottom of the hill at 2.0 the road turns RIGHT around a wonderful curving stone wall—a stone masterpiece! There's a large barn back in there built in 1929 by "Pickle" Edgmon, although it was fading quickly the last time I was there so be careful if you explore.

Continue to follow the old road and it will eventually run alongside the Buffalo River and come to the Pickle Hole (aka Hedges Hole) at 2.2. This is a terrific SSS pool filled with sandstone boulders.

To return to the parking area simply turn around and hike the road back the way you came. Or you can also follow the River downstream until you reach the open hayfields next to the parking area, although this is a pretty tough trip across very steep hillsides. If the River is low you could also simply follow the River downstream and have a blast!

Balanced Rock Falls (1.2 miles round trip, no trail)

Balanced Rock Falls is one of the most unique in Arkansas, and has only recently been exposed through social media (2019). A social trail developed leading to the falls (**dotted red line**—it's on the other side of the creek from the route I describe below). If you take the social trail you have to wade Leatherwood Creek at least twice, which can be quite dangerous during high water (high water is a good time to view this waterfall). As of 2021 there is no official trail nor a plan to construct one, yet.

But here is a description of an unofficial route (the way I go, the **solid red line** on the map) that will take you straight to the falls without having to cross the creek. Well, actually you do cross the creek at the beginning, but on a concrete bridge so you don't have to get your feet wet. This is all "bushwhacking"—there is no official trail.

There are plans for development on the east side of the River leading to the Villines Farmstead area so be aware that parking may be different than shown here. If the low water bridge is flooded, have someone drop you off on the other side of Hwy. 74 bridge (caution—no pedestrian lane); or there is a small pullout at the first sharp curve—park there and follow the powerline down to the creek.

From the parking lot head across the low water bridge to the far end of the other side (**solid red line**), then continue across a smaller bridge that crosses over Leatherwood Creek (just before the gate). The Buffalo River Trail goes left just past the gate, while going straight ahead would take you up to the Beaver Jim Villines Farmstead. But you want to TURN RIGHT just before the gate and pass underneath a powerline.

Hike beside Leatherwood Creek going upstream on the level, and soon you will come to a small step-across creek coming in from the left (side creek #1)—continue across this and follow Leatherwood Creek. The route wanders through an open flat area next to the creek with mossy boulders and towering beech trees.

Continue upstream through the flat open forest until you come to a small bluffline on the left—you will not be able to hike upstream without crossing the creek at that point. So instead of getting wet, you can simply head UP the very steep hillside on your LEFT (before the bluff) and hike up and over the small bluffline down to a small creek (side creek #2) at .4 (maybe there will be a trail here one day, which would be great!).

Cross creek #2 and scramble up the other side. From that point you have options. Option #1 (**solid red line**): To go directly to Balanced Rock Falls, simply hike up and across the very steep hillside that is in front of you, and contour around as you climb. You will eventually run into a third creek (side creek #3), and Balanced Rock Falls will be upstream. So TURN LEFT when you reach creek #3 and follow it upstream and you will run into the waterfall at .6. You have to scramble up some rocks to get to the very base of the falls, but you can see the falls without having to do this. There are waterfalls above Balanced Rock (high water) also.

Option #2 (**dashed red line**): Instead of making the big climb from side creek #2, hike straight ahead and back down to Leatherwood Creek where you will pick up the social trail from the other side. Just upstream is the beautiful Beaver Jim Cascade that spans the entire creek.

Balanced Rock Falls (no official trail)

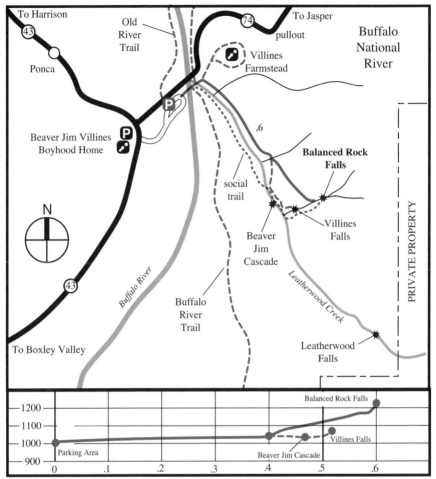

From the cascade during high water you would need to scramble up the hillside and go above some short bluffs and over to side creek #3 where there's an unnamed waterfall that pours into Leatherwood Creek. This is the side creek that Balanced Rock Falls is in, and you'll find the beautiful double-decked Villines Falls just above you. The social trail scrambles straight UP the steep hill on the right side around Villines Falls to Balanced Rock.

There are many more waterfalls in this drainage including Leatherwood Falls at the far end of the area, and some will have social trails going to them. It is a beautiful natural area but quite steep and rugged so take your time and be safe and happy!

The only bit of human history up Leatherwood Creek is noted on page 218 of "Old Folks Talking" (by Jim Liles)—includes a chimney ruin of an elderly recluse's cabin from the early 20th century. This great book is the most complete history of the settlement of the Upper Buffalo River and highly recommend (if you can find a copy).

Lost Valley Trail (2.6 miles, round trip)

This little area is one of the special places in the world. Calling it an SSS is an understatement! This popular trail is short, and for the most part, very easy to hike (it is the most-used hiking trail within Buffalo National River). Although the last section of trail does get pretty steep as it climbs up to a cave—which reminds me—be sure to bring a flashlight (one for each hiker) if you wish to go into the cave. NO DOGS.

The trail begins at the far end of the Lost Valley Campground. To get there, turn off of Hwy. 43 between Boxley and Ponca onto NC#1015 (paved, then gravel) and follow this road to the end. A flood wiped out the little campground, so it is day-use only, and a Ranger's residence.

The trail begins by crossing over Clark Creek (which eventually empties into the Buffalo River). This is the creek that the trail will follow up into its headwaters. The first half-mile or so is on a wide, level trail. It's a nice stroll that passes some large trees, including sweet gums, cedars and my favorites, the giant beeches. The creek is a typical babbling brook, with lots of smooth rocks for a floor. It does dry up once in a while though—springtime is the greatest here!

The trail forks at .7—TURN RIGHT, and head over next to the creek (we will return from the left). The trail runs along the creek to some huge stone blocks. These are called "Jig Saw Blocks." It looks like they fell off of the bluff just behind them—that would have been interesting! Just beyond, the trail comes to the Natural Bridge on the right. All of this is an SSS. When the water is running good, this is a magical little spot. When it's almost dry, you can actually hike through the bluff, and come out on the other side upstream.

Continue on up the trail (bear right at the next two forks), and you'll find yourself standing at the base of a 200-foot bluff, and Cob Cave at 1.0, another SSS. This is the giant overhang that you can hike back into. It is named for corncobs that were found there many years ago—left by Indians. At the far end of this spot is Eden Falls, which is a spectacular waterfall. The falls come out of Eden Falls Cave, which we'll hike up to in a minute. There are lots of mosses, ferns and other lush stuff around the base of these falls.

No matter what time of year you are here, you're sure to find something that interests you. Spring is great, of course. But so is fall, with all the colored leaves. And even the dead of winter is nice. One hint for popular times—come during the week to avoid the crowds.

To get to the cave, go back down the trail to the first intersection that you come to, turn right, and follow the trail *up* the hill. It's a short but steep climb, and the view back behind gets better with every step. The trail ends at the cave at 1.1—use some caution here, 'cause it's pretty narrow and it's a long drop! Eden Falls Cave isn't very large or long, but it does have Clark Creek flowing out of it, which makes it special indeed, and an SSS. This is of course what makes Eden Falls that we

Lost Valley Trail

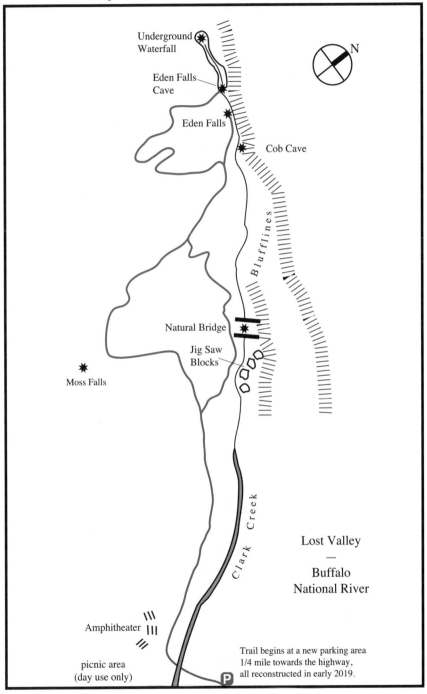

Underground Waterfall

Eden Falls Cave

Eden Falls

Cob Cave

N

Blufflines

Natural Bridge

Jig Saw Blocks

Moss Falls

Clark Creek

Lost Valley

—

Buffalo National River

Amphitheater

picnic area (day use only)

P

Trail begins at a new parking area 1/4 mile towards the highway, all reconstructed in early 2019.

just saw from below. It's not an easy crawl to get back into the cave. But if you get in, you'll be rewarded, 'cause the creek also forms a waterfall *inside* the cave—it's about 35 feet tall.

To get back to the campground, just head back the same way that you came in, only bear right at all intersections (you'll hike a short stretch of trail that you didn't hike on the way in, and pass "moss falls" on the right, an SSS). Soon you'll be back at the trail fork at 1.9, and from there it's a nice level stroll home, for a total hike of 2.6 miles.

Hemmed-In Hollow Trail—Center Point Trailhead
(5.4 miles to the Falls, 10.8 miles round trip)
Including the Goat Trail to Big Bluff

Trail Point	Mileage In	Mileage Out
Center Point Trailhead	0.0	5.4
Goat Trail to bluff	2.7	2.7
Big Bluff	2.9	2.9
Granny's Cabin	3.5	1.9
Jim Bluff	3.7	1.7
Sneeds Creek at Buffalo River	3.9	1.5
California Pt. Intersection	4.7	.7
(Compton Trailhead)	6.5	2.5
Hemmed-In Hollow Falls	5.4	0.0

This trailhead is located 3.5 miles north of Ponca on Hwy. 43. The trail that begins here actually follows an old road all the way to the Buffalo River, passing the Goat Trail to Big Bluff, and connecting to the trails that lead to Hemmed-In Hollow, which is what I'll describe. Most of this trail is open to horses, and is used frequently by them. It is the less severe way to hike into Hemmed-In Hollow. (The other route is from the Compton Trailhead, which is a lot shorter but much steeper— and is described on page 54.) You can also get into Sneeds Creek and to Jim Bluff and the rest of the River upstream via this trail. All of this trail is inside the Ponca Wilderness Area (Ponca quad map). NO DOGS.

The 1300 foot drop to the River begins as a leisurely stroll down an old road. (At .1 you will pass the Chimney Rock Trail, which heads off down the hill to the right. This is a horse trail that goes by a mining site, part of it along the old ore road, visits the Clemmer homesite, then connects with the Old River Trail across the River from Steel Creek Campground.) At times the road does get a little steep, although you probably won't notice it 'til the hike out, when you will be breathing

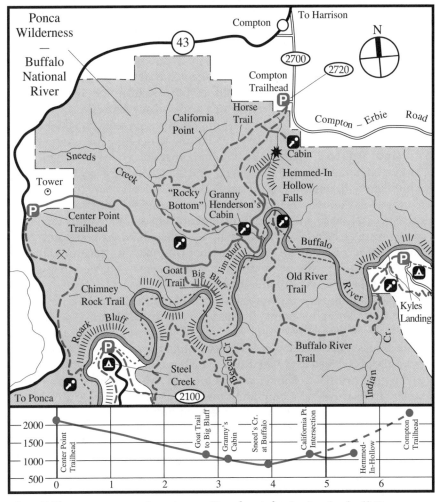

hard! There are some nice views off to the right during leaf-off. It passes by a couple of old fields, then really gets steep at about 1.0.

The trail swings back to the left, then right, and passes an old homesite area. As you come on around the hill and level off a bit, more remains are visible, and off to the left a view down into Sneeds Creeks opens up.

At 1.6 there is a fork in the road. Take the LEFT FORK, which goes downhill and is more of a single-track path instead of a road. At 1.8 there is another intersection—TURN LEFT and go around the large boulders that have been placed in this old roadbed.

The trail heads down the hillside, levels off some, then continues down the hill, then levels off some more. It works its way on around to

the right-hand side of the hill, and you've got some nice views down into the Buffalo River Valley below. At 2.5 you may notice several large sinkholes that are on either side of the trail—must be a big cave around here somewhere. Also, the view gets really nice during leaf-off through here, as you can see a long ways off in both directions.

By 2.7 the trail has dropped a little more down the hill, leveled off, and has come to a trail intersection. The main trail GOES STRAIGHT AHEAD and continues along the old road. If you turn right here, you will be hiking on the Goat Trail, which leads on out to Big Bluff. (This is not to be confused with the Goat Bluff Trail that you reach via the Erbie Church Trailhead.) Let me take just a minute to describe this short spur.

Goat Trail to Big Bluff. The first thing that you will see is a Park Service sign that warns of the danger of the area ahead. They have had a problem with folks falling off of Big Bluff and don't really try to encourage folks to use this trail. I would like to urge the same caution. It is *extremely dangerous* out on Big Bluff, and any fall off of it would almost surely be fatal. Besides, it's a real pain to have to haul the body out. So, for the record, I'm not suggesting that you hike this trail out to Big Bluff. If you do, please be careful. There is *no camping* allowed in this area, and the trail is not maintained by the Park Service.

The trail drops on down the hill, swings around, then joins the end of Big Bluff. From this point on, please be careful. Big Bluff is 440 feet tall. It is broken up quite a bit by ledges, which is why you are able to walk across it in the first place. The ledge that the trail is on is supposed to be about 300 feet above the River, which leaves a considerable chunk of the bluff overhead. The remains of the Bud Arbaugh place (first settled by Martha and Abraham Villines about 1840) is visible across the River—a pretty nice spot to call home, wouldn't you say!

There aren't many places in Arkansas as impressive as this place. The trail hugs around the bluff underneath a large overhang. The views straight down to the River, as well as up the River valley, are wonderful. The bluff area itself is pretty nice, with lots of interesting things to see. The middle area of the bluff is about 1000 feet from the main trail intersection. Towards the end of the bluff, the trail sort of peters out— must be time to get back to the main trail.

Back up on the main trail, continue on down the road as it drops on down the hill some more. It levels off and swings back to the left, then the right, around another old homesite. At 3.0 the trail heads downhill again and there is an old rock wall just off to the right. After a straightway, the trail veers off to the left and continues downhill.

As trail gets steeper, you may be able to see a tin roof through the trees—this is Eva "Granny" Henderson's cabin, which we'll get to in a minute. But first, there is more steep trail to do, as is makes a sharp turn to the left. Down, down, down it goes, 'til at 3.5 you come to a trail intersection. No matter which way you are going, you should walk on

over to the Henderson cabin, which is just a couple of hundred feet to the left. It's my favorite cabin in the entire Buffalo Valley. It has been restored somewhat and is in much better shape than when I first saw it way back in the '60's. The view downriver is pretty nice too.

Also to the left is the trail that goes up Sneeds Creek and on up the hill to the Compton Trailhead. The description of this trail is found on page 60. I highly recommend the hike up Sneeds Creek. But for now, we'll TURN RIGHT at the trail intersection and continue down the road to the River, Jim Bluff, and on to Hemmed-In Hollow.

There is one last steep pitch and then another intersection at 3.6 (there are a couple of giant sweet gum trees there). The main trail TURNS LEFT. The trail to the right is actually the Old River Trail, and soon crosses the Buffalo River—almost always a wet crossing for hikers. Jim Bluff is also down this trail. Just before it crosses the River, there is a trail that takes off to the right. It runs alongside a neat little bluff that actually has a couple of calcite cave formations (flowstone) that have formed on it. And this bluff grows up into Jim Bluff, an overhanging wonder that is a landmark on the Buffalo. This area is naturally an SSS.

Back at the intersection, head to the left down a *level* path that soon comes alongside the River. At 3.9 you come to the mouth of Sneeds Creek, where the trail TURNS LEFT before crossing the creek and going upstream. There is a sign here that is visible from the River—it reads "Sneeds Creek/Hemmed-In Hollow Trail." This is the first of two stopping points that are used by canoeists to access the falls (Which is 1.5 miles ahead by way of the normal trail. When the River is low, it is quicker to walk across the gravel bar, and then go up to the falls via another access trail.). On most spring weekends, you'll see a lot of paddles here! In fact, it can get down right crowded.

Up Sneeds Creek we go, but for just a short distance, 'cause the trail TURNS RIGHT and *crosses the creek* at 4.0, then continues upstream on the other side. Off on the right is a small bluff that appears to have had a recent accident—a fresh rock slide. Just beyond that, the trail TURNS RIGHT—there is a lesser old trail that goes straight ahead, so be sure to make this turn. From here the trail crosses a small creek, swings around to the right and crosses the creek again, and enters an SSS at 4.1—everywhere you look the place is carpeted with thick moss, and there are lots of old cedars hanging about too.

The trail eases up the hill just a little, and swings back to the left, underneath a small bluff. Then at 4.4 it turns back to the right, and climbs up some steps that are cut into the bluff. This trail work is tough stuff! It follows along on top of this bluff for a while, swinging on around the hillside. At one point, there is a small stream, that during the wet season, makes a nice waterfall as it tumbles over the bluff.

At 4.7 we come to what I call the California Point intersection. A left turn will take you *up* the hill, past a terrific view of Hemmed-In Hollow

and the falls, and on out to the Compton Trailhead, which is 1.8 miles from here. This is the quickest route into the falls area. But it is also the steepest! (See description below.) The falls are .7 miles STRAIGHT AHEAD. For a complete description of the route from here to the falls, see page 56 (I didn't want to weigh you down with two descriptions of the same thing—when you are back in this far every little bit of weight counts!). But for now, here is a brief description.

The trail wanders on down the hillside just a little, through a wonderful beech forest, and intersects with another trail at 5.2. This other trail turns back to the right and goes .5 miles down to the River at the mouth of Hemmed-In Hollow (this is the traditional spot on the River that canoeists use to access the falls). The main trail goes STRAIGHT AHEAD, following the waters that have just come over the falls. At 5.4 the trail lands down on the creek. Look up—you are staring at the tallest waterfall between the Rockies and the Appalachians. Congratulations, you made it. Take some time. Explore around and enjoy yourself. I just hope that you don't have to hike out today too! By the way, the area from the last trail intersection, up to and including the bluff here, is *closed to camping*—be sure to go elsewhere to spend the night.

Hemmed-In Hollow Trail–Compton Loop (7.2 miles)
To Hemmed-In Hollow Falls and Sneeds Creek
(5.0 miles round trip to falls and back only)

Trail Point	Mileage Clockwise	Mileage Counter-Clockwise
Compton Trailhead	0.0	7.2
Cabin (via Bench Trail)	.8	6.4
Falls Overlook	1.5	5.7
California Pt. Intersection	1.8	5.4
Hemmed-In Hollow Falls	2.5	6.1
Sneeds Creek at Buffalo River	2.5	4.7
Jim Bluff	3.0	4.4
Granny's Cabin	3.0	4.2
Goat Trail to Big Bluff	3.8	5.0
Center Point Trailhead	6.5	7.7
Rocky Bottom	3.4	3.8
Sneeds Creek-Upper Crossing	4.7	2.5
Rock Quarry	6.2	1.0
Compton Trailhead	7.2	0.0

This is the second of two trailheads that will take you down into the famed Hemmed-In Hollow, home of the tallest waterfall between the

Hemmed-In Hollow (Compton Trailhead Loop)

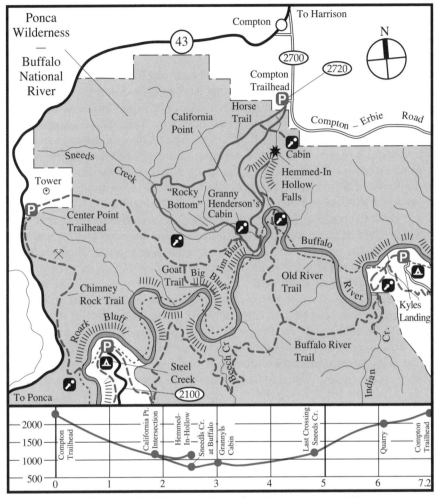

Rockies and the Appalachians. And for this description we'll continue on to Jim Bluff, then up Sneeds Creek, and finish our hike by looping back to the trailhead via a little-used horse trail. NO DOGS.

To get to the trailhead, go north out of Ponca on Hwy. 43 for 8.3 miles, then turn right at the community of Compton onto NC#2700. Continue on this dirt road for another .8 miles, then turn right onto NC#2720 at the sign—the trailhead is just up this road on the left. There are two trails that begin here. The one on the right is mainly a horse trail, and is the one that we will return on. We will be hiking *clockwise*. The trail on the left is closed to horses, and is the quickest (steepest!) way to get to Hemmed-In Hollow (it is actually 2.5 miles to the falls). All of this trail is inside the Ponca Wilderness Area (Ponca quad map).

I must caution you here. This area is great for dayhiking—a quick jaunt down to the falls and back. ***But let me warn you***—the hike out on this trail will humble even the greatest of hikers. Be sure to plan the entire day, carry lots of water, lunch, extra snacks, and a first aid kit. Better yet, spend the night, or two, or three. Take your time and enjoy this place.

We will take the trail on the left. It heads out into a scrub forest and swings around to the right just a little. At .2 miles it enters the woods proper. At this point there is a small, rocky hollow just off to the left—this is the creek that creates Hemmed-In Hollow Falls. Not too impressive here, but it grows up a bit! As the trail eases over to the edge of the hillside and makes its way down through lichen-covered rock, you can look out across the way and see the fields down on Horseshoe Bend at the River (during leaf-off). If fact, the views all the way down are just great, which is one of the reasons why I enjoy this trail.

By .7 the trail has leveled off and comes to an intersection. GO STRAIGHT at this intersection to continue with the main trail. A left turn will take you a couple of hundred yards over to a neat little mountain hut/cabin. [This old road continues past the cabin all the way to the Compton-Erbie Road near McFerrin Point (as the "Bench Trail")—a spur also drops down to Camp Orr.] A right turn will take you up to the horse trail that goes back to the trailhead.

As the main trail works its way down the hillside you can look back to the left and begin to see the bluffline that forms Hemmed-In Hollow. There are some pretty steep spots here, and the trail isn't in very good shape, so be careful. During leaf-off the views just keep getting better—the River, the bluffs, even the old Lockhead barn down at Horseshoe Bend is visible.

Down, down, down the trail goes, through a couple of tight, steep switchbacks, and more great views. After the third set of switchbacks, the trail swings back to the left, levels off in a rock-slab area at 1.5, and one of the finest views in any wilderness area anywhere in the country opens up. An SSS to say the least. Time to stop, drop your pack, and get out the camera.

Especially in the spring, when the trees are just coming out and they have that brilliant green, and the water is flowing, you'll see Hemmed-In Hollow Falls in all of its splendor. You've got a one-on-one view of it from here, unobstructed by trees. And the view of the rest of the kingdom is equally great too. The River upstream. The never-ending bluffs. This is what wilderness was meant to be. No sign or sound of man. Only the hush of the water cascading over the falls, and the cry of a red-tailed hawk above.

The trail continues down the hillside, crossing a small stream that would have a nice little falls of its own during the wet season—tumbling down over moss-covered rocks. It goes across another small creek,

then down to a trail intersection at 1.8. If you turn right here you'll head off towards Jim Bluff, Sneeds Creek, Big Bluff, and the trail out to Center Point Trailhead. To get to the falls, TURN LEFT here. The area above this is known as California Point, so for the sake of clarity, we'll call this intersection the "California Point" intersection.

The trail doubles back to the left below the trail that we just came down, and gives you a chance to look up and see some of the small waterfalls that we saw from above. There is also a terrific forest of beech trees in this area. Lots of little ones, whose golden leaves rustle and make music on a sunny winter day (beech trees don't lose their leaves like everyone else—they hang on and paint the landscape 'til spring). And of course there are some giant ones too, whose smooth bark beg you to reach out and pet them. Unfortunately, this smooth bark also invites fools' knives to leave their destruction once in a while.

The trail has leveled off through here, and passes next to a couple of interesting rock formations. The first is a pot-holed one. The next covered with thick mosses and ferns. I would have to rate all of this area as an SSS. And the beeches get more numerous and larger as you get closer to the falls. By 2.2 the trail has worked its way down the hill just a little and crosses a small stream.

At 2.3 there is a trail intersection of sorts. The trail that turns to the right and goes down the hill is a shortcut to the trail that leads out of the hollow to the Buffalo River. There is also a real rough trail that heads off to the left and up the hillside. Try to ignore both of these trails.

Just beyond we intersect with the real trail that heads out to the Buffalo River at Horseshoe Bend—it's an easy downhill walk of about a half-mile. This is to the right. The main trail continues STRAIGHT AHEAD. There is also a sign here that says *no camping* beyond this point. Be sure to comply. In fact, try not to camp anywhere within sight of any of the trails, nor within 100 feet of any water. This is a good practice to do on any trail.

Past this intersection the trail crosses a creek on slab rocks—use caution since the rocks are usually very slick. This spot is an SSS, 'cause there are two nice waterfalls here—one on the creek that comes down from the big falls, and the other on the creek that you step across. From this point on the trail runs alongside the creek, and follows it *up* to the falls.

There is another good-sized falls down on the creek, and during leaf-off you can look up from here and see Hemmed-In Hollow Falls. The trail comes down to the creek, and depending on what the falls are doing, you can do two things: If the falls aren't running much, you can simply head up the creek bed to the base of the falls. This is at 2.5 miles from the trailhead. If the falls are running well, you'll need to cross the creek here and make your way up the opposite hillside to a level spot about a third of the way up the bluffline. There is no real trail, and it's

pretty steep. Once up there you can see that this level area will take you all the way around behind the falls to the other side. The falls, of course, are simply wonderful. But the bluff here is pretty terrific, too, I think. Lots of different colors and textures. And even a tree growing out of it now and then.

There had been no official measurement of the height of the falls until recently. I'd seen everything from 150' to more than 300' tall. We needed to get an exact measurement for the **Arkansas Waterfalls Guidebook** so we got an extra-long measuring tape and got the job done—209' is now the official height. It is indeed an impressive sight. Especially when it's running about half tilt, and the wind is blowing—it will actually blow the stream of water around, like it's dancing.

Now here is some extra stuff for those of you who like to explore. Get on the ledge and go behind the falls and off to the left. There is a rough trail that continues along the base of the bluff, around and out of sight of the falls. It works its way around to another impressive water-fall (which, when it's running good, is nearly impossible to go behind without getting wet!). Beyond this a ways, there is a real rough trail that heads *up* through a break in the bluffline. And I do mean *up*.

I do not recommend that anyone take this route, but once again, I want to tell you about it just so that you will know. If you can make it up on top, you'll be treated to a fantastic view of Hemmed-In Hollow, and all of the country beyond. There is a little trail that runs along on top of the bluff—*warning*—one slip and you are dead. It's that simple. At the point where the trail crosses the stream that creates the big falls, there is a pretty remarkable miniature canyon down below, just before the stream goes over the edge. Then the trail winds on around to the other side of the bluffs for another view of the falls.

Whew, what a spot! Oh, did I mention that this is an SSS? OK, now it's time to leave and head out to the rest of our hike. You have several options. They all start by going back out the way that you came in. If you are going on to Camp Orr, Kyles or any destination on the Buffalo River Trail, then you need to take the first left on the trail just past the double falls down below. It's a half mile from that intersection down to the River—.7 miles from the falls. This is the traditional spot for canoe-ists to stop and hike up to the falls.

For every place else, follow the main trail back to the California Point intersection. If you are just dayhiking, then turn right and head back *up* the hill for a 1.8 mile climb that you won't soon forget! The trail that goes STRAIGHT AHEAD will lead us on to the Buffalo River, Jim Bluff, Granny Henderson's Cabin, Sneeds Creek and then back out to the Compton Trailhead. It also connects to the trail that goes to Big Bluff and the Center Point Trailhead.

The mileage situation might get a little confusing here, but bear with me for a minute. I'm going to continue the running count from

Compton Trailhead as if we *had not* taken the spur trail into the falls. If you *do* make the side trip to the falls, then just add 1.4 miles to the total to come up with your total miles.

From California Point, which is at 1.8, the trail runs level, swinging on around to the right. During leaf-off you can look down to the River and fields beyond. Then it veers away from the River and follows along on top of a small bluff. At 2.1 (from the Compton Trailhead, remember) the trail turns sharply to the left and goes down through the small bluff, via some steps that were cut into the bluff.

The trail swings to the left, then back to the right, heading downhill just a little. During leaf-off you can look ahead and see the tin roof of Granny Henderson's Cabin. Just beyond at 2.4, there is an SSS area—everything is covered with a thick carpet of moss, old cedars, and even a cactus or two. Just beyond the trail crosses a small creek, then swings back to the left, crossing the creek again.

It drops down to and comes alongside a larger creek—this is Sneeds Creek. There is a lesser trail that takes off to the right here—be sure to BEAR LEFT. The trail follows the creek downstream, past a fresh bluff slide just off to the left. And at 2.5 it crosses Sneeds Creek. This is often a wet crossing. Lots of folks seem to get lost in this area for some reason. Be sure to TURN LEFT on the other side and head over to the Buffalo River. This is the first of two stopping points that are used by canoeists to access the falls (1.5 miles by the trail). And on most spring weekends you'll see a lot of paddles here! There is a sign that can be seen from the River that reads "Sneeds Creek/Hemmed-In Hollow Trail."

The trail turns right and heads upstream alongside the River on an old road bed. There are lots of witch hazel bushes along here. On sunny, late-winter days their blossoms produce my favorite perfume.

At 2.9 the trail comes to two giant sweet gum trees and an inter-section. The main trail TURNS RIGHT and heads up the hill. The trail that goes straight ahead is the Old River Trail, and soon crosses the River—usually a wet crossing for hikers. But Jim Bluff is also down this trail. Just before it crosses the River, there is a trail that takes off to the right. It runs alongside a neat little bluff that has a couple of calcite cave formations that have formed on it. And this bluff grows up into Jim Bluff, an overhanging wonder that is a landmark on the Buffalo. This area is, of course, an SSS.

Back at the intersection, head up the hill on an old road. It is a steep climb, up to another intersection at 3.0. This is what I call Granny's Cabin intersection. If you want to go to the Goat Trail and Big Bluff, turn left here and continue up the old road. The Goat Trail turns off to the left in .8 miles and runs out to Big Bluff, which is another .2 miles, making it a mile from here to Big Bluff. Center Point Trailhead is 2.7 miles past the Goat Trail turnoff.

We are going to TURN RIGHT and go over to Eva "Granny" Henderson's cabin (take the upper trail that goes behind the cabin). It doesn't take long to see why this cabin is here—the view downstream is just great. I love the outside of this cabin—my favorite one on the River. Please be careful when poking around these old places—and remember, the Park Service prohibits spending the night in any of them. These are historical sites, and are easily damaged. You can see that the tin roof on the cabin has been repaired in an attempt to preserve it.

The trail continues on past the cabin and heads down the hill (there is an old potbelly stove off to the right). It goes through an old field below, and comes to and crosses Sneeds Creek at 3.3. You may notice some recent beaver activity in this area. The trail heads up this picturesque little mountain stream, and at 3.4 comes to an SSS. This spot is called "Rocky Bottom," and as you can see, is a giant slab of rock that completely spans the stream and forest floor. It's a hundred feet or more across, and a lot longer. Nothing but slab rock. It's a terrific spot to hang out on and count stars. And its a great place for "moon dipping" too. (You'll have to ask me what that is.)

Off to the right there is a creek that spills onto the slab—during the wet season there is a nice waterfall here. The trail goes right through the middle of the big slab. Towards the upper end of it, the creek has cut a small canyon through the rock—this is how the Grand Canyon got started!

The trail continues upstream on an old roadbed, and at 3.6 it leaves the road TO THE LEFT. It stays pretty much next to the creek for a while, and comes alongside a small bluff on the right. There is an overhang spot on it that looks like it was once used as a corral. Or maybe a still. In fact, as you hike along, you can see several openings. There is some neat stuff to look at along this bluff, and I would consider it another SSS.

There are several small, grown-up fields that the trail goes through next. And at 3.8 it comes to the remains of a building on the right. Across the creek is the Evans-White home, a much larger and more urban-looking one than Granny's place. If you go on over and take a look you'll notice a couple of unique features of this house. It has a "built in" root cellar that is connected to the back of the house (most cellars weren't connected), and it had water piped into the kitchen (unusual in the early 20th century Ozarks).

Just as the old fields disappear at 4.0, the trail TURNS LEFT and crosses Sneeds Creek. It continues upstream on the other side along an old road, and eases up the hill a bit. Down on the stream, and just out of sight, is one of my favorite places in the area—a miniature slickrock canyon that is a definite SSS. This canyon, at 4.2, has several small waterfalls too.

The trail soon comes back down to and across Sneeds Creek again.

This is the beginning of the little canyon. On the other side it stays on an old road and continues upstream, looking down on the creek here and there. At 4.4 it crosses the creek a fourth time. During the wet season you may have to hunt to find a dry way across all of these crossings. On the other side of this one there is a neat little spring that has a little surprise growing in it.

Just beyond is an old car body. In fact, there are several remnants of "early man" in the next stretch of trail, which continues its upstream course. Then it comes to a sort of waterfall area, with one that spans the entire creek. This area is referred to in some publications as "a place of quiet cascades." There is another spring, another waterfall, and by 4.7 the creek has split into two forks (actually there are three forks that have just come together here), and the trail crosses the first, then a little ways upstream it crosses the second, and leaves Sneeds Creek, sadly. This area is a great place to camp.

Just after the last crossing, the trail TURNS RIGHT and leaves the old road, then heads *uphill* on plain trail for a short distance. Unfortunately, "uphill" will be the trend for a while. There may be some yellow blazes on the trees in this area that mark the trail for horses.

The trail gets back on another old road again, switchbacks up the hill, and swings around to the left, then right, and begins a long, straight climb up the side of the hill. The view is nice though, and the hollow below is a deep one. We pass 5.0, just as the trail swings sharply to the right. After it curves *up* some more, there is some relief from the climb, but not much.

At 5.4 the road intersects with another one—TURN LEFT and continue up the hill. In a short distance, the trail does level off for a little bit as it passes through a saddle in the ridge. There are several roads that intersect here, so be sure to continue straight ahead—it's easy to figure out where to go 'cause the old road that you're on goes uphill!

It swings to the left, then to the right, and seems to top out as it comes alongside an old field off to the left. And at 5.9 the trail turns to the left and runs in between a couple of old fields, then tops out and actually runs downhill for a short period. There are some good, open views out to civilization along here—like some of the fields and a tower that is on Hwy. 43 (right next to the turnoff to "Possum Trot"). As the trail enters an open area, you can see a rock quarry at the other end of the open area. The trail passes right next to it at 6.2, then goes through a wood gate and begins a wonderful *level* stroll along an old road. It passes a nice garbage dump, and at 6.4 comes to a trail intersection, just as it begins to climb once again. If you turned right here you would go on down and connect with the hiking trail that comes from the Compton Trailhead—and to Wild Vic's Cabin.

GO STRAIGHT and continue up the hill on the old road. And at 6.5 the trail leaves the road TO THE RIGHT, and heads off through the

woods on level trail. The trail passes just below a house, climbs up just a little, and levels off again. From here, the trail meanders out through the scrub forest, rises up just a little, and finally comes out at the trailhead at 7.2, completing our loop.

Hideout Hollow Trail (2.0 miles round trip)

This is a wonderful short little trail that takes you into a large bluff and waterfall area. I know of few people who know about or hike it. I understand that this area just happened to be included, quite by accident, when the boundaries for the park were drawn up late one night in a motel room. NO DOGS.

To get to the trailhead, which is called the Schermerhorn Trailhead, turn off at Compton onto NC#2700 (dirt) and head towards the Compton Trailhead. Instead of turning off the dirt road to the Compton Trailhead, continue straight ahead for a couple of more miles. Just after you cross the National Park Service Boundary, turn left into the primitive parking lot (3.5 miles from the highway at Compton).

I knew Jim Schermerhorn many years ago. He was perhaps the most advanced caver that ever lived in Arkansas. He was also a terrific filmmaker, and did a lot of work in caves in Arkansas, as well as around the world. He died much too young. This trailhead was named after him.

From the parking lot the trail takes off straight out into the woods. It works its way down a hill and across a small stream, then eases its way up the other side. There is one spot where the trail passes underneath what I call an "N" tree—a tree that in its early years probably had another tree fall on it and bent it over, then it continued to grow up, forming an "N" shape in its trunk. (This tree recently blew over!)

The hillside gets kind of rocky, and there are some nice large trees scattered about. The trail continues up the hillside gradually, then levels off, then rises up just a little, up and across a flat-topped ridge.

It begins to head down the hillside through a thick stand of trees, several of them nice large pines, then goes through an area with lots of rock outcrops. In this area you'll be able to look out and see the emerging drainage area in front of you. Soon you come out on top of the edge of a tall bluff at .8 miles, and have some great views into and across this hollow—Hideout Hollow, and off to the right into the Cecil Creek Valley. This spot, from this point on up the drainage, is a major SSS. And in my opinion, the area is one of the best kept secrets of the Buffalo Area, so lets not tell anyone else!

One of my favorite sights is the large, apartment-sized rock across the way that has broken off from the bluff—it has some giant pines

Hideout Hollow Trail

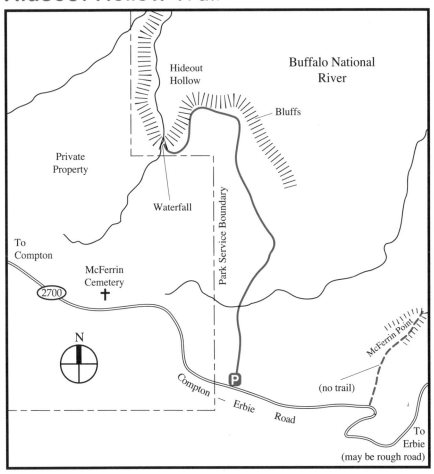

sprouting from it. It's a difficult thing to try and find your way down into this hollow, and I won't tell you how, but if you make it, you are in for some wonderful stuff.

The trail turns to the left here, and continues along on top of the bluff. A word of caution—there are lots of tall bluffs in this area, and if you have little ones with you, please keep a hold on them at *all* times. There are a couple of signs of past man in here—a small rock structure and a couple of old car doors. The trail runs back away from the bluff a little, and you can begin to hear water, a sign that neater stuff is ahead.

And the trail passes through a cedar grove, where there isn't much of a definite trail tread—just follow along the best you can. Downhill just a little ways to a creek at mile 1.0 the trail goes. This is the head of Hideout Hollow, and down below the trail is the large waterfall that

we've been hearing. There are also some other lesser falls below the trail. Private property is just 60 feet upstream—respect their rights.

It's rather thick across the way, but you can work your way around to get a better view of the big falls, and the bluffline that you've been walking on. Looks like a great place to "hideout" don't ya think? To return to the trailhead, head back the same way that you came in, for a total hike of 2.0 miles.

McFerrin Point Bushwhack (no trail)

Here is a little-known spot that is fairly easy to get to, with a terrific view. There is no official trail to it (social trail may exist), but you should be able to find your way to it with this description—it's only about a half a mile from the road. This rocky promontory is well worth a visit. It is shown on the Hideout Hollow map on page 62. NO DOGS.

From the Schermerhorn Trailhead for the Hideout Hollow Trail, continue east on the Compton to Erbie Road (NC#2700) for another half mile or so, to a point where the road begins to head *steeply* down the hill and curves sharply to the right. Pull off to the side of the road and park right where a powerline crosses the road (there is only room for maybe one car).

Head into the woods on the north side of the road (same side as Hideout Hollow Trail) below the powerline and hike along a bench on the level. This bench curves to the right just a little—don't climb or descend too much—basically stay at about the same level. Eventually you will cross under *another* powerline—the ridge has really narrowed down at this point, and you will be walking on top of it. Continue to follow the narrow ridge, and it will soon become all one bluff—this is McFerrin Point, and you are in for one of the most spectacular views in the Buffalo River area! You can see deep into the Cecil Creek drainage, Newberry Point, Erbie, and up and down the Buffalo River.

The first time that you try to find this spot, you should go in the winter, when all the leaves are off and you can see better. The view is pretty nice then too. The October scene from this point of the blazing hardwoods sprawled out below is especially nice. By the way, it is named after Joe McFerrin, whose family once had an extensive farmstead that included Hideout Hollow and McFerrin Point.

BUFFALO RIVER TRAIL—UPPER SECTION

The Upper Section of the Buffalo River Trail (BRT) is in the Upper River District and runs 36.5 miles from South Boxley to Pruitt. It is presented here in four sections: South Boxley to Ponca (page 66), Ponca to Kyles Landing (page 72), Kyles Landing to Erbie (page 82), and Erbie to Pruitt (page 88). NO DOGS.

There is a gap between Pruitt and Woolum with no trail, but hopefully that will be added one year soon. The Lower Section of the BRT is in the Middle and Lower River Districts and runs 43.6 miles from Woolum to Hwy. 14 (see page 120). An extension through the Lower Buffalo Wilderness may be built in the future (or it may remain as a "bushwhack route"). The middle and lower sections of the BRT are part of the 700 mile Trans-Ozark Hiking Trail, that will eventually run from near Ft. Smith, Arkansas to St. Louis, Missouri.

BRT Mileage Log —South Boxley to Pruitt

Trail Point	Mileage Downstream	Mileage Upstream
South Boxley Trailhead	0.0	36.5
Arrington Creek	3.3	33.2
Dry Creek	7.6	28.9
Running Creek	8.2	28.3
Ponca Bridge Trailhead	11.0	25.5
Bee Bluff	12.3	24.2
Steel Creek Trailhead	12.6	23.9
Steel Creek	13.6	22.9
Big Bluff Overlook	15.6	20.9
Beech Creek	16.6	19.9
Slaty Place Intersection	18.4	18.1
Buffalo River at Horseshoe Bend (via spur)	20.3	20.0
Hemmed-In Hollow Falls (via spur)	21.0	20.7
Indian Creek	20.4	16.1
Kyles Campground Spur	20.8	15.7
Buzzard Bluff	22.0	14.5
Camp Orr Road	23.6	12.9
Cherry Grove Cemetery	26.0	10.5
Parker-Hickman Farm	27.0	9.5
Erbie Campground Spur	28.0	8.5
Adair Cemetery	30.0	6.5
Cedar Grove Picnic Area	32.2	4.3
Ozark Campground	33.9	2.6
Pruitt Trailhead	36.5	0.0

Buffalo River Trail—South Boxley to Ponca
(11.0 miles)

Trail Point	Mileage Downstream	Mileage Upstream
S. Boxley Trailhead	0.0	11.0
County Road 8105	1.7	9.3
Arrington Creek	3.3	7.7
Dry Creek	7.6	3.4
Running Creek	8.2	2.8
Sinkholes	10.3	.7
Ponca Bridge	11.0	0.0

This is the beginning of the Buffalo River Trail. This first stretch winds around the hills on the east side of the Buffalo River, giving views of the River and historic Boxley Valley seldom seen. It ends at the low water bridge at Ponca, where the rest of the trail continues on to Pruitt, a total length of 36.5 miles. The trail is not blazed, but you should find signs at all the questionable intersections. Boxley, Murray and Ponca quad maps cover this section. NO DOGS on trails.

It took a major effort by a number of volunteer groups to build this section of trail, which was completed in 1994. Groups that worked on the trail included the Ozark Society, American Hiking Society, and the Sierra Club, as well as Jim Liles and Ken Smith from the Park Service.

The trail begins at the South Boxley Trailhead, which is located on Hwy. 21, 1.1 miles south of where it crosses the Buffalo River—turn right off of the highway and into the parking area just before the road climbs out of the valley (at the Boxley Valley Historic District sign). This is also the site of the original Whiteley homestead, and you'll see the root cellar and chimney. This is a good spot to access the lower part of the Upper Buffalo Wilderness Area—continue hiking down the road (it is gated shortly).

From the parking area, cross the highway and follow a road through a gate and across Smith Creek (it is often a wet crossing). TURN LEFT just past the creek off of the road and skirt the left side of a large field. This field, like many along the River, is leased to a private individual. The trail swings to the right along the left side of the field, at the base of a steep hill, and heads away from Smith Creek.

It runs along the field for a while, just back in the woods, then begins to head up the hill. It swings back to the left and gets pretty *steep*, as it climbs up the rocky nose of a small ridge. It finally levels off and comes to the edge of another field at .7.

The trail route heads into the field, TURNS RIGHT and heads up

Buffalo River Trail (South Boxley to Ponca)

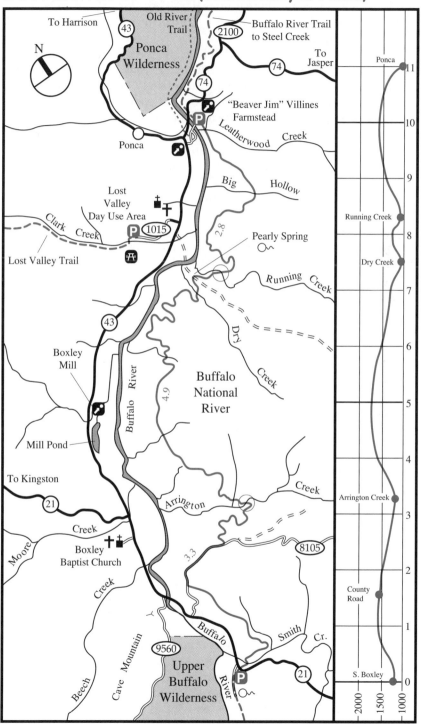

the hillside in the field—there is no real trail here for a while, only cow trails—just follow the directions and you'll be fine. Towards the top of the field swing TO THE LEFT on the level and head for a narrow part of the field. There is a pond down below, and the route takes you right next to a smaller one at .8. There is also an SSS view from here, looking up the Buffalo drainage into the Upper Buffalo Wilderness Area.

Continue on the level, as the field opens up some, then narrows down again—stay at the top of the field and mostly level. There is an interesting SSS rock formation at 1.3 that kind of reminds me of a wave, frozen in stone. The route goes through a tunnel of locust trees just beyond, which have long sharp spines—*ouch!*

And just beyond the spines, at 1.4, the field opens up a great deal to an SSS view all around—Cave Mountain and Beech Creek are off to the left, the road climbing out of Boxley Valley towards Kingston is visible straight ahead across the way. There are some giant oaks here too. The route begins to head downhill here some, past a pond, and drops down to County Road 8105 at 1.7 (the far end of the big field is private property, and so the route drops down below it—look for sign posts.

TURN RIGHT and follow this road (it's about a half mile down the road to the left to Hwy. 21). The road rises up a little, past a driveway on the left, a power line, and a couple of ponds. One of the little ponds is full of frogs that serenade passing hikers. The road crosses a spring branch full of moss-covered rocks, then levels out. There is an old grown-up field on the left along the way. You will eventually reach the end of the old field, then pass through a bit of forest on both sides of the road, then TURN LEFT off of the road and head down into the woods on regular trail—this is at 2.1, and it should be signed, but you need to be looking for it. If you miss this turn and stay on the road, you will come to a big open pasture—just turn around and look again!

This next section is a really nice hike. The trail swings back and forth as it heads down the hill, crossing a spring branch along the way. It levels to the right, and begins to head into the Arrington Creek drainage. There are lots of beech trees around, both large and small. The trail crosses a couple of small streams, and at 2.8 comes to a wonderful SSS—a miniature moss-covered canyon of waterfalls! There is a second canyon too that the trail wraps around mostly on the level.

Just beyond the second canyon, the trail joins an old road trace and begins to head down the hill at a pretty good clip. It turns to the left some at 3.1 and gets even steeper, and there is another SSS waterfall area up and to the right. Towards the bottom of the hill, the trail leaves the road trace TO THE LEFT, and continues on as plain trail. It drops on down to Arrington Creek at 3.3—a really nice SSS area. This is a perfect spot to stop for lunch and explore around a little.

The trail crosses the creek (often a wet crossing), and heads to the left a little, then to the right up into a ravine of moss-covered rocks,

crossing it to the left at 3.4—another SSS. There is a big hill ahead, and we are on our way up! The trail climbs steadily, steep at times. It comes to another SSS canyon at 3.6 (this one has a tall waterfall in it), then quickly curves to the right up and away from it.

The steep hillside is behind you now for a while, and the trail levels somewhat and swings around a little. It rises up and curves back to the left, then intersects with a road trace at 4.1—TURN LEFT onto this trace. The walking will be quite easy for a while now, as you will follow this road on the level for 1.5 miles. It crosses a spring branch as it curves around to the right—stay on the main road trace—past an SSS moss-covered boulder area at 4.7, and continues mostly level.

At 4.9 there is a gushing spring branch at an old homesite—another SSS. There are several mossy boulders up on the hillside as the road trace ambles on. It eventually comes to a really neat moss-covered boulder on the right at 5.5 that has a spring coming right out of the bottom of it! This is an important spot, because just beyond it at 5.6 the trail *leaves the road trace* TO THE LEFT and heads down the hill on a lesser road trace—be on the lookout for this turn.

It continues downhill some, turns to the right and levels off, then crosses a small stream and hits normal trail. There is a small waterfall down below the trail, and a larger one below that. There are some bluffs out ahead that we are going to be on top of in a minute. The trail passes a couple of areas that look like they had been mined at one point, and a wonderful SSS view of Boxley Valley at 6.0. The large barn that you can see is the one next to the highway that has the broken iron kettle out in front (from Civil War days).

The trail wraps around to the left on top of the bluffs, which are lined with bearded cedar trees, all of it an SSS, then veers away to the right, and heads downhill. It swings further to the right, easing on down across a steep hillside, and makes its way through a couple of small hollows. There are several large beeches around, and an occasional leaf-off view of the Buffalo River below.

It crosses a ravine at 6.8, heads up out of it and around the hill, then swings level to the right, and begins to drop down into the Dry Creek drainage. There is a huge beech tree in a tiny ravine, then the trail enters a small patch of private property—go across a road there and head towards the creek on trail, as it swings to the left.

The trail crosses Dry Creek (after leaving the private land) at 7.6, then heads uphill to the left some. It soon levels off and comes to a dirt road at 7.8. The trail crosses the road and joins an old road trace as it eases uphill above Pearly Spring. Just as the trace tops out and curves to the right, the trail leaves it STRAIGHT AHEAD on the level as normal trail.

It swings around to the right and drops just a little, and heads up into the Running Creek drainage. The trail runs along on top of a

small bluff, then drops down past more big beeches to another stretch of private property and then across Running Creek at 8.2 (often a wet crossing). There is a small field on the other side that the trail crosses at an angle—watch for the sign.

The trail eases uphill some, along a small stream, then crosses the stream and goes past a couple of neat SSS water areas. It gets serious about climbing, then crosses the stream again at 8.5—an SSS waterfall area (when there is water!). It's a steady uphill grade for a while, with good leaf-off views. Finally, the trail tops out and runs along the edge of the rocky hillside. There is a leaf-off SSS view at 9.0—you are across from the turnoff to Lost Valley, and you have a great view of the area.

There is some uphill going here, but not too much, as the trail makes its way through broken limestone bluffs. It levels out across a flat away from the edge of the hillside, as it heads towards Big Hollow. It crosses a couple of small drains, an SSS one at 9.6, then across another flat, then across several small drains again. We are working our way around the head of Big Hollow, and all those drains are feeding it!

The trail picks up a road trace or two through here, and at 10.0 it lands on one that we will follow all the way to Ponca. It runs mostly level, then heads downhill a little and passes an interesting SSS area on the left at 10.3—sinkholes!

A sinkhole is an area where surface water is sucked down into the ground, and ends up in a cave somewhere down below. They can be just a small depression in the ground, or a gaping hole that swallows up trees. One point to remember—anything that goes into a sinkhole (like trash), will pass through the cave system and probably come back out on the surface somewhere, most likely in a spring— **i.e.** *please* be careful and don't add anything extra to the natural order of things!

Anyway, there is one neat sinkhole next to the trail on the left, but there are also a couple of huge sinkholes (like 100 feet or more across) out in the woods a little ways. These big ones aren't "open" to the caverns below, but they do carry a lot of water down into them when it rains! This is a great spot to explore.

From the sinkholes, the trail continues on the road trace, swinging back and forth, and heads downhill at a pretty good clip. The Leatherwood drainage becomes visible off on the right. There are a number of big beeches along the road, and a huge shagbark hickory. And there are lots of great SSS leaf-off views on the way down. You can see Roark Bluff in the distance, the bridge at Ponca, and up Boxley Valley.

The hill gets *very* steep as it nears the bottom. And, guess what, there is a well-worn *elk* trail that crosses our trail. An elk trail? Yep! They cross this ridge from Leatherwood, and go on over to the fields down to the left and graze there—you can often see them from the highway.

Right after the elk trail, our trail passes an outhouse and bottoms out at the end of the old Ponca low water bridge at 11.0.

If you have the time, you should stop here and look around. There is a nice historical spot over to the right, and a short trail that goes to it—the "Beaver" Jim Villines homestead. Also, Leatherwood Creek that you have been looking down into is a wonderful place. You should hike up into it and see what you can find (see Balanced Rock Falls page 46). This is really a lovely place in the spring.

Buffalo River Trail—Ponca to Kyles (9.9 miles)

Trail Point	Mileage Downstream	Mileage Upstream
Ponca Bridge	0.0	0.0
Bee Bluff	1.3	8.6
Steel Creek Trailhead	1.6	8.3
Steel Creek	2.6	7.3
River Overlook	3.4	6.5
Big Bluff Overlook	4.6	5.3
Beech Creek	5.6	4.3
Slaty Place Intersection	7.4	2.5
Buffalo River at Horseshoe Bend (via spur)	9.3	4.4
Hemmed-In Hollow Falls (via spur)	10.0	5.1
Indian Creek	9.4	.5
Kyles Landing	9.9	0.0

This stretch of the BRT begins at Ponca, across the old low-water bridge, and on the other side of the Buffalo River. Park in the parking area before you cross the bridge. *A word of warning here*—if you plan to be on the trail overnight, don't park your car here—take it on into Ponca—the River could come up and sweep it away! NO DOGS on trails.

To get to the trail, walk across the old bridge (the amount of air-space under this bridge is generally used to gauge the floating level of the River). The trail takes off to the LEFT, about twenty feet beyond the gate. ("Beaver" Jim Villines homestead is straight ahead from this gate a little ways, and worth a visit—also Leatherwood Creek, a wonderful little scenic area is off on the right.) The trail crosses under the highway bridge, then heads out into a cedar thicket, with a couple of large beech trees here and there, and basically follows the River downstream. The trail is pretty level. At about .2 the trail has come to the first SSS—the forest floor on both sides of the trail is covered with a thick carpet of lichens and mosses. The trail is not marked with any type of blazes, although for the most part it is easy to follow.

The trail continues to run level along the top of a bluffline, which makes for a lot of nice views up and down the River. It crosses a couple of small creeks, and begins a gradual ascent up a couple of benches, then joins an old log road. During the wintertime you will notice that this area is alive with small beech trees—they don't lose their leaves in the fall—and the whole area becomes a golden forest on a sunny day. It is especially nice when the wind blows.

Buffalo River Trail (Ponca to Kyles)

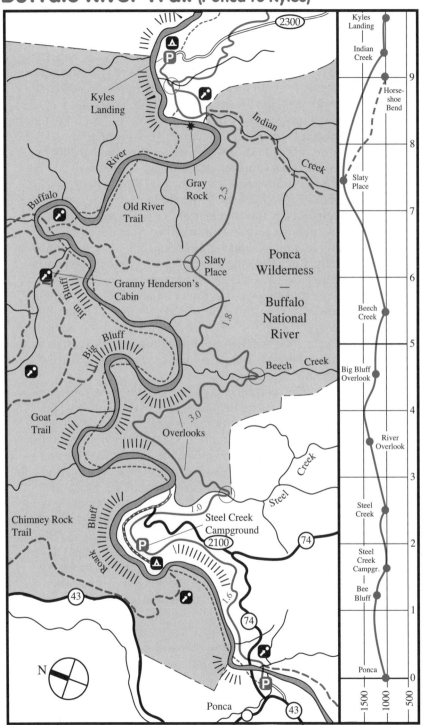

The trail leaves the old roadbed to the RIGHT, swings away from the River, and begins to make its way up into a small hollow. At .8 the trail crosses a small stream. During the wet seasons, you will discover some nice waterfalls here just above the trail. As with all stream crossings, no matter how small, be careful of slick rocks as you step across.

The trail begins to climb up a little more aggressively, and continues to swing away from the River. During leaf-off, Roark Bluff comes into view as you work your way into another hollow. This is the huge bluff that is just across the River from Steel Creek Campground.

The trail levels off a bit, passes just below some smaller "pancake" bluffs, and then crosses a couple of quick streams. There will be some larger waterfalls both above and below the trail during the wet season. You are now about a mile from the Ponca bridge.

Even though you are only a mile from "civilization," with the exception of the sound of a vehicle now and then from the highway just above you, and the sight of some old abandoned fields across the River below, you pretty much have the feeling of being back in the middle of nowhere. And that's kind of nice, what with only a short walk.

From the waterfall area the trail pretty much levels off for a while, and during leaf-off you not only continue to get views of Roark Bluff, but Bee Bluff also comes into view—this colorful bluff is on our side of the River, and in fact the trail will eventually run just above it. At about 1.2 the trail comes alongside a smaller bluff on the right, where the view up and down the River gets even better.

Along this bluffline is another SSS—besides the view the trail heads up a steep little pitch and actually passes in between a broken spot in the bluff. Trails in the Ozark Mountains were simply made to go through places like this. And the more a trail can wind around in the rocks and bluffs the better! All along the bluff you can look up and see a bunch of old, twisted cedar trees clinging to the edge, looking down at you. At one point the trail actually goes underneath the bluff.

Across the River you can see the old Clemmer homestead. Not too much of it is left now, but it is still a testament to our old time heritage. Also there is a good look at George Ridge, the mountain behind the homestead area. And in this area we reach the highest point in this short section of trail, and then make a couple of quick switchbacks down the hillside. Bee Bluff that we were looking at a little earlier, is down below the trail now. I don't recommend scampering down through the woods to get a better look though—you might not ever come back up! Anyway, you'll get a good view shortly.

The trail continues downhill and comes alongside the top edge of those big bluffs—*careful!* There is a short spur trail to the left in a few feet that gives you a wonderful view of the bluffs—an SSS. In fact the bluff is a giant version of the spot where the trail went through a split in a smaller bluffline—only this split-off section goes a long way down!

Just past this area (which has a tremendous view too), the trail continues to head downhill, twisting and turning down through lots of rocks and broken bluffs. There are a lot of rock steps through here too. At 1.6 the trail forks—the left fork runs right down into the parking lot at Steel Creek Campground. The main trail has hit an old roadbed here and continues STRAIGHT AHEAD, on the level, and through a thick section of river cane.

The trail parallels the parking lot and camping area, then leaves the old roadbed TO THE LEFT. It makes its way around the hillside, running just above the road that is between the large field and the trail. The view of Roark Bluff during leaf-off through this entire area is just great. Of course, there's nothing quite like taking a break from the trail and heading down to the River to get a first hand look! This bluff really lights up first thing in the morning.

The trail winds on around the hill on the level and crosses the main Park Service road into the recreation area at 2.0—the trail goes straight across this road and into the woods. (If you turned left onto this road you would immediately come to an intersection where there is a pay station— a left turn on the road at the pay station would take you back to the campground; a right turn would take you over to a horse camp where you will find many friendly folks and their horses, and also you could hike over to the ranger station, phone, canoe access & bathroom.)

Steel Creek is one of several National Park Service campgrounds on the River. It is located off of Hwy. 74 just out of Ponca a couple of miles. The trip on the paved road down into the area is *very steep*—not recommended for buses or RV's. There is a primitive campground here (walk-in sites only, no RV parking), pit toilets, water, and canoe access. The area was originally developed as a private horse ranch, and a real nice one at that, but was later taken over by the Park Service.

After the trail crosses the road it trail takes off uphill, up a series of steps, and past some real nice moss-covered rocks. It heads *up* the hill, past several large beech trees. It climbs up, around and behind the ranger station and other buildings that you get a good look at below. The trail levels off, swinging to the right into and across a small drainage. There is a wonderful rock garden on both sides of the trail. It passes under a power line, then eases on down the hill. It levels off again and goes through a forest of large beeches and hardwood trees. Just above the trail there is a nice bluffline.

At 2.5 the trail crosses a small stream and begins to drop down into the Steel Creek Valley and swings away from the Buffalo River. There is a good view back to the Ranger's complex and the fields, where you have a good chance of seeing a herd of deer, and a couple of elk, especially early in the morning or late in the evening.

The trail comes alongside Steel Creek and heads upstream. Steel Creek is a medium-sized stream that headwaters up in the Low Gap

area, and even though it must have some scenic drops along the way, it is mostly a quiet but pretty little steam at this point. The trail passes under another power line, then crosses Steel Creek at 2.6. This crossing will probably be a wade-the-creek situation during the wet season, but you can use stepping stones during the rest of the year.

Steel Creek forms the boundary of the Ponca Wilderness Area. This is one of the finest wilderness areas in the state, and includes such wonderful things as Indian Creek, Hemmed-In Hollow and Big Bluff. It contains 11,300 acres, and we'll be in it all the way to Kyles Landing. Once across the creek the trail heads uphill again, crossing a small stream that has some nice waterfalls both above and below the trail during the wet season. It continues uphill, then swings sharply back to the left. At this point there is an SSS just in front of you. There is a drainage here (the trail swings away from it) that creates a series of waterfalls, one of them a big one. There is a little bluff that you can walk out onto get a look at the falls, and there is also a good view up the Steel Creek Valley during leaf-off.

From the SSS (be sure that you have stopped and explored some), the trail heads *uphill* at a pretty good clip, swinging back to the left. It levels off, then up again, then level, then up—you get the idea. It makes its way up through some broken bluffs, then level, then up again. Jim Liles of the Park Service had a face-to-face encounter with a huge black bear in this area—the bear was trying out some new trail!

At 3.3 the trail crosses a small creek where you'll find some smaller falls both above and below the trail. Down the hillside from this spot a ways there is a pretty good drop-off that makes a very large waterfall during the wet season, but you can't see it from the trail. From this area you can sometimes hear the traffic on Hwy. 74 heading up to Low Gap, and can look out and see the dirt road down into Steel Creek.

The reward for all the climbing comes at 3.4 where, if the climb hasn't taken your breath away, the view certainly will—a definite SSS. The view is just wonderful. There is so much to see. It's a panoramic view of the River, the Steel Creek Complex, all the bluffs in the area, and the hills beyond. The River makes a wide sweeping curve below you and heads out of sight around a corner downstream. You can see Roark Bluffs, another bluff named Bee Bluff off to the right, and, well, pretty much the whole world. I would sit here a spell and rest if I were you, 'cause what's ahead isn't much fun!

From the viewpoint the trail heads uphill very steeply. Go slow. Fortunately, it doesn't last too long before the world is level again. It stays like this for a half a mile so that you can enjoy the view of the River and country spread out below you, especially during leaf-off. There is a barn or old homesite visible just across the River.

At 3.9, just as the trail begins to go down the hill, you pass a prospector's dug pit off to the right, the first of several in this area. Early

settlers, like Abe Villines and his sons, might have been looking for lead here, to cast bullets from. They also made gunpowder from bat guano collected from local caves.

The trail winds its way somewhat down and around the hill known as Fisher Point, passing a number of different-sized pits. And during leaf-off you can spot Big Bluff through the trees for the first time. The trail swings off to the right, away from the River and levels off (some nice level camp spots just down below and to the left). It continues to run along a fairly level bench, with Big Bluff looming off to the left. There is a much smaller bluff uphill to the right. During the leaf-on season you would be pretty much isolated in this area—no view or sound of the River, and no view of the distant bluffs.

Towards the end of this bench the trail passes just downhill of a couple of giant rocks—nearly house size. There are some nice large beech trees in the area too. At 4.5 the benches give way to a real steep hillside that falls off all the way to the River, which now begins to come into view again (during leaf-off), as well as Big Bluff just off to the left.

At 4.6 the trail is right on the edge of the hillside (actually a giant bluff that we will see later on), and another spectacular SSS viewpoint. You are looking squarely at Big Bluff right in front of you and just off to the left. It's very obvious! This is the "precipice across the River from Big Bluff" that Neil Compton spoke of in the forward. With good eyes, or a pair of binoculars, you can even see the "Goat Trail" that crosses it about two thirds of the way up (see page 52 for a description). It is actually a multi-decked bluff that is 440 feet tall.

The River makes another wide sweeping horseshoe turn out in front of you. Off to the right down on the River, the stream that you see coming into the River is Beech Creek, our next objective. This is another one of those spots where you should come and sit a spell. And a photographer's note—Big Bluff is lit up by the sun best in the afternoon. Also from this viewpoint you can see Jim Bluff in the distance (down on the River), and maybe even some of the bluffs in the Hemmed-In Hollow area.

From the viewpoint, the trail heads uphill just a little, then levels off and begins to descend. Although the trail remains fairly straight, it is actually heading up into the Beech Creek drainage. The River has turned and is heading away from you. The trail drops quickly, down to and across a small stream, then levels off. During wet periods this little stream creates a major waterfall just downstream as it falls off a large bluff (we'll see it from the other side in a little while).

The trail picks up an old log road and continues to head up into the Beech Creek drainage. During leaf-off, if there were other hikers ahead on the trail, you could see them across the valley. The views up and down the valley are good. You can see a similar bluffline across the way too, just like the one that we are on top of now. At 5.2 the trail crosses

another small stream. This one has great possibilities for waterfalls too. But this one is different. It gives us a wonderful SSS area before tumbling over the bluff—a small water slide canyon. And it is a lot safer area to have a look at, even out to the edge to look at the large falls, which aren't quite as large as the previous one, but still nice.

The trail, still on the old road, crosses another smaller stream, then leaves the old road TO THE LEFT. It swings around and gives you a pretty good view of the SSS area that we just passed. During leaf-off you will also have a view straight down Beech Creek, the Buffalo River, and will be looking right at Jim Bluff and Hemmed-In Hollow.

The trail turns back up into Beech Creek proper, and begins to drop down some more, through some broken bluffs. At 5.5 it comes to a road intersection. The trail goes STRAIGHT AHEAD, back on an old road again. There is another road that comes from the right and crosses the trail and continues down the hill to the left. This old road will actually take you on down to the Buffalo River if you wanted to get there. It does cross Beech Creek several times though.

The main trail (old road) heads downhill and comes alongside the creek, which in the wet season is a really nice stream. Before long, the trail does a 180 degree turn and crosses Beech Creek at 5.6. The trail is just trail now, and heads up the hill at a pretty steep grade.

As the steepness lessens just a little, you will notice a small drainage off to the left, along with some minor limestone bluffs. This is another miniature slickrock canyon, and is an off-trail SSS. If you have the time, go have a look at it before the trail crosses the creek.

The trail comes next to this stream, runs alongside it for a little ways (still uphill), and crosses it at 5.8. The trail climbs just a little more, then levels off and passes 6.0. It continues level and runs along just above some broken bluffs. From this point, especially during leaf-off, you can look straight across and see the bluffs, waterfalls, and trail/ road that we just came from.

At 6.2 there is a small creek that spills over the bluff—this area, because of the waterfall and the views all around, would qualify as an SSS. From this point the trail leaves the edge of the hillside, crosses that creek and begins to climb up. That is one thing that you can generally count on anytime that you are hiking here in the Ozarks—there will always be more climbing!

As you head up the hill you will be able, during leaf-off, to get a good look at the River. On the left-hand side of it you'll see a huge bluff—this is the bluff that we were standing on at 4.6 when we had the best view of Big Bluff (still visible). Pretty impressive now too!

The trail makes a sharp turn back to the right, then back to the left through a smaller broken bluff area, and begins a rather long and tedious climb. It climbs up and around the hill to the right, working its way up into Big Hollow, which comes into view off to the left. It tries

to level off here and there, but pretty much continues *up*. At about 7.0 it does level off and hits an old road—TURN LEFT on this old road (be sure to watch for this when coming from the other direction). There is a small culvert here, and a sign leading back to Steel Creek.

Once on the road, most of the climbing is over. In fact, if you are only going to Kyles, then you are *finished!* You are on this road trace for about a half mile (during leaf-off there are some good views over into Hemmed-In Hollow, which is to the left just across the River). Then you'll pass a small pond on the right at 7.4. This marks the area known as "The Slaty Place." You'll notice some broken slate rock off to the left, and there is a trail intersection.

There is an open area here. Off to the right there is a sign for the continuation of the main trail. Straight ahead about a hundred feet is another trail sign that tells of the mileage down to the River. This trail turns to the LEFT off of the old trail and is kind of a spur trail down to the River and to Hemmed-In Falls. And I do mean *down*, or rather it is *up* on the way back. If you want to go this way, here is the description (the main trail continues back to the right at this intersection, and I will pick up that description in a few minutes):

SLATY PLACE TO HORSESHOE BEND. From the sign, the trail heads off fairly level into the woods, rises slightly up and over a rise, then begins its descent down the other side. After .4 miles the trail crosses an old woods road for the first of many times—this road is heading to the same place that the trail is, it just takes a more direct (*steeper!*) route to get there.

As we switchback down the hillside, during leaf-off you can look out through the trees and see Hemmed-In Hollow across the way. At one point, after the second crossing of the road, you can also look back and see the large bluff that is opposite Big Bluff (the trail was there earlier). You can also look down and just barely see Jim Bluff too, as well as the drainage of Sneeds Creek.

The third time the trail hits the road it continues down the road for a little while, then exits TO THE RIGHT. It passes just below some rock formations off to the right, then drops down across the old road again. It switchbacks down some more, as the views of the bluffs get better. Also visible, actually on the other side of the River, is an old homestead—Granny Henderson's place. You can get a firsthand look at it along the trail up into Sneeds Creek.

A little ways before the trail drops down the hillside sharply and crosses the road again, you've come a mile from the Slaty Place. Just beyond, another old barn comes into view down below—this is the Lockhead place, which the trail will soon drop down past.

The trail switchbacks down through some broken bluffs, then crosses the road again. There are some nice large beech trees in this area, then another road crossing. The trail swings around back and forth,

79

then comes into a pine forest and levels off. And just after it passes a huge pine tree on the right, the trail comes to an intersection with the Old River Trail.

TURN LEFT at the intersection to get to the River or on to Hemmed-In Hollow (you are on the Old River Trail now—it goes upstream all the way to Ponca. If you turned right the Old River Trail would take you to Kyles, Camp Orr and beyond). Just up the trail a ways there is an opening and a spur trail off to the right that leads out into the fields that contain the Lockhead place. The barn there is in pretty good shape, and there is also a smaller outbuilding, but the home place is no longer standing—just the chimney. Remember—*be sure not to camp in, or disturb, any of these historical sites.*

The main trail continues along an old cedar-lined woods road. As it turns and heads downhill somewhat there is a large slab rock area off to the left—lots of folks camp here—it's a great place to lay out at night and look at the stars, and there is also a wonderful deep swimming hole on the River here.

The old road continues down the hill to an intersection. TURN RIGHT to get to the River at Hemmed-In Hollow (a left turn will keep you on the Old River Trail upstream). From the intersection, the trail remains level and eventually comes alongside the Buffalo River, then comes to a crossing of it. If you are going up to the falls this is where you cross—the trail continues on the other side and follows Hemmed-In Hollow .7 miles up to the falls. This spot in the River is called "Horseshoe Bend," and if you look at the map you'll see why. You are 1.9 miles from the Slaty Place. Now back to the main trail.

SLATY PLACE TO KYLES. During leaf-off from this point, you can look out through the trees and see the campground at Kyles and the bluffs there. The trail takes off as pure trail, and runs out through the forest on the level. There is a little up-and-downing, but not much, as it makes its way along the left hand side of the hillside.

You can look on down to the River and see some bluffs even during leaf-on in a few spots, and Kyles off in the distance. At 8.4 someone was nice enough to set up a rock bench alongside the trail.

From the bench, the trail swings around to the right of a hill and begins to descend. The drainage that opens up in front of you is the Indian Creek drainage (more about that later), and you will work your way down alongside it as the trail drops. Which, by the way, it begins to do quite rapidly at this point!

It swings back over to the left, to a really nice view of the River area, then back to the right again. You will see several old woods roads throughout here. The trail follows them for a while, but you shouldn't have any problem finding the trail.

Just off the end of one of these little roads at 8.8 the trail makes a hard right. At this point there is a spur trail that continues straight

ahead for just a few feet. This is a good lookout point, down to the River, and over to Kyles and the bluffs beyond. Not really a great picture taking spot, but OK. The infamous canoe-wrecking "Gray Rock" is just out of sight downstream.

Beyond this spot the trail continues to drop down the hill, some level, but mostly down, swinging back and forth across the ridgetop. During leaf-off, the view through the trees keeps changing—the Buffalo Valley on one side, then Indian Creek on the other. Right at 9.0 the trail swings back to the right, across a woods road, and drops down to a wonderful lookout spot—a definite SSS. This is Indian Creek proper—a great view up and down the drainage. You can tell that there must be something down in there of great scenic value 'cause it looks too darn rough! If I were you I'd plan to linger a while here.

The trail continues downhill, and at 9.2 hits the same old woods road that we just crossed and TURNS RIGHT on it, but only follows it for a couple of hundred feet, exiting to THE LEFT. The trail heads down a narrow, rocky ridge at a rather steep angle, bottoms out in a little saddle, then up and over another rocky section, then down the very tip of the ridge to the valley floor.

The trail crosses Indian Creek at 9.4. I definitely recommend a side trip up into Indian Creek. This little area is one of the most scenic spots in Arkansas—see page 94.

Just across the creek, bear to the LEFT (the lesser trail to the right heads up into Indian Creek), and continue on the level to 9.45 where you will come to an intersection (you have just left the Ponca Wilderness). The main trail goes to the RIGHT, and heads uphill on an old road. If you went straight here you would wind through an old field, along the banks of the River, past *Gray Rock* (there is even a sign there now), and on to Kyles Landing. If you want to go to Gray Rock, then by all means head straight ahead. Otherwise, the main trail to Kyles is more direct (to the right).

The main trail heads up a small hill, passing through an old homesite area of Frank Villines. There are some really nice views of the painted bluffs, and a couple of homesite/barn spots along the way. The trail drops down the hill as it turns to the left and intersects with the trail that goes on to Gray Rock—TURN RIGHT here. This trail is also the Old River Trail, and there will probably be a horse trail sign here showing the way.

On down the trail just a couple hundred feet is another intersection at 9.8. Turn right and head off into the woods for the continuation of the main trail to Erbie, or GO STRAIGHT AHEAD on into Kyles Landing campground, which is at 9.9.

Buffalo River Trail—Kyles to Erbie (7.5 miles)

Trail Point	Mileage Downstream	Mileage Upstream
Kyles Landing	0.0	7.5
Buzzard Bluff	1.3	6.2
Shop Branch	2.3	5.2
Camp Orr Road	2.9	4.4
Bluff Falls Area	4.3	3.2
Cherry Grove Cemetery	5.3	2.2
Parker-Hickman Farm	6.3	1.2
Erbie Campground	7.5	0.0

Kyles Landing is another Park Service campground, with primitive (walk-in) sites, pit toilets, canoe access and water. It is located three miles off of Hwy. 74 between Ponca and Jasper, and is well marked. It is a steep, rough road coming in. No buses or RV's. NO DOGS on trail.

There is a trailhead bulletin board way in the back of the campground area. Right after you pass by it, the Old River Trail takes off to the left (downstream)—go STRAIGHT AHEAD and cross a rocky creek—this is Bear Creek. Just beyond, there is an intersection. The Old River Trail and Buffalo River Trail (to Ponca) continue straight ahead. TURN LEFT at this intersection to go on to Erbie.

The trail crosses Bear Creek again and continues on the level through open lowland forest. It crosses the creek again and joins an old woods road as it eases up the hill just a bit. Back down again it goes, continuing alongside the creek, passing by a nice waterfall. Most of the year, this creek is pretty dry, like its neighbor Indian Creek. Past the waterfall, the trail crosses the creek for the last time, then begins a rather steep climb up and out of the Bear Creek drainage. It switchbacks some as it climbs *up*, then goes through a nice broken bluff area and levels off—this bluff area is an SSS.

The trail remains fairly level for a while, then turns back to the left and heads *up* once again to and across the Kyles Landing road at .9. If you just wanted to do a short loop, then turn left on the road and follow it back to the campground.

After crossing the road, the trail turns to the right and follows just below the road for a little ways. There is a nice view of the River valley downstream. During leaf-off, you can see a large bluff on this side of the River—that is Buzzard Bluff—and the trail will go across the upper end of it shortly. You can also see the fields of Camp Orr, the Boy Scout Camp. I was first introduced to this country in this area way back in the early 1960's—it hasn't changed much, thank goodness!

Buffalo River Trail (Kyles Landing to Erbie)

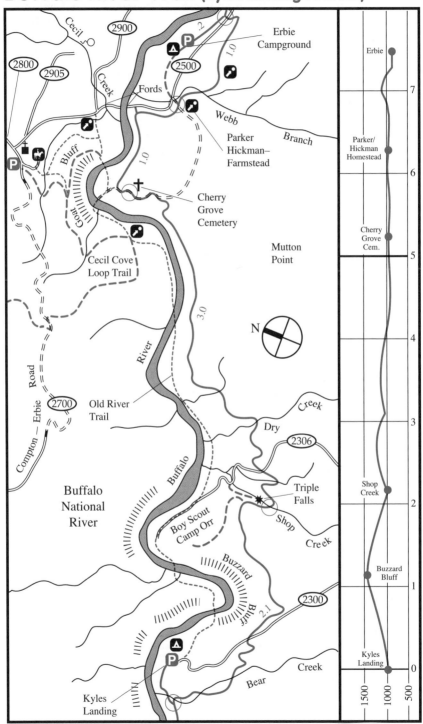

Erbie Campground

2900

2500

2800

2905

Fords

Cecil

Creek

Parker Hickman–Farmstead

Webb Branch

Bluff

Cherry Grove Cemetery

Goat

Cecil Cove Loop Trail

Mutton Point

N

Old River Trail

River

Compton — Erbie Road

2700

Buffalo National River

Dry

Creek

2306

Triple Falls

Buffalo

Boy Scout Camp Orr

Shop

Creek

Buzzard Bluff

2300

Kyles Landing

Bear

Creek

Erbie

Parker/ Hickman Homestead

Cherry Grove Cem.

Shop Creek

Buzzard Bluff

Kyles Landing

7

6

5

4

3

2

1

0

1500

1000

500

The trail climbs uphill, but not too steeply. It swings away from the road and levels off, crossing a couple of tiny seeps. During leaf-off there are some nice views back upstream from this area, which is at 1.3. As the trail comes out to the edge of the hillside, you can look down below and see a lot of the River, and Buzzard Bluff. Although this isn't a real open, spectacular view like you would like to see, it certainly does qualify as an SSS!

The trail then swings back to the right and away from the view, crossing a small creek, and still pretty much on the level. And at 1.8 the trail crosses an old road that is heading straight down the hill. You will notice some blue paint on a couple of trees in this area—in fact, you will see this paint in several locations during the next several miles. They mark the boundary of the Boy Scout Camp—the trail goes in and out of the boundary a few times.

This also marks the beginning of a downhill trend in the trail. It gets pretty steep, especially if you were hiking from the other direction—uphill. As the trail levels off a bit, it goes through a rocky area, and at 2.1 it turns sharply to the right and goes around the point of the hill. At this turn there is a faint trail that heads downhill to the left. This is a spur that heads down into the Boy Scout Camp.

Also in this area you may be able to hear water—there is a large waterfall on Shop Creek down below—I'll tell you about it in a minute. In the meantime, the trail continues downhill into the Shop Creek drainage. You can look across and see the trail on the other side, and even a power line over there too. As you get closer to the creek, look at the trail tread at your feet—you can probably tell by the rock walls here that it took a great deal of work to build the trail here! Enjoy, but be appreciative of those who put out so much effort.

You cross the creek at 2.3. Like many in the area, Shop Creek is dry much of the year. When there is water here, this is a definite SSS. There are lots of large boulders just tossed about in the creek bed.

The trail heads downstream and uphill. Now you are getting closer to the waterfall. If you can hear it and are the adventurous type, then you will probably figure out how to find it. If not, here are some simple directions: Continue on the trail until it passes under a powerline. Follow the powerline for a couple of hundred feet 'til it comes near the creek off to the left. This is where the waterfall is—just head down the hillside into the creek bottom and you'll discover Triple Falls.

Of course Triple Falls is an *off-trail* SSS. And I must say, it is one of the more unusual waterfalls in the Ozarks. It's pretty high, with lots of moss-covered rocks and a nice pool at the bottom. But the unique thing about it is, that most of the year the falls are created by a spring that emerges just above the falls. So even when Shop Creek is dry, this falls often runs and looks great. When there is water in the creek, it really runs. There is a steel cable that runs across the top of the falls—I guess

to aid in crossing the creek—but it sure messes up my pictures! This falls is just a short hike up from a parking spot at Camp Orr.

Back up on the main trail, it continues past the powerline, around the hillside, and drops down to and across Rock Bridge Creek at 2.7. There is a series of natural "bath tubs" here that look inviting (depressions that have been carved into the bedrock by the swirling waters of the creek).

From this area the trail runs pretty level as it goes through a tunnel of cedar trees, and comes out to and across the road down to Camp Orr at 2.9. Then it heads down the hill at a good clip, and picks up a couple of old roads at different spots. At one point, be sure to go STRAIGHT AHEAD (across a road that takes off to the right), and then down to the right on an old road. The correct route takes you just below a nice bluff area off to the right. It then drops down to and across Dry Creek at 3.2.

Shortly after crossing the creek, the trail swings to the left and crosses a small creek. During periods of heavy runoff there would be a wonderful waterfall just uphill to the right. The trail heads uphill, climbs up a crude set of steps, swings back to the right, then the left.

The trail then tops out and levels off—this is pretty much the end of any real climbing from here on along the trail. So if you lived to this point, you are in good shape! For the past mile or so the trail has been away from the River, and will continue to be that way for a while longer.

It crosses several small streams, in and out of small drainages, but mainly just ambles out through the hardwood forest. At 3.9 there is a trail intersection. It's a short spur that heads down the hill and joins up with the Old River Trail that continues to follow (and cross) the River down below. The main trail goes STRAIGHT AHEAD.

The trail stays level, crossing a couple of small creeks. At one of these creeks there would be a wonderful waterslide-type falls just above the trail during heavy runoff periods. In fact, as the trail begins now to run alongside the River and below a good bluffline up to the right, there are lots of possibilities for excellent waterfalls. This area begins at 4.3, and is an SSS for the next half mile or so. The trail now comes closer to the River than I believe it does at any other time.

This next little bit is probably one of my favorite spots on the entire trail. There are lots of neat stuff above the trail along that bluff to explore. Gosh, during the wet season you might almost get tired of gazing at all the waterfalls! Life is tough, isn't it.

All too soon the trail climbs up a flight of steps and levels off—there is a good view here of the J.W. Farmer homestead complex that is just across the River. The Cecil Cove Loop Trail takes you past this spot (description begins on page 98).

From that area the trail rises uphill and runs along the base of the neat bluff that we've been following—this area is another SSS. And then

it goes up a well-built flight of steps that takes you through a split in the bluff, or a freestanding pillar of rock. Right at the top of this unique little spot, there is a perfect sitting "bench" off to the right. Sorry, there is only room for one hiker though! Enjoy the view. This is at 4.8.

That marks the end of the bluff area, and the trail heads out to the right, away from the River, and out into the forest. It crosses a small creek, then intersects with a Park Service road at 5.2. You have a couple of choices here: If you are in a hurry, then turn right and head uphill on the road. It will take you up, around and down to the Parker-Hickman Farm. This is the shortest way there, but there isn't much to see along the way, and you have a mild hill to climb. I suggest that you TURN LEFT and follow the road downhill (this is the official route of the main trail). You will shortly come to Cherry Grove Cemetery at 5.3. This is a nice little spot to stop and spend some time, even if you aren't into cemeteries.

There are some pretty old headstones here—dating back to the 1850's, including one commemorating a young man killed during the Civil War (in fact soldiers from both sides of the Civil War are buried here). There is even a gentleman that died at age 70—man, that was ancient for back then! Anyway, there are lots of unique little headstones here—each with a story of its own.

Just beyond the cemetery, the trail leaves the road TO THE RIGHT. From here the trail goes out across an old field, now grown up into a dense cedar thicket. It opens up some, then plunges into the normal forest again and comes alongside the River.

Across the way you can see the large, open fields in the area of the Erbie Church—see pages 90 & 96 for trails in that area. At about 5.9 there is an intersection. The little spur to the left takes you out to the edge of a bluff that disappears into a deep hole of water. There used to be a swinging bridge here—there are a couple of truck axles driven into the rock for bridge cable anchors. There is a nice overhang on the bluff here—an SSS!

Back at the intersection, TURN RIGHT and head up a set of steps. The trail goes up onto the top of the bluff, then skirts around the edge of an old field, and comes to another intersection. This is just a short spur that goes down to the River. Continue STRAIGHT AHEAD and go across an open field. The prominent hilltop that is visible up to the right is called Mutton Point. The trail stays level as it works its way through several grown up fields.

The trail eventually comes out to the road and the Parker-Hickman Farm site at 6.3. If you turn right on the road, it will take you back to the Cherry Grove Cemetery—you can use it and the trail that you've just come on to make a nice loop through the area.

TURN LEFT on this road and go through the farm complex and a gate (TURN RIGHT after you pass through the gate to continue on the

main trail). Here at the gate you'll find a large sign that describes the farm site area. This is the oldest standing homesite in the Buffalo River area, and is very well preserved. If you stop and spend some time here you'll probably not only learn a great deal, but you'll gain some appreciation for early Ozark life as well. The Parker family first lived on the site in 1838 (or was it 1835—I've seen both dates listed). Although it has been added onto several times, and the flavor of the original building is lost somewhat, that first cabin is still standing. The sign does a great job of explaining things.

FROM THE GATE with the large sign, if you are just going to Erbie Campground and want to get there the shortest way, then continue on the road just ahead to a road intersection. Turn right on a road, cross a stream, then turn left off of the road out into an open field on a wide, well-mowed path. It curves around through the field, on the level, and comes out at the campground in less than a half mile. This is a great area to see elk, and there are usually lots of droppings around to prove it!

FROM THE GATE with the large sign, if you are staying on the main trail, TURN RIGHT (if you are coming from Kyles or the homestead) and follow the fence row. The trail continues along an old road bed, following Webb Branch that is off to the left. It then meets another road—TURN LEFT onto this road and follow it and a power line down to a crossing of the stream.

Continue on the road beyond the stream a couple of hundred feet. Just as the road begins to climb uphill, TURN RIGHT off of the road onto regular trail. Back in the trees off to the right you can see an old oak-shingled smokehouse—worth a look if you have the time. A one-room schoolhouse once stood off to the left (a spring there too). The trail crosses a narrow road that leads to the smokehouse, then plunges back into a dense cedar thicket, and follows a small stream uphill.

Up a rocky hillside the trail continues to climb, then by 6.8 it has crossed another old road bed and levels off somewhat. You will be able to look down and see Erbie Campground below. The trail climbs up some more, up onto what I've seen listed as "Tornado Hill." It's very rocky. As the trail heads down the hill, the view is wonderful, and all of the moss-covered rocks about qualify as an SSS.

From there the trail drops down further, comes alongside a nice little slickrock area, then swings back to the left, then right. At 7.3 it comes out to the main road from Hwy. 7 to the campground. Go straight across the road, and you'll find a trail intersection there. TURN LEFT to head back to the campground at 7.5, or turn right to continue on the main trail to Ozark Campground and Pruitt.

Buffalo River Trail—Erbie to Pruitt (8.7 miles)

Trail Point	Mileage Downstream	Mileage Upstream
Erbie Campground	0.0	8.7
Adair Cemetery	2.2	6.5
Cedar Grove Picnic Area (Ponds Trail)	4.4	4.3
Ozark Campground	6.1	2.6
Pruitt	8.7	0.0

Erbie Campground is a Park Service campground that has primitive campsites, toilets, water, canoe access and an outdoor telephone. The turnoff to Erbie is on Hwy. 7 between Jasper and Pruitt, and is a well marked (NC#2500—gravel road—5.4 miles). The trailhead is located on the downstream end of the camp-ground. There are lots of elk that hang out in the fields upstream, so if you camp here, get up early to see them. NO DOGS on trail.

From the trailhead, head downstream on a spur trail that connects with the main BRT at .2. TURN LEFT to go to Ozark Campground and Pruitt (turn right to go up and over "Tornado Hill" to the Farmstead, Kyles, Steel Creek and Ponca). The trail eases down the hill just a little, crosses a small stream, and intersects with an old road—TURN LEFT here and remain on the old road. The River is just out of sight through the trees below.

The trail crosses several slab rock areas that can get rather slick when wet. At one point the trail used to go through a tunnel of beauti-ful old cedar trees that were draped Spanish moss, but they have all been removed (to reduce the "fuel load" in case of a wildfire).

As the trail turns to the left and heads downhill at .8, TURN RIGHT off of the road and into the woods. The trail crosses a small creek, then turns back to the right and climbs just a little, crossing under the third power line since leaving Erbie. Just beyond, the trail levels off and you've got a nice view in this area of the River and the bluffs on the opposite side.

As the trail swings around the hillside to the right, there seems to be the remains of an old homesite off to the right. Then the trail turns left onto an old road, passes by a historic little trash dump as it heads downhill, then levels off and comes to an intersection at 1.2. TURN RIGHT off of the road for the main trail. The road itself heads down to the River.

From there the trail climbs up to and through a small bluff line, then continues along on top of it for a while. There are some good views downstream. It swings away from the River and crosses a small

Buffalo River Trail (Erbie to Pruitt/Hwy. 7)

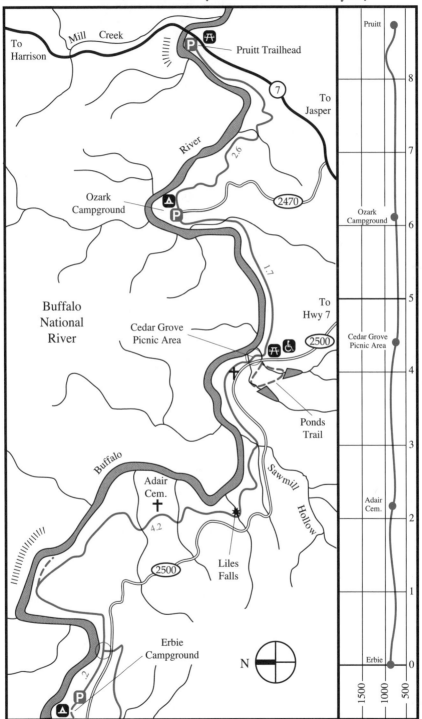

To Harrison

Mill Creek

Pruitt Trailhead

7

To Jasper

River

2.6

2470

Ozark Campground

Buffalo National River

1.7

To Hwy 7

2500

Cedar Grove Picnic Area

Ponds Trail

Buffalo

Adair Cem.

4.2

Sawmill Hollow

2500

Liles Falls

Erbie Campground

N

Pruitt

8

7

Ozark Campground

6

5

Cedar Grove Picnic Area

4

3

Adair Cem.

2

1

Erbie

0

1500 1000 500

stream, and during heavy runoff there would be a nice waterfall just below the trail. There is a good upstream view of the River and bluffs as the trail continues on.

As is the case on many parts of this trail, you can look down and see the upper branches of smooth, white-barked sycamore trees that line the River. They are a nice contrast, especially during leaf-off, when there isn't much color around.

The trail now swings away from the River, through a cedar grove, and remains level. It hits an old roadbed and climbs slightly for a little ways, then leaves it and goes into a young stand of pines, through an old grown up field of cedars, and continues into some scrub oaks. There seems to be quite a bit of elk "sign" in this area. What you see are "rubs" on some of the trees at about waist high. The great (and not so great) bulls will rub their antlers during the fall of the year—some say to scratch an itch, others say it's to rub off the velvet from their antlers. At any rate, it scars the tree, and is a sure sign that a bull elk has passed. Deer of course do this too, but their rubs are much lower to the ground.

The trail runs alongside a small creek, then drops down to and across it at 2.1. It heads uphill on an old pioneer road, and comes to a trail intersection at 2.2. There is a little spur trail to the left that leads a short ways to Adair Cemetery. This is a quaint little plot that is much smaller than the Cherry Hill one that we visited earlier. Some of the graves date back to the 1840's. At least one Confederate soldier is buried here.

GO STRAIGHT at the intersection along the old road, through the remains of several structures, and past some giant oak trees. There is a pretty good sized pond down to the left, along with the usual spattering of old tires and other trash. The road drops down the hill and swings around to the right. In just a short distance, the trail TURNS LEFT off of the road and heads into the woods. You know you're on the right trail if you see ten or more tires beside the trail that are part of an old dump.

The trail does some up-and-downing as it swings off through the woods, passing a small overhang bluff just off to the right. The River comes into view for a short time, then disappears as the trail heads up into a hollow. As you approach this hollow, if the water is running, you'll realize that you are in for a real treat. There are a couple of real nice waterfalls—above and below the trail. Be careful if you try to go to the edge of the bluff beside the trail to get a better view—the rocks can be *real slick*, and the fall is a long one.

The trail crosses this area at 2.9, and it is definitely an SSS. A good place to take some time out and look around. As you leave the area, you can look back and get a good look at the lower falls as the trail swings around the hillside, staying pretty level. This is Liles Falls, named after Jim Liles, the man who developed a lot of the hiking trails here.

After the trail crosses under a powerline (the first of *many* times in this section), it comes out on top of a bluff that overlooks the River. There are some good views of several large fields across the way. Then it drops down a drawn-out set of steps at 3.2, down to and across a small stream in the bottom, then back up the hillside again.

Back to the left you go, up to the top of the hill and out onto another bluff with good views of the River and the fields beyond. Back down the hill again, swinging to the right, then to the left, and down to and across Sawmill Hollow Creek. You are right next to the main road here, and there is a neat, giant culvert under the road that somehow looks out of place.

The trail crosses the creek and heads downstream alongside it. Then it swings to the right and runs right next to the big River. This part of the trail can get a little messy at times because there may be horse traffic that uses it. At 3.8 there is a small spring, then the remains of a hunter's shack, as the trail runs along an old road.

After a long straight stretch, there is an intersection. A road goes to the right, and one to the left (where the horses go), but the trail goes STRAIGHT ahead on pure trail into the woods, splitting the two roads. It remains level through a cedar thicket, then rises up and joins an old road as the River comes into view.

Just past 4.2, the trail heads down and back to the right, past a nice little falls on the creek below. At 4.3 it crosses the creek near a smaller falls. This creek comes out of "North Pond," which we'll talk about in a minute. The trail runs around to the left and up the hill and comes out at Cedar Grove Picnic Area at 4.4. There are a couple of tables here and a real nice view up and down the River.

This picnic area is on the road from Hwy. 7 to Erbie Campground, and it is accessible to wheelchairs. There are a couple of short trails that cross the road and visit "South Pond" and "North Pond"—see page 106. The trail to the left and South Pond is made of hard-packed gravel and is accessible to wheelchairs. The short trail runs nearly level .1 miles out to the pond.

The trail to the right goes about the same distance to North Pond but is just regular trail, not wheelchair accessible. There is also a trail that connects the two ponds, making a loop of about .4 miles. These are nice, clear ponds, but shallow (in the process of naturally filling up).

Back at the picnic area overlook, the main trail drops down through a set of steps and turns right (there is a short spur that goes to the left here down to the River). It heads down to and across the creek that comes from South Pond. It eases up the opposite hillside, and swings back next to the River as it continues uphill some more. It levels off, then drops and turns back to the right, down to and across a small creek at 4.7—when wet this creek has some small "stairstep" falls in it.

Back up the hillside and alongside the River again, then level, and

at 5.2 begins to ease down the hill and back to the right away from the River. It climbs up a little, through several small blufflines, then up and over a ridgetop. It then heads downhill and comes alongside a small creek at 5.5, which it begins to follow to the left and downstream.

There are some nice little falls on the creek, and the trail crosses it at 5.7, then continues downstream on the other side. There are a couple of pioneer roads that come down the hill and join the trail. As the creek veers off to the left the trail curves around to the right and leaves it. When the water is very high, this section of the trail might be under water. There are a couple of small bluffs beside the trail here.

At 6.1 the trail comes into one end of Ozark Campground (Park Service), crosses the main road (turn right to get to Hwy. 7), and continues on into the woods up and around the campground. This is a Park Service campground with toilets, campsites, a large open pavilion and an outdoor telephone. The turnoff is located on Hwy. 7 between Pruitt and Jasper. (There is no real trailhead here, so just park where you can.)

The trail makes its way up the hillside, away from the campground. It levels off, with some good views down on the River, and still more open fields across the way. Be sure to keep your eyes open for elk out in those fields. The trail swings back away from the River to the right and eases down the hill, intersecting with an old road trace—TURN LEFT. It leaves the trace shortly thereafter to the right. It crosses a small creek that has a nice little falls on it below the trail, then swings back to the left, then to the right, as the River comes into view again—some big sycamores too!

Back to the right again we go, pretty much on the level. And at 7.2 we cross a road and continue off into the woods. There is an old dried-up pond off to the right. In this area you may begin to hear the sounds of Hwy. 7. We cross a small creek with a little waterfall, then wind around through some scrub trees.

At 7.5 there is a neat spring whose moss-covered rocks lead the way to a pond that the trail is wrapping around. There is a lot of algae in this pond at certain times of the year that you can peer deep down into and wonder about. The trail in this area also crosses under the powerline several more times, a constant reminder of man.

The trail is on an old road trace through here, and it makes its way *up* the hillside—easily the largest climb in quite a while. As you kind of top out, the more obvious old road continues up the hill, but you want to TURN LEFT onto a lesser old road that heads downhill just a little. From this point you can look out and see the wonderful bluffs at Pruitt.

The hillside out in front of you now is where Hwy. 7 is, and the trail runs around to the left under the highway. The trail begins to drop down the hillside just a little, and comes to the first of two wood bridges. Just beyond at 8.2 there is a little spur off to the left. It drops down to a great view up and down the River. This is a perfect spot to stop, drop

your pack, and soak up the place for one last time.

Next the trail gets real steep, and there are a couple of switchbacks. It drops down beside some smaller bluffs, and at 8.6 comes to the second wood bridge—it's a level stroll from here on. And at 8.7 the trail ends at the Pruitt picnic area at Hwy. 7. The Pruitt Canoe Access area is farther downstream. The BRT may continue downstream and connect with the rest of the BRT at some point in the future...

Indian Creek Area (no official trail)

This area is one of the most scenic spots in Arkansas. Some of it is rather difficult to get into, which I guess makes it all the more special. There are lots of waterfalls, a cave or two, giant boulders, lots of sheer bluffs, and lots and lots of mosses and ferns—this is a lush place. It is located in the Ponca Wilderness Area (and on the Ponca quad map), near Kyles Landing Campground. Although it is possible to find a level spot to camp in the area, I don't recommend it—most folks dayhike. This is not a place for young children, or novices. NO DOGS on trails.

A note of caution—National Park Service records show that more injuries from slips and falls have occurred in the Indian Creek area than in any other part of the National River!

There are two ways to access the area. One is from below, via the Buffalo River Trail coming out of Kyles—this is the way that most folks get into the area. The other way is from above, off of Hwy. 74 near Low Gap. This access isn't used very much, partly because most people can't find it, and partly because it's pretty rough.**NOTE:** There has been a dispute with a property owner and the Park Service about access from this top parking area—sometimes the road is blocked with rope. Check with the Park Service for the latest info.

First, from Kyles. The turnoff to Kyles is located on Hwy. 74 between Jasper and Ponca, NC#2300. It's three rough and steep miles on gravel from the highway down to Kyles. This is a Park Service campground with primitive campsites, water, toilets and canoe access. The trailhead is located back to the left at the far end of the campground. Head out past the bulletin board to pick up the trail.

Just past the board, the Old River Trail (horse) that takes off to the left (downriver). Continue straight ahead and cross Bear Creek. The Buffalo River Trail leads off to the left here (also downriver), and goes to Erbie, Ozark and Pruitt. GO STRAIGHT at the intersection. At the next intersection, in a couple of hundred feet, you will have a choice. The Buffalo River Trail turns left and heads up the hill, eventually coming to Indian Creek—we'll take that route back. For now, continue STRAIGHT AHEAD on an old road—this is the Old River Trail.

At the next intersection TURN LEFT (the horse trail goes straight ahead), and head out across a large, grown up field. The Buffalo River is just off to your right, and soon you'll come to a short spur that leads over to the famous "Gray Rock." Keep going on around through the field, and you will come to an intersection with the Buffalo River Trail that left us a minute ago. Continue straight ahead 'til you come to a creek that is usually dry—this is Indian Creek! You've come about a half mile from the campground.

There is somewhat of a trail that enters the canyon of Indian Creek and goes upstream (the Buffalo River Trail crosses the creek and heads up the hill on its way to Ponca). The "trail" up Indian Creek isn't

Indian Creek Area (no official trail)

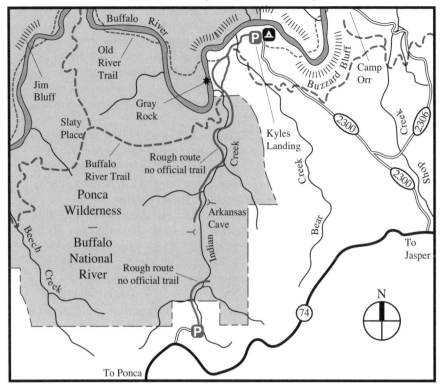

marked or maintained. But I would suggest that you use it whenever you get the chance. It crosses the stream several times. There is a lot of neat stuff through here, both on the creek as well as up on some of the bluffs that are sneaking down from above. At one point the trail is well above the creek, up on top of one of those bluffs, and the view is just terrific.

Eventually, after about another half-mile of hiking, you will come to a spot on the creek where you can't go anywhere, and this is the beginning of the really neat stuff. First, just off to the left and above the trail is Arkansas Cave. (When you are standing inside the cave, the opening looks like the state of Arkansas.) It is also called Tunnel Cave, and Horeshoe Cave. During the wet season, there is a wonderful waterfall coming out of this cave, that spills over moss-covered ledges and past dense ferns to the creek bottom below. More waterfalls are just upstream.

From this point on you either have to enjoy the view and then turn around and go back, make one of two semi-dangerous climbs in order to continue. I always take the climb on the right. Others opt to climb up to the cave and follow it upstream—it comes out at stream level later

on. But there is a major problem with going through the cave. It is home to the endangered Gray Bat, and entry into the cave is *prohibited*. Really, *don't* enter the cave at any time during the year (you will be ticketed). You could end up killing some bats simply by disturbing them. And although you may not care too much about bats, since each one eats a thousand mosquitoes every day, you would in effect be adding to the mosquito population by disturbing them! The cave is also now being used by Indiana Bats during the winter months as well (also an endangered species).

The climb up the right side is no picnic—many folks use a rope to help out. It can be free climbed if you are careful. You have to make your way up a steep slope, then around the back of a large opening in the bluff, then squeeze through a small opening in the bluff to emerge upstream. Only experienced scramblers should try this.

Once upstream, there is more neat stuff. But once again your passage will be blocked by a rock canyon. And if you look up towards the end of it, you'll see the "eye of the needle." Water seldom comes over this rock slide, but when it does, it is quite a sight! Off to the right and up is a cave entrance that you may want to explore some.

To continue upstream, you need to climb *up* around to the left. It is very steep, but worth the effort, as there are still more wonderful things to see further upstream, including a 50 foot waterfall. If you are able to make it all the way, you would come out up on top at the parking area that I'll describe next. Most people come up from Kyles, get as far as Arkansas Cave, then return to the campground.

Now, the access from above. From the Low Gap store, go east on Hwy. 74 towards Jasper. After 2.4 miles, (there is a pond on the left, and this is directly across from the turnoff into Horseshoe Canyon Ranch), TURN LEFT onto a little-used, single-tracked dirt road (this is the road that may be roped off at the highway). This road will dead-end in just a little bit. Park here and head downhill, and you will naturally work your way down into the drainage. Just keep going downhill, following the stream, and before you know it, you'll be in the scenic area. Although it's kind of hard to tell just exactly when you are in the "scenic" part—'cause it just keeps getting better. And the going gets rougher. And rougher. You'll pass 52 foot tall Hammerschmidt Falls on the right (named after longtime US Congressman John Paul Hammerschmidt, who helped create Buffalo National River park), and then get into lots of neat stuff, and eventually come to the area already described. *Don't exceed your ability though*—if you get hurt, help is a long ways away!

A good way to see this area is to run a shuttle—begin from the top and have a car waiting for you at Kyles. Or have someone drop you off at the top and then have them come in from the bottom. Any way that you get into this area will be a treat for you. Like a lot of the areas on the Buffalo, try to visit during the week when there aren't as many folks around.

Old River Horse Trail (13.2 miles)

The Old River Trail follows an historic farm road through the bottomlands of the Buffalo River. It extends 13.2 miles from Ponca to a horse camp at Old Erbie near the Cecil Cove Trailhead. Along the way it visits many old farmsteads and other historical features. It goes past a lot of scenic stuff too!

There is not a separate map for this trail, but it is shown as its own dotted line on two of the Buffalo River Trail maps—BRT from Ponca to Kyles (page 72), and Kyles to Erbie (page 82). This is the main horse trail through the area, and is used a lot by them.

This trail along the River gives you a much different perspective than does the Buffalo River Trail, which pretty much takes the high route. The Old River Trail crosses the River *20 times,* so it is best to hike it in the summertime, when those lovely pools of cool water will be most appreciated!

A note of caution—the trail gets quite grown up with weeds and poison ivy in the summer, so think twice about *hiking* it (makes a great horse trail). And if you do, you will probably want to wear long pants. What I do is wear a pair of those pants that have zip-off legs—the legs come off at River crossings and make into shorts, then the legs go back on for the brushy hikes in between.

Cecil Cove Loop Trail (7.4 miles)

Trail Point	Mileage Counter-Clockwise	Mileage Clockwise
Cecil Cove Trailhead	0.0	7.4
Van Dyke Spring	0.4	7.0
Rock Wall	2.0	5.4
Trail Intersection	2.2	5.2
Jones Cemetery	2.7	4.7
Jones Homesite	2.9	4.5
Compton-Erbie Road	5.2	2.2
Short Cut Loop	6.6	6.6
Farmer Farmstead	6.4	1.0
Goat Bluff Trail	6.8	0.6
Cecil Cove Trailhead	7.4	0.0

This loop is part of a trail system that originates at the Cecil Cove Trailhead, which is located next to the Erbie Church (across the River a ways from Erbie Campground). There are several ways to get to this area, but the old route from Compton via the Compton-Erbie road is **NOT RECOMMENDED** (this is the road past the Compton and Schermerhorn trailheads). My choices: #1) From Hwy. 206 at Gaither, take the Erbie Cutoff Road/NC#2825 south (next to the water tower, paved, then gravel) for 2.2 miles then TURN RIGHT onto NC#2800 (gravel) for 5.6 miles to Erbie. #2) From Hwy. 7 at Marble Falls take NC#2800 (gravel) west 7.4 miles to Erbie. #3) You can also get there by fording the Buffalo River from the Erbie Campground area (but *only* when the River is low!). NO DOGS on trails.

The Cecil Creek Loop Trail begins at the trailhead that is located adjacent to the Church. The first section (known as the Cecil Creek Trail) of this nice loop runs upstream along Cecil Creek and is an easy, scenic stroll. Since it does cross the creek several times, you may have some wet crossings during periods of high water. The second section (the Cecil Cove Bench Trail) is more strenuous as it climbs up the hillside 500 feet, then loops back around and intersects with the Compton-Erbie road. At this point you can either follow the road back down to the trailhead, or continue on another old road down to a historical side on the River, and return to the trailhead via a nice little trail (the Farmer Trail). For the sake of clarity, we'll call the loop that is described the "Cecil Cove Loop." The entire loop *is open to* horses, but isn't used by them very much. We will hike this loop counter-clockwise.

The trail begins off to the right of the toilets and heads downhill a little on an old road bed. There are some nice views of the bluffs across the way on Newberry Point. It eventually leaves the old road TO THE

Cecil Cove Loop Trail

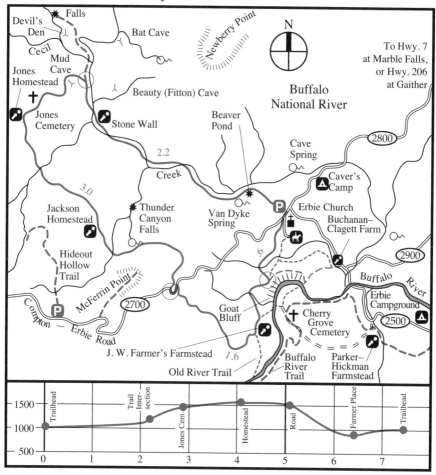

RIGHT and continues down the hillside. At .3 it comes to a beaver pond and dam, which is actually the water from Van Dyke Spring that emerges from the base of a bluff just upstream. You can cross the top of the dam, or cross the small stream below it. The trail heads upstream to the left along the spring pool (Cecil Creek is on your right). There is a small set of bluffs along the pool, and it is a very nice SSS.

The trail passes the spring entrance at .4, then continues on up the valley, passing through the middle of a small field. This and other clearings along the way were once corn fields, grown by the families who once lived in the area. Cecil Creek is visible just off to the right.

This is a nice, level, easy walk. You may want to hike this during a sunny February day. One of the reasons is because there are a lot of witch hazel bushes here. They will bloom on sunny days in late winter, and let me tell you, there is no finer fragrance in all of nature. They are

common along and in stream bottoms in the Ozarks, and there seems to be a large number of them here. By the way, witch hazel bushes are where the 'ol timers get their forked branches that they use for well witchin'—they use them to find the best spot to dig a well.

The trail comes alongside the creek, then swings away through an open forest. There are lots of rock piles here—these were once cleared to create a field, which is of course now grown up with trees. Back to the creek we go again, as some nice bluffs come into view across the way.

At 1.0 the trail crosses Cecil Creek for the first time. This spot is home to countless smooth rocks of all sizes that have been polished by the creek for ages. You can usually use these for a dry crossing. After the crossing, the trail heads off into the woods, still on the level, through some scrub trees and cedar thickets, and away from the creek. At 1.2 it comes back alongside the creek for a brief period, than back away from it again.

At 1.4 the trail has returned to the creek, and crosses it. It is a wider stream bed here, and since the creek usually runs underground at this point, it is a dry crossing. More smooth rocks everywhere, with a few jagged ones thrown in for good measure. Once on the other side, the trail turns right and continues upstream. And it passes another SSS area—where a bluff comes down into the creek (there is even a small cave entrance here, but it doesn't go anywhere).

As the trail goes on, it passes through several more cedar thickets. Sometimes the trees are so thick that they form a canopy over the trail—kind of like walking through a green tunnel! The trail rises up onto a high bank, looking down on the River. Then it comes down to and crosses the creek for the third time at 1.8. You may notice that the rounded rocks are getting smaller.

Back into the scrub timber the trail heads, then comes out alongside not only the creek but right next to one of the best rock walls that I know of in the Ozarks. Although this isn't really a "natural" thing, I'd have to consider this spot an SSS. The main thing that strikes me about this wall is that it's so wide and stable. It was built by pioneers who cleared the creek-side for use as a field. The remains of the homestead are across the creek.

Just past the wall, the trail drops down to and crosses the creek right at the 2 mile mark. It goes up onto a bench and gets away from the creek—you won't see the creek again. So if you are going to do the entire loop and need to get water, now is the time to do it!

The trail swings to the left, and climbs up the hillside to a trail intersection at 2.2 (Just off to the left of this trail intersection is the site of a former church—only a few foundation rocks remain now.). This is the official end of the " Cecil Creek Trail," and the beginning of the "Cecil Cove Bench Trail." I'm going to combine them both and continue with

the description of the "Cecil Cove Loop Trail."

[But let me pause for a moment first, 'cause there is a third trail that intersects here, and we'll explore it for a moment. This other trail takes off to the right, and is good trail for a little while. It comes down the hill, crosses a flat (great campsite), crosses Cecil Creek, then turns left and heads up a steep hill—it isn't contoured or marked very much, so you have to kind of find your own way up the steep slope (not really even a trail at all). After a while it veers off to the left and runs across the hillside and around to an SSS area full of thunderous waterfalls. This is Broadwater Hollow Falls, and is about a mile from the main trail intersection. To get back to the main trail, I would recommend that you follow the creek that forms the waterfalls downhill, where it will intersect with Cecil Creek—turn left on the creek and continue downstream to the point where this trail originally crossed it. On the way down, there is a sinkhole called "Devil's Den" that is up above the creek on the east bank—it is one of the deepest sinkholes in the Buffalo area, nearly 100 feet deep! You'll have to hunt to find it. Of course don't attempt to climb down into it, unless you are an experienced caver—ropes required. There may be a good trail to the falls someday, but for now is has simply been "scratched in."]

[Also, if you are interested in caves, you might want to know about this. Just across Cecil Creek from this trail intersection, up on the opposite hillside, is the longest cave in Arkansas—Beauty Cave (also called Fitton Cave). This cave is so long that it has two front doors—the other one is called Bat Cave. These entrances are gated, but entry can be obtained by qualified cavers by checking with the National Park Service folks (limited to one group of 4–8 people per day). Access is via the Cecil Cove Trail. There is a special "Cavers Camp" located near the Cecil Cove Trailhead.]

BACK TO THE TRAIL INTERSECTION (former church site), the main trail continues *up* the hill on an old woods road. And I do mean *up*. This begins a rather long and steep climb. At the first turn in the trail you can see a bluff area straight ahead—this is actually Mud Cave, a spot where the churchgoers went to hold services during the heat of summer. The trail continues *up* the hill, and during leaf-off there are some nice views back up into the headwaters of Cecil Creek.

The trail does level off somewhat, swings back to the left, then back to the right again, and then eases up the hillside some more. There are several lesser old road traces and gullies that intersect the trail—just continue on what you perceive is the right track. There are a lot of places where you can see that the old roadbed is eroded.

After another little climb, at 2.7 we come to the Jones Cemetery. I love these old cemeteries. They seem so peaceful out here in the middle of the forest. Those folks who are here for eternity must enjoy their home too. As with most of these old cemeteries, there are several head-

stones of infants whose birth and death are on the same day.

From here the trail continues on uphill just a little, winds around, then comes next to a couple of old log structures. Just beyond at 2.9 there is an intersection—turn right for a short walk to the middle of the old homestead of William J. Jones. There is half of the chimney and the rock foundation left. You can tell that this was once a large home.

Back at the trail intersection, the main trail TURNS LEFT and continues. It's a pretty easy walk now for a while. Soon another homestead area appears off to the right, this the one of Faddis-Keaton. It is marked by a rock wall along the trail. There are some wonderful old oak trees here, as well as one of the biggest walnut trees that you'll see anywhere. And the trail crosses a spring-fed stream here too—probably one of the reasons why they choose this spot to live!

The trail is on an old roadbed, and it meanders around through the woods, crossing several small streams. One of these streams, at 3.4, is an SSS area that is full of giant boulders both above and below the trail. During the wet season there are lots of waterfalls here.

A "bench" is a section of the hillside that is naturally leveled off—like a spot where a giant might sit on if one were around. This section of the trail is called the Cecil Cove Bench Trail because of the "bench" that it runs along through this area. Ozark benches are the result of eons of erosion of the less resistant rock, like shale. Soon this particular bench peters out, and the trail heads up the hill and lands on another bench, then continues on the level again.

Once up on the level, you will pass another old homestead—the Franks-Jackson place. There are the remains of a couple of buildings here. What a neat spot to live. It sits on this narrow bench, with a great view out to the rest of the world, and even a spring for water.

At 4.3 there is another SSS—an area of boulders that in spring would reveal a lot of tumbling waterfalls. This is a good spot to stop and survey the country around you. The trail is running along this narrow bench. Above you the hillside is very steep. And below, even steeper! The broken views through the trees often reveal distant features of the Cecil Creek valley. This is a major mountainside that you are clinging to.

Soon there is a bluffline that appears just above the trail. And lots of moss-covered rocks. We'll follow this bluffline to the nose of a ridge, as the trail curves around to the right at 5.0 and is now facing the Buffalo River Valley. During leaf-off you should be able to see Mutton Point, which is across the River.

Also during leaf-off you'll be able to see the fields down on the River at Erbie, and a dirt road comes into view below—we intersect with that road at 5.2. TURN LEFT on this road, and walk down it. (This is the Compton-Erbie road—if you turned right you'd come out at Hwy. 43 at Compton.) If you are tired and want to take the quick way

back to the trailhead at the Erbie Church, then just continue down this road—the trailhead is about 1.4 miles away, and it's all downhill! If you aren't finished hiking yet, and want to continue with the loop, then stay with me. It will be 2.2 miles back to the trailhead, for a total loop of 7.4 miles—it would be a total of 6.6 miles if you took the main road.

After about 800 feet, TURN RIGHT onto an old road at 5.4—it is blocked with large rocks, but there is no sign. It eases up the hill, then levels off for a short time, passes a spur that goes to the right up to an old homesite, and begins to drop down the hillside. This is all on an old roadbed. It passes under a powerline, and also by a wonderful display of worn out tires! The hill gets pretty steep and rocky at times, but you have a nice view of the opposite hillside across the River.

The trail makes a turn back to the left and goes through a pine woods on a little lesser grade at 6.2, then resumes its downward trend and finally comes out to a "T" intersection at 6.4. This is the old J.W. Farmer homeplace. There are several buildings here that are very well preserved. The cedar logs in the farm barn were recycled from the former Cherry Grove schoolhouse, which once stood across the River.

The trail that we have intersected is the Old River Trail that runs from Ponca to Erbie. This is the main horse trail through the area. If you turned right you would be going towards Camp Orr. We want to TURN LEFT at this intersection. An unusual spring house made out of wood is just up the trail—most are made of stone. The old road that we've been walking on continues straight ahead and slightly downhill, but we want to TURN LEFT off of the old road onto a level trail into the woods just past the spring house remains.

(By the way, at this intersection, if you would have followed the old road, it would cross the River, and take you to the Cherry Grove Cemetery, and the Parker-Hickman Farmstead area.)

The trail continues on the level between some "pancake" bluffs on the left and a field on the right. Then it swings away from the field, crosses a small stream, then makes its way up a hillside. And this hillside is the beginning of a large SSS. There are lots of slab rocks and wonderful old, twisted cedar trees everywhere. The trail does get a little steep though. It finally levels off at 6.7. There are some great views of the River and the fields along it at Erbie. There is one spot where you can veer off the trail and get a good look at the bluffs just ahead—these are called "Goat Bluffs," and they disappear into a deep pool of turquoise water below.

At 6.8 we come to a four-way trail intersection. To the right is the GOAT BLUFF TRAIL—it runs along on top of the bluffs for a third of a mile (some terrific views of the River, and lots of picture-perfect old cedars with Spanish moss hanging off of them around too—an SSS all the way), and finally drops down the hillside on a winding flight of steps to an old road that is next to the River. This site is called *Old Erbie*, which

is where the Erbie store and post office once stood. This road leads out to the Buchanan-Clagett farmstead, and is part of the Old Erbie Area Loop hike—see page 104.

BACK at the trail intersection on top of Goat Bluff, TURN LEFT to continue to the Cecil Cove Trailhead (straight ahead at this intersection is a road trace that is used by horses to get to the horse camp). The main trail runs pretty level through a cedar thicket with a large field off to the right. At 7.1 it comes alongside a rock wall. This wall, which is made from "slab" rock instead of the more traditional rounded-off stones, also has several fence posts incorporated into the design (they probably had barbed-wire fencing strung between them).

Soon the trail comes out onto the main road at 7.3. (This is the road that you would have taken if you took the short cut while back up on the hill.) TURN RIGHT and walk down the road, and by 7.4 you will come to the trailhead and will have finished the Cecil Cove Loop!

Old Erbie Area Loop Hike (1.8 miles)

This little loop is an easy and scenic stroll. It is about half road walking and half trail. It begins at the Cecil Cove Trailhead (see directions on page 98). Hike down the road in front of the church that leads to the River. (There is another road that takes off of this road to the left at the church—be sure to stay STRAIGHT AHEAD, heading downhill.) This road goes down to the Buchanan-Clagett farmhouse at .6 miles, a handsome structure that is just off of the road on the right. (Buchanan was killed "in the service of the Union," and his headstone is in the Cherry Grove Cemetery.) TURN RIGHT here and go through a cable gate across a farm road. (If you went straight on the gravel road you would end up at the Buffalo River.) NO DOGS on trails.

There is a large barn on the left. They say the builder of the frame house hung himself from the barn hay loft. There is also an old road tract that heads up the hill to the right, up to the horse camp. The road trace that goes straight ahead and on the level is the one you want.

This little lane, which is closed to cars, will take you next to a large field that runs along the River. If you are here early in the morning or late in the evening you'll stand a good chance of seeing some elk. Trust me, when you see one, you'll know what you are looking at! They are about the size of an adult cow or horse. The Arkansas Game and Fish Commission reintroduced them to the area several years ago and they are doing well. There may be a limited elk hunt someday, but mostly they are just here to keep us company. In the fall you might even get to hear them bugle. Lots of ticks in this area too!

At the far end of the field, the old road ends at the base of Goat Bluffs at .9, an SSS. This area is the site where the Erbie store and post office once stood, known as "Old Erbie." (The Old River Trail goes to

Old Erbie Area Loop Hike

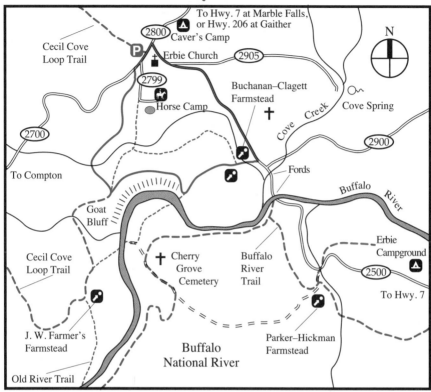

the left here, across the River, and eventually ends up at Ponca.) We want to pickup the Goat Bluff Trail straight ahead, which begins at the base of the bluffs. It leaves the bottomland via a flight of winding rock stairs that climb up onto the bluffs. This is a wonderful section—you get some great views of the River and bluffs, and there are lots of terrific old, twisted cedar trees around that have Spanish moss "beards." All of it is an SSS!

At the far end of the bluffs at 1.2 you'll come to a four-way intersection. The Cecil Cove Loop Trail comes in from the left (it is .4 miles to the J. W. Farmer Homestead that way—also known as the Farmer Trail). To the right is a horse trail on a road that leads through fields to a horse camp. We want to continue STRAIGHT AHEAD, on plain trail, which is also the Cecil Cove Loop Trail, towards the Cecil Cove Trailhead.

The trail runs pretty level, with a little rise now and then. It crosses a small stream, visits an unusual rock wall, and finally comes out on the Compton-Erbie road. TURN RIGHT on this road and it will take you a short ways back to the trailhead and the completion of the loop at 1.8.

Ponds Loop Trail

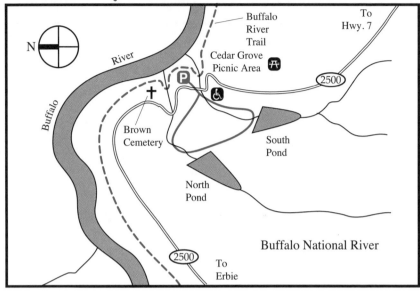

Ponds Trail (.4 miles total)

There is a small picnic area that is located on the road from Hwy. 7 to Erbie that is called Cedar Grove Picnic Area. There is a nice over-look of the Buffalo River there. Also the Buffalo River Trail comes right through it (at mile 21.2). And there are a couple of short trails that lead off to two ponds—South Pond and North Pond. These are very short trails, and one of them is wheelchair accessible. NO DOGS on trails.

To get to the trailhead, turn off of Hwy. 7 about 2.3 miles south of Pruitt onto NC#2500 at the Erbie Campground sign, then go two miles The parking lot is on the River side of the road (on the right), which is where the picnic tables and the overlook are located. The two trails take off across the road from the parking lot. The trail to the left (South Pond) is made of hard-packed gravel, and is accessible via wheelchair. This little trail runs nearly level for .1 miles out to the pond.

The trail to the right goes about the same distance to North Pond, but it is just a regular trail, not handicap accessible. There is also a trail that connects the two ponds, making a loop of about .4 miles. These are nice, clear little ponds. And a stroll to visit them is just the ticket to help work off that picnic lunch!

Koen Interpretive Trail

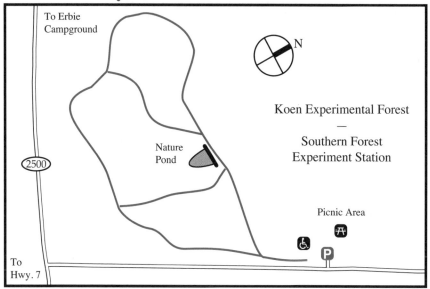

Koen Interpretive Trail (.5 miles)

If you are looking for a nice leisurely stroll through a variety of tree species, this is the trail for you. There are 34 different kinds of trees and other plants identified along this short loop. Wheelchair accessible. DOGS ARE ALLOWED on leash.

To get to the trailhead, turn off of Hwy. 7 about 2.3 miles south of Pruitt onto NC#2500 at the Erbie Campground sign, go less than a half mile on the dirt road and turn right. After a couple of hundred yards, turn left into the trailhead parking area. There are several picnic tables here, and there are also benches scattered along the trail. For more information on this trail contact, the Forest Service office in Jasper.

The Henry R. Koen Experimental Forest (U.S. Forest Service) was established in 1950 to develop scientific principles of forest management and to define and evaluate land management concerns in the southern region. There is a great deal of research going on in this tract of land. Mr. Koen is known as "the Father of Forestry" in the Ozarks. He was Supervisor of the Ozark National Forest from 1922—1939.

Pick up a trail guide that is available at the trailhead—it describes all of the plant species that are highlighted. These include: black cherry, winged elm, prickly pear, red mulberry, plume grass, common persimmon, boxelder, winged sumac, wild plum, honeylocust, sycamore, white ash, mockernut hickory, shortleaf pine, pitch pine, eastern redbud, black locust, black raspberry, buckbrush, Indian cherry, black walnut, eastern white pine, Virginia pine, sassafras, tulip poplar, loblolly pine, eastern redcedar, flowering dogwood, hackberry, chinkapin oak, summer grape, chokevine, blackberry, southern red oak.

Mill Creek Trail (1.5 miles)

This is a wonderful little trail that is located at the lower end of the Pruitt river access, just off of Hwy. 7 (between Jasper and Harrison). It is easy to walk and goes through a variety of forest and stream environments, not to mention a couple of historical spots.

The trailhead is on the north side of the River (turn right at the "Pruitt Access" sign, NC#3250). Go down to the access area and find the trailhead sign—park off to the left.

DOGS ARE ALLOWED (on leash).

The trail takes off level from the trailhead beside the Buffalo River. This is a nice, easy, level walk for the most part. It swings to the left and begins to follow Mill Creek, a quiet medium-sized creek. The trail runs through a pretty open bottomland hardwood forest. It rises up over a small bluff, then down to a trail intersection on the other side. The sign reads "Low water trail—turn right (across river), High water trail—straight ahead." The creek here is pretty wide, and usually you'll have to wade the shallow water. I would go straight ahead.

The trail continues alongside the creek until it comes to a dirt road—TURN RIGHT on the road and cross Mill Creek on a low cement bridge. Just across the other side, TURN RIGHT off of the road onto the trail again—there is a sign.

This section works its way downstream and gradually uphill, and heads up to the Shaddox cabin. This structure has actually been recycled. It was built using the logs from an old log home which stood near this site. Re-use of old buildings was characteristic of thrifty Ozarkers. The trail crosses in front of the cabin, and then works its way back down the small hill again. It swings through the forest and comes to a trail intersection—go straight and you'll end up back at the creek crossing. TURN LEFT for the continuation of the trail.

The trail goes through an old grown-up field, and under a power line, then back into the woods, and to another trail intersection. TURN LEFT, and a short spur leads up the hill to Shaddox Cemetery. This one is larger than most we will visit in the area. (Like many cemeteries within Buffalo National River, this one is private land.) Ezekiel Shaddox, the builder of the original log house, is buried in this cemetery.

To continue with the hike, go back down the spur to the main trail. This section gradually comes down off the hill, through the woods and back to Mill Creek, then turns right and heads back upstream alongside the creek. At one point, a step has been carved out of a giant tree that fell across the trail and embedded itself partway into the earth. Soon after, you'll reach the point where you might be able to wade across Mill Creek to the trail on the other side, but it is best to simply continue on back to the cement bridge and loop on back to the trailhead.

Mill Creek Loop Trail

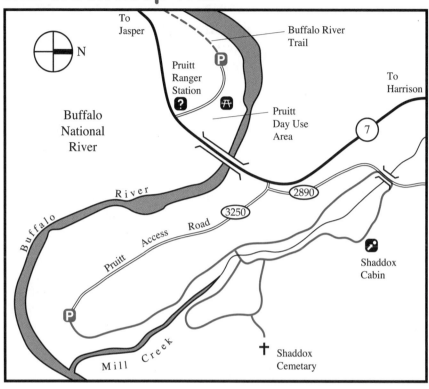

MIDDLE BUFFALO AREA TRAILS

Twin Falls Bushwhack
(no official trail)

Twin Falls is one of those spots that you hear a lot about, and see pictures of, but never know how to find. It is located in the Richland Creek Wilderness Area of the Ozark National Forest. Richland Creek flows into the Buffalo River at Woolum. There isn't a real trail into the area yet, but I hope there will be someday. DOGS ARE ALLOWED.

What I want to do is give you directions to get to the falls from two different areas. One is from the Richland Creek Campground. This is one of the most scenic hikes in the state, but you will have to wade across two pretty good sized creeks (not recommended in high water). The other way in is from Hill Cemetery, which is perhaps a more direct route, but much less scenic. Whichever route you take to the falls, I would recommend that you get a copy of the Moore quad map to take with you. The Forest Service also publishes a good map of the wilderness area that would do nicely too.

Hill Cemetery Route. There are several ways to get to Hill Cemetery, but this is the way that I go. From the community of Lurton on Hwy. 7 (located just north of the community of Pelsor), turn east onto Hwy. 123. Follow Hwy. 123 to the intersection with MC#5070/Forest Road #1200 (paved, then gravel). Turn right on Forest Road #1200, and follow it to NC#5080/Forest Road #1205—turn right on it too.

As this road drops sharply down a hill and begins to climb back out again, TURN RIGHT onto NC#5082. This is Iceledo Gap. It is a jeep/4WD road to Hill Cemetery—(very rough and may be 4WD only). There are a couple of different ways to get to the falls from here, but the following route is the way that I go in, and it seems easiest to follow.

(The other route is shown on the map as a dotted line—it also follows an old road most of the way, but you have to figure out where to leave it and bushwhack down to the falls—good for exploring.)

From the parking lot follow the old road downhill and off to the left of the Cemetery. It will soon cross a small creek. This is Big Devils Fork. Twin Falls is a "twin" because it's where two creeks come together and tumble off a ledge into a terrific pool below. The two creeks are Long Devils Fork, and Big Devils Fork. You should realize by now that if you simply followed this little stream that you just crossed downstream you would eventually come to the falls. You would be right, and that is essentially just what we are going to do. Only we're going to follow beside it on an old road that will be much easier hiking.

It is nearly three miles from the Cemetery to the falls. Most of the time we will be on the old road, which is following along beside the creek, out in the woods a ways. At one point the road swings away

Twin Falls Bushwhack (no official trail)

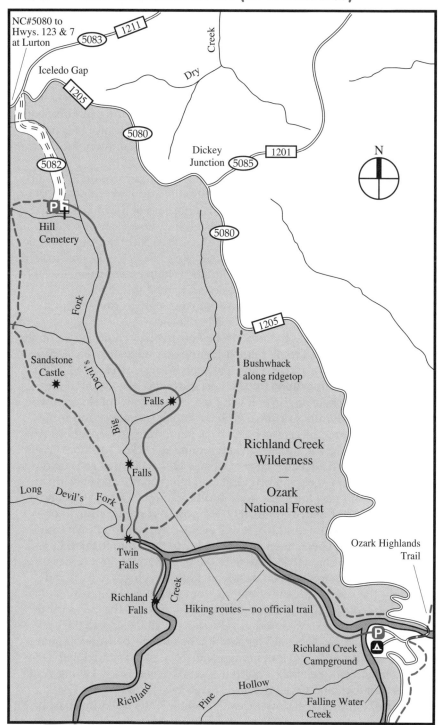

NC#5080 to Hwys. 123 & 7 at Lurton

1211

5083

Iceledo Gap

1205

5080

Dickey Junction

1201

5085

5082

P

Hill Cemetery

Dry Creek

N

5080

1205

Fork

Devil's

Sandstone Castle

Big

Falls

Bushwhack along ridgetop

Falls

Richland Creek Wilderness

—

Ozark National Forest

Long Devil's Fork

Twin Falls

Richland Falls

Creek

Hiking routes — no official trail

Ozark Highlands Trail

P

Richland Creek Campground

Richland

Pine Hollow

Falling Water Creek

from the creek and crosses another creek that has an impressive water-fall of its own on it.

Now here comes the only complicated part. The old road will eventually turn sharply back to the left and head up a steep hill. This is your signal that it is time to leave the road and bushwhack on down to the falls. Just veer off to the right when you feel that this is happening, and head downhill to the creek. Then turn left and follow it just a short ways to the falls. You can do this at any time during this hike—go down and follow the creek. There are a couple of other nice falls on the creek, including Hamilton Falls, named after Don Hamilton. And when you reach Twin Falls, you will know it—a major SSS.

Camping is allowed in the wilderness area, but *please* do not camp any where near the falls—this is a very fragile area and is already being "loved to death" by overuse. The pool at the base of the falls is a great swimming hole—but don't try to dive into it 'cause it isn't very deep. Downstream of the fall about a third of a mile is Richland Creek. While you are in here you might as well see Richland Falls too. Go to Richland Creek, turn right and go upstream for about half a mile. This falls isn't very tall, but it spans the entire creek and is quite impressive.

It's about three miles downstream to the campground—all of it fabulous scenery, with lots of swimming holes!

NOTE: There is another red-dashed bushwhack route shown on the map—this unnamred route follows the top of a ridge from NC#5080 down to the area near Twin Falls (part of it is on an old road trace).

Richland Campground Route. Lets start with how to get to the campground. There are several ways to get there too, but since we've already come in from Lurton, lets go back to the cemetery and come in that way. From the cemetery, go back out to Iceledo Gap and turn right. It will take you up the hill and around to Dickey Junction—the intersection with NC#5085/Forest Road #1201. This road goes on down to the Richland Creek Valley (at Eula, and the "Nars," and ends up at Woolum), and past the Stack Rock Trailhead on the Ozark Highlands Trail. After all of that, don't turn on this road—continue straight on NC#5080/Forest Road #1205. It will eventually take you down to and across Richland Creek, then just beyond turn right into Richland Creek Campground. (Some folks hike in to the falls from the "Wilderness Access" parking lot that you passed just before you got to Richland Creek—there is a trail part of the way, but then it gets rough.)

Once you are in the campground, go on down to the lower picnic area (on the right, now closed to vehicles). Go all the way to the back of the picnic area. There is a registration box there—be sure to sign in. OK now, stick with me. From that box there is a kind of trail that heads out following a creek that is off to the left. This is actually Falling Water Creek, *not* Richland Creek (Richland Creek joins Falling Water Creek a couple of hundred feet downstream). Falling Water will turn sharply

to the left in front of you. You want to get to the other side. Sometimes there are logs that you can cross on. Most of the time you will just have to wade.

Anyway, once on the other side, head up onto the top of the small hill just in front of you. There is a social trail that begins up on top. You should be able to look down to the right and see another creek—that is Richland Creek, and we are going to follow it upstream all the way to Devils Fork. This social trail isn't an official trail, and it is not marked or maintained, but if you follow it properly, it will get you to where you want to go, and you'll have a fine hike in the process.

This trail stays up high for a while, then goes down along the creek for a while, then back up again. At places it is a mess. And at other places it is the finest little trail in the state. All of the creek beside you is class A scenery—an SSS all the way. The only advice that I can give you about following this trail is this. Whenever you have a choice, take the *uphill* route. This trail does peter out in several locations, but by going up hill you'll always take the correct route.

Eventually the creek will take a sharp turn around to the left, or south. This is a ninety degree turn. There is an old campsite right in the middle of the turn. If you will go down to the bend in the river and look straight across it you will see another creek coming in. That is Devils Fork, and just upstream about a third of a mile is Twin Falls. Sometimes you can cross Richland a little upstream, on a series of rocks, but I've seen more folks fall in there than have gotten across dry. So you may have to wade.

Also upstream on Richland Creek, is Richland Falls, a 100 foot plus wide waterfall that spans the entire creek. When the water is low, there are several, much narrower falls here. And when it's warm, each one has a different temperature, so you can take your pick (which one to sit under). By the way, if you will be camping in this area, the best spot that I know of just above Richland Falls (*not* Twin Falls), and on the far side of the river. There is a wide level bench there.

I can only tell you that the Richland Creek Wilderness is one of the most scenic areas in this country. And I do mean in the entire United States. I have never seen anything else quite like it. I hope that you get to spend some time here. But I also hope that you spend that time wisely—don't build any fire rings, leave any trash, or in anyway disturb any part of this wonderful area.

**Another way to get to Richland Campground is from the community of Pelsor on Hwy. 7—take Hwy. 16 east from there, past the community of Ben Hur, then turn left onto Forest Road #1205 (a mile past Ben Hur), and follow it all the way to the campground.

Tyler Bend Trails

Tyler Bend is one of the main visitor facilities at Buffalo National River. There is a nice visitor center and museum there, as well as modern campgrounds, picnic areas, and canoe access. Tyler Bend is located just off of Hwy 65 between St. Joe and Marshall (just south of the bridge across the Buffalo). There are three trail parking areas—one just off to the left as you begin the drive down the hill to the Visitor Center, the Visitor Center itself, and just beyond the Visitor Center on the right, at the Amphitheater. DOGS *ARE* ALLOWED on all four trails here.

There are four short trails in the park, and all of them connect with the Buffalo River Trail (on its way from Woolum to Hwy. 65), and to each other. You can make several different lengths of loop hikes by connecting these trails. The trails are the River View Trail, the Spring Hollow Trail, the Buck Ridge Trail, and the Rock Wall Trail.

River View Trail

River View Trail to Collier Homestead Trailhead—1.4 miles
River View/Spring Hollow Trails Loop—2.9 miles
River View/Buck Ridge Trails Loop—3.8 miles
River View/Rock Wall Trails Loop—4.0 miles

I'll begin with the River View Trail, which begins right at the Visitor Center. It is certainly the most impressive, as it has some great views of the River valley (you probably could have guessed that). It visits the Sod Collier Cabin, and comes out at the Collier Homestead Trailhead. You have the option of making a loop hike out of it by connecting with any of the other trails.

The trail begins to the left of the Visitor Center, and takes off to the left into the woods. It drops down alongside one of the many large, open fields, and follows it. As you come to the end of the fields, you can look out through the cane and see the Buffalo River. At about .3 miles the trail crosses a little wood bridge that spans a small creek. The trail swings on around to the left, and begins a gradual rise up into a hollow, away from the River. You might look around here and try to imagine just how much work it took to build this trail—the hillside is very steep, yet the trail is nice and level to walk on.

The trail continues to ease on up the hill, then at .7 miles it drops down just a little and crosses a small creek, and then turns back to the right and continues to head up the hill. It swings back to the left, then tops out and levels off at .8 at a wonderful view point. This is one of the spots from which the trail gets its name! The view down to the River and upstream is just terrific. There are lots of old, twisted cedar trees hanging out here, many covered with Spanish moss.

At this spot the trail turns to the left and continues along the ridgetop, heading uphill. There are lots of views in this area, and lots

Tyler Bend Trails

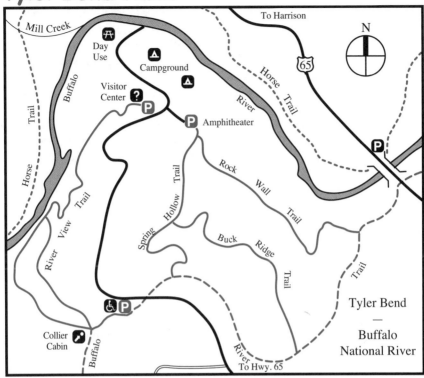

of Spanish moss hanging down on you. At .9.there is a trail intersection. One trail goes steeply up the ridge. This trail levels off on top at a developed overlook (which is wheelchair accessible) and comes out at the Collier Cabin. If you were just going to do this trail and return to the Visitor Center, I would certainly recommend that you take the main trail (TO THE LEFT) on the way up (it is less steep), then come back down the steep trail.

So turn left here, and continue on the main trail. It makes its way gradually up into the hollow, and eventually tops out at 1.3 at the Collier Cabin. This is a very well preserved structure, and like most of the homesites in the area, there are a lot of flowers and herbs surrounding the home in the spring and summer.

The Buffalo River Trail joins here—it goes straight ahead behind the cabin (it's about a half mile from the cabin down to the Calf Creek Road, then on to Woolum), and also to the left, where we will follow it. (If you wanted to loop back and go down the steep trail that we were at a minute ago, turn right at the cabin—the level section of this trail is wheelchair-accessible trail and has a nice River overlook.) Our main trail TURNS LEFT at the cabin and follows an old road across the top of the ridge to the Collier Homestead Trailhead at 1.4.

If you want to continue hiking from this spot and do a loop back to the Visitor Center, then continue from the Collier Homestead Trailhead across the paved road and into the woods—this will be on the Buffalo River Trail. In .4 miles you will intersect with the Spring Hollow Trail. Turn left and follow it .9 miles down the hill to the Amphitheater (you will intersect with the Buck Ridge Trail after .5 miles), then on around another .2 miles back to the Visitor Center. Your total loop this way would be 2.9 miles.

OR, from the Spring Hollow Trail intersection, continue along the Buffalo River Trail for .6 miles to the next intersection, which will be with the Buck Ridge Trail. Turn left and follow the Buck Ridge Trail to an intersection with the Spring Hollow Trail after .8 miles. Turn right and follow it .4 miles to the Amphitheater, then on around back to the Visitor Center. This would be a 3.8 mile loop.

OR, from the Buck Ridge Trail intersection, continue along the Buffalo River Trail .5 miles to the next intersection, which will be with the Rock Wall Trail. Turn left and follow the Rock Wall Trail down the hillside, along the rock wall and .9 miles to the Amphitheater, then on around back to the Visitor Center. This would be a 4.0 mile loop.

Spring Hollow Trail

> Spring Hollow Trail to Buffalo River Trail—.9 miles
> Spring Hollow/Buck Ridge Trails Loop—2.7 miles
> Spring Hollow/Rock Wall Trails Loop—2.9 miles

This is a fine trail that follows Spring Hollow, and the little stream in it, from the wide-open fields in the valley, up to the Buffalo River Trail at the top of the hill. The first .5 mile section is nearly level and is an easy hike. The next section climbs up the hillside. You can connect with the other trails in the park for a loop hike of up to 2.9 miles.

The trail begins at the Amphitheater parking lot, and makes its way off to the right as it enters Spring Hollow. The trail stays down in the bottom for a while, crossing a creek and passing by an old log structure. There is a long, narrow old field just across the way. At .5 miles it intersects with the Buck Ridge Trail, which goes to the left. TURN RIGHT and continue up Spring Hollow.

The trail crosses the small stream a couple of times—it is real moist in here, and there are a lot of delicate wildflowers along the way during the springtime. It swings back to the left and begins a pretty good climb out of the hollow. It makes a couple of sweeps across the nose of the hill, and finally intersects with the Buffalo River Trail. It is .9 miles back to the Amphitheater.

Turn right to take the Buffalo River Trail upstream to Woolum, to get to the Collier Homestead Trailhead, or to hike the River View Trail back to the Visitor Center. Turn left to take the Buffalo River Trail on to

Hwy. 65, or to loop back to the Amphitheater via either the Buck Ridge or Rock Wall Trails.

Buck Ridge Trail

Buck Ridge Trail to Buffalo River Trail—1.2 miles
Buck Ridge/Rock Wall Trails Loop—2.6 miles
This trail begins at the Amphitheater and follows the Spring Hollow Trail for the first .5 miles. It TURNS LEFT at the intersection, crosses a small creek, and then begins a winding climb up the hillside to Buck Ridge.

As it gets near the top, the trail swings to the right around Buck Point. Then it levels and heads out across a flat and over to the middle of Buck Ridge. From here the trail continues down the middle of the ridge, climbing up a small hill a time or two. It begins to swing around the head of a steep hollow to the right and intersects with the Buffalo River Trail.

Turn right at this intersection to take the Buffalo River Trail over to the Spring Hollow Trail, to the Collier Homestead Trailhead, or to take the River View Trail back down to the Visitor Center. Turn left if you want to take the Buffalo River Trail on to Hwy. 65, or to connect with the Rock Wall Trail and loop back to the Amphitheater.

Rock Wall Trail

Rock Wall Trail to Buffalo River Trail—.9 miles
This neat little trail heads out from the Amphitheater across the right side of the large open field that sprawls out to the Buffalo River. It heads into the woods and soon comes alongside a wonderful example of a pioneer wall—built by the early settlers of the area from the rocks that they had cleared from the field. This rock wall, though not particularly tall or sturdy, is one of the longest rock walls that I know of along a hiking trail. The only longer one is up on Hare Mountain on the Ozark Highlands Trail.

The trail follows the rock wall for a half mile. Along the way you'll find lots of wildflowers in the springtime, and near the end of it there are a couple of nice bluffs. Just as the trail gets to the end of the wall, it veers off to the right, then crosses a creek and begins a long climb up the hillside. About halfway up the hill, right in an opening, the trail turns sharply back to the left. As it nears the top of the hill and the end of the ridge, the trail turns back to the right, goes through a low spot in the ridge (a "saddle"), and drops down to an intersection with the Buffalo River Trail.

Turn right at this intersection to take the Buffalo River Trail on to Woolum, or to connect with any of the other trails in the park. Turn left to take the Buffalo River Trail to Hwy. 65 and the Grinders Ferry TH.

Ozark Highlands Trail (Section Eight—20.9 miles)

The 164-mile Ozark Highlands Trail (OHT) is one of the most scenic trails anywhere. A recent survey of *Backpacker* magazine readers rated the OHT as the number one hiking trail in the United States! It begins way over on Hwy. 71 at Lake Ft. Smith State Park near Mountainburg, runs across the Ozark National Forest, and ends up at the Buffalo River, across the River from Woolum (connecting with the Buffalo River Trail there). It took twelve long years to build this trail, and a lot of it was constructed by volunteers. Members of the Ozark Highlands Trail Association have contributed over 300,000 hours!

Here is the master plan. The OHT is just the first section of a monster trans-Ozarks trail system that will cross Arkansas and link up with the Ozark Trail that is being built across Missouri. With all of the side and connecting trails along the way, this system will total nearly 700 miles! The Buffalo River Trail is a big part of this system, and the section from Woolum to Hwy. 14/Dillards Ferry is now part of it. Other sections will be built around the Leatherwood Wilderness on the Sylamore District of the Ozark National Forest (finished!), and all the way around Lake Norfork to the Missouri border (under construction). Boy, I only hope that I'll be able to walk that far when we finally get all of it built!

The OHT is divided up into eight sections, the last one being from Richland Creek Campground to Woolum, where it connects with the Buffalo River Trail and continues on to Tyler Bend and Hwy. 65. Together, there is 190 miles of continuous trail! There is also 17 miles of loop and spur trails that connect with the main OHT, including the popular Shores Lake to White Rock Mountain Loop. All of this is described in its entirety in my 136-page *Ozark Highlands Trail Guide*. If you want to hike this trail, you really should pick up a copy of this book (see page 159 to order). It will take you by the hand and lead you every step of the way. Below is a very brief description of section eight of the trail from Richland Creek Campground to Woolum.

This stretch of the OHT is one of the least used, but is one of the most scenic, especially during leaf-off seasons. The trail leaves the campground and follows Richland Creek downstream from up on the hillsides. It visits many SSS hollows choked with moss-covered boulders and small waterfalls.

It climbs up and over a ridge to the Stack Rock Trailhead, then drops down into the Dry Creek drainage, revealing many spectacular views down the Richland Valley to the Buffalo. It passes through the Buffalo Wildlife Management Area, which contains the largest concentration of black bear in Arkansas (and a few elk too). It finally joins a little-used road and runs through the lower Richland Creek Valley, ending just across the River from Woolum. DOGS ARE ALLOWED.

Ozark Highlands Trail (Richland Cr. to Woolum)

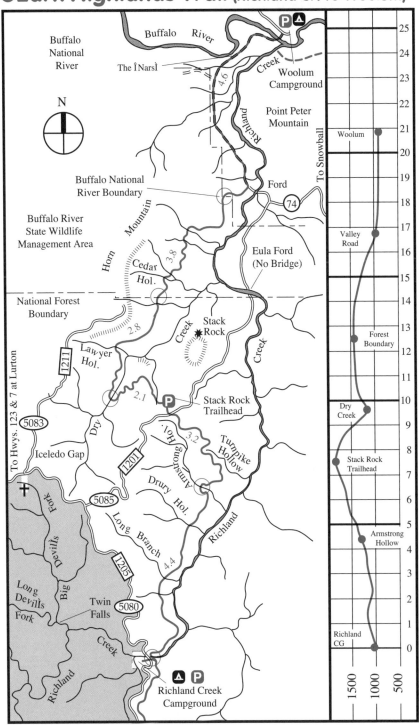

Buffalo National River

Buffalo River

The ÎNarsÌ

4.6

Creek

Woolum Campground

Point Peter Mountain

To Snowball

N

Buffalo National River Boundary

Ford

74

Buffalo River State Wildlife Management Area

Horn Mountain

3.8

Cedar Hol.

Eula Ford (No Bridge)

National Forest Boundary

Creek

Stack Rock

2.8

Lawyer Hol.

1211

2.1

P

Stack Rock Trailhead

Creek

To Hwys. 123 & 7 at Lurton

5083

Iceledo Gap

Dry

1201

3.2

Armstrong Hol.

Turnpike Hollow

5085

Drury Hol.

Richland

Long Branch

4.4

1205

Big Devils Fork

Long Devils Fork

Twin Falls

5080

Creek

Richland

Richland Creek Campground

Woolum — 21

Valley Road — 17

Forest Boundary — 13

Dry Creek — 10

Stack Rock Trailhead — 8

Armstrong Hollow — 4

Richland CG — 0

25
24
23
22
21
20
19
18
17
16
15
14
13
12
11
10
9
8
7
6
5
4
3
2
1
0

1500 1000 500

119

Buffalo River Trail—Lower Section

The Lower Section of the Buffalo River Trail (BRT) is in the Middle and Lower River Districts and runs 43.6 miles from Woolum to Hwy. 14/Dillards Ferry Trailhead. It is presented here in three sections: Woolum to Grinders Ferry/Hwy. 65 Trailhead (page 122), Grinders Ferry/Hwy 65 Trailhead to South Maumee Road (page 130), and South Maumee Road to Dillards Ferry/Hwy 14 Traihead (page 144). An extension downstream through the Lower Buffalo Wilderness may be built in the future (currently it's just a bushwhack route). NO DOGS.

All of these sections are considered part of the Ozark Highlands Trail (OHT) which runs from Lake Ft. Smith State Park to Woolum (164 miles). One day the trail will extend to the Missouri Border and connect with the Ozark Trail across Missouri to create the 700-mile Trans-Ozarks Trail.

Camping is allowed along the trail (out of sight please!) and down on the River gravel bars (LEAVE NO TRACE!), at Grinders Ferry (gravel bar), and at two small primitive campgrounds at South Maumee and Spring Creek (both off of the trail).

Trail Point	Mileage Downstream	Mileage Upstream
Woolum	0.0	43.6
Point Peter Mountain	1.2	42.4
Ben Branch	3.5	40.1
Dave Manes Bluff	4.0	39.6
Hage Hollow Creek	6.1	37.5
Whisenant Hollow Bluffs	7.3	36.3
Tie Slide	9.2	34.4
Calf Creek	12.3	31.3
Collier Homestead Trailhead	13.1	30.5
Tyler Bend VC (via spur)	14.5	29.9
Grinders Ferry TH/Hwy. 65	15.0	28.6
Long Bottom Road	16.6	27.0
Illinois Point	16.9	26.7
Amphitheater Falls	17.7	25.9
Gilbert Overlook	19.1	24.5
Bear Creek	20.8	22.8
Zack Ridge Road Trailhead	**21.6**	**22.0**
Brush Creek	22.7	20.9
Red Bluff Spur Trail	23.5	20.1
Red Bluff Road Trailhead	**26.1**	**17.5**
Rocky Creek	28.0	15.6
Little Rocky Creek	29.3	14.3
Pileated Point	29.5	14.1
Hoot-Owl Hollow	30.7	12.9
Saw-Whet Owl Falls	31.0	12.6
South Maumee Road TH	**32.3**	**11.3**
Maumee Falls	33.2	10.4
Spring Creek	35.6	8.0
CR#99 (Spring Creek Road)	37.6	6.0
Kimball Creek	41.0	2.6
Hwy. 14 (Dillards Ferry)	43.6	0.0

Buffalo River Trail—Woolum to Grinders Ferry/ Hwy. 65 Trailhead (15.0 miles)

Trail Point	Mileage Downstream	Mileage Upstream
Woolum	0.0	15.0
Point Peter Mountain	1.2	13.8
Ben Branch	3.5	11.5
Dave Manes Bluff	4.0	11.0
Hage Hollow Creek	6.1	8.9
Whisenant Hollow Bluffs	7.3	7.7
Tie Slide	9.2	5.8
Calf Creek	12.3	2.7
Collier Homestead Trailhead	13.1	1.9
Tyler Bend VC (via spur)	14.5	1.3
Grinders Ferry/Hwy. 65 TH	15.0	0.0

This section of the Buffalo River Trail (BRT) is a sleeper trail—it has some tremendous scenery, but because access to the upper end is limited, it won't get a great deal of use. It begins in the Richland Creek Valley at the original terminus* of the Ozark Highlands Trail (OHT), runs across the tops of many bluffs that overlook the River, goes near Tyler Bend campground, then across Hwy. 65 to the Grinders Ferry Trailhead. The trail continues downstream for another 27 miles to Dillards Ferry at Hwy. 14. NO DOGS.

*The BRT from this point downstream to Dillards Ferry/Hwy. 14 is now shared with the OHT, so you may see it labeled as BRT/OHT or OHT/BRT, but they are both the same trail. It's blazed white here and there, yellow blazes are for horse trails.

Getting to the beginning of this section can be a bit of a challenge. The easiest way is to go to the Woolum access on the River (turn off of Hwy. 65 at Pindall or St. Joe to get there). This area has primitive campsites and canoe access. Then you have to wade the Buffalo River. It is a wide crossing, that can be anywhere from knee-deep to over your head—and is **extremely dangerous to cross during high water**. Most of the time it is about waist deep. If you are lucky, you can talk someone with a canoe there into running you across. If you do, have them ferry you downstream of where Richland Creek comes in—this will save you having to wade it too. If you wade the Buffalo, it is shallower to go across right where the road does, instead of trying it below Richland.

The only other way to get to the beginning of this section, is to drive in from the other end of the Richland Valley, on a dirt road. If you come in from Snowball, you'll have to ford Richland Creek once. If you

Buffalo River Trail (Woolum to Grinders/Hwy. 65)

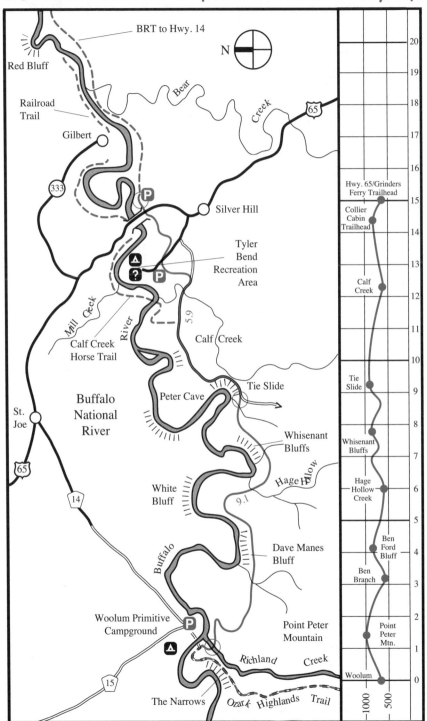

BRT to Hwy. 14

Red Bluff

N

Railroad Trail

Bear

Creek

65

Gilbert

333

P

Silver Hill

Tyler Bend Recreation Area

Mill Creek

Calf Creek Horse Trail

River

5.9

Calf Creek

Buffalo National River

Peter Cave

Tie Slide

St. Joe

65

14

White Bluff

9.1

Whisenant Bluffs

Hage Hollow

Dave Manes Bluff

Buffalo

Point Peter Mountain

Woolum Primitive Campground

P

15

Richland Creek

The Narrows

Ozark Highlands Trail

Hwy. 65/Grinders Ferry Trailhead — 15

Collier Cabin Trailhead — 14

Calf Creek — 12

Tie Slide — 9

Whisenant Bluffs

Hage Hollow Creek — 6

Ben Ford Bluff — 4

Ben Branch

Point Peter Mtn.

Woolum — 0

-1000 -500

20
19
18
17
16
15
14
13
12
11
10
9
8
7
6
5
4
3
2
1
0

come in from the Richland Creek Wilderness area, you'll have to ford Richland Creek twice. No problem either way, unless there is a lot of water in Richland!

A lot of this section of trail is on old roads, and there are a lot of intersections with other roads, as well as with the main horse trail in the area. It can get a little confusing at times. Be sure to keep an eye out for directional signs, and follow them.

So OK, here we go. This section begins just across the Buffalo from Woolum. The Ozark Highlands Trail ends here—if you continued on this road to the right you could hike 164 miles of trail, all the way to Lake Ft. Smith State Park on Hwy. 71. You want to go across Richland Creek. It is usually knee-deep or less, but often dry in the summer. Then cross the large field and head for the trail on the other side. This crossing is a couple hundred yards upstream from the mouth of Richland.

The trail leaves the valley at .2, and heads *up* the hillside on some steps. It is pretty steep for a little while, and the trail switchbacks to the left. It eventually levels off somewhat, and you are looking right down on the River. The views, especially during leaf-off, are good. There is an SSS view at .5. Just beyond, the trail swings back to the right, away from the River. It works its way up and along the top of the ridge. This is part of Point Peter Mountain.

As the trail levels off on top at 1.0, there are several sinkholes next to the trail. Must be a cave around somewhere. It crosses a seep, and continues on the level, across the wide hilltop. At 1.2 there is an intersection. The trail/road to the right is a horse trail, and swings back down to Woolum. There are two trails/roads to the left that you can take. The one on the left is level and again is a horse trail. The one on the right, which goes uphill just a little, is also a horse trail, but is not the one you want. So at the intersection, TURN LEFT and then TURN LEFT again (follow the sign).

The trail stays on the old road for a while, and pretty much just makes its way around Point Peter Mountain, staying up high . There are some good views along here during leaf-off, and an old homesite or two, plus an old car body, complete with tail fins. The trail runs along fairly level, with some up-and-downing. Then at about 2.7, it turns to the left, and begins a plunge down towards the River.

It does get steep at times—aren't you glad you're hiking it downhill! When you reach the bottom and level out, you come next to a nice little bluff-lined stream at 3.4. This is a minor SSS. You stroll along this pleasant creek, 'til you cross it at 3.5. This is Ben Branch.

Just around the corner there is an intersection. The main road heads uphill to the right. There is a lesser road that takes off to the left, down towards the River. There is also a path that goes STRAIGHT AHEAD and level—this is the one you want. After less than 100 feet, TURN RIGHT and you will be on good old plain American hiking trail. Yea!

Old roads are a great way to get around these hills, but nothing beats properly constructed trail.

The trail heads up a small drainage, and gets a little steep as it swings back to the left. It levels off shortly, and from here on for a while it is just a wonderful hike. As it swings around to the right, there is a spur trail at 4.0, that leads a few feet out onto the edge of Dave Manes Bluff. This is the first of many SSS views that you have. The River sprawls out below you in both directions (White Bluff looms above the River downstream). There are fields as far as you can see. And the immediate area around you has lots of craggy bluffs. It's time to drop your pack and take a break.

From the viewpoint, the trail continues along the top of the bluffline. There are lots of nice views. At 4.4 a road comes near the trail off to the right. There is an old field out there too. Just beyond, there is an unofficial spur trail to the left that leads out onto a "slice" of bluff—another SSS. The trail stays along the edge of the hillside for a little while longer, then swings back to the right, and leaves the River behind. It heads up a hollow, right next to a nice field on the right. It leaves this field, then comes alongside another, smaller one. At 4.8, just as the field ends, the trail intersects with a road—TURN LEFT on this road.

This begins another road section, but at least this part of the road is moss-covered. There is a lesser road that takes off to the right just ahead, but ignore it. At 5.1 there is a fork in the road—take the RIGHT HAND fork. It runs along on down the hillside to the bottom, where it comes out into a giant valley at 5.5, and another road. TURN RIGHT, and continue on the valley road. There is a wooden gate to the left, and an old car body to the right. At some point, you will be able to see some massive bluffs on downstream—these are located at Whisenant Hollow, and the trail runs on top of them at 7.3.

At 6.0 you need to TURN LEFT onto a road (the Slay family cemetery is hidden down a ways). Just down this road is where you will get back on "real" trail again—it takes off to the right. The trail crosses through the bottomland, across Hage Hollow Creek, then begins to work its way up a small hollow. It crosses this little stream several times. At 6.3 it joins an old, narrow, grown up road and heads steeply uphill. At 6.5 the trail leaves the road TO THE LEFT, and continues out through the woods, but still climbing.

It switchbacks a time or two, and finally, at 6.7 it swings over to the edge of the hillside, and overlooks the River at an SSS. It's a great view, and especially of those giant bluffs that are now much closer. The trail eases up the hill, levels off, then begins to descend. It lands at another SSS view, then continues *down* the hillside.

At 7.1, the trail crosses Whisenant Hollow, which is a small stream, then heads up the other side. It gets real steep as the trail switchbacks to

the right, then to the left (if its real wet, you may hear and see a waterfall off in the woods). At 7.3 all is well again, as the trail has leveled off, and there is a spectacular view—you are now standing on those massive bluffs that you've been looking at.

And this is just the beginning. There are three SSS viewpoints right in a row. Each has a little different view of the bluffs and the world below. These bluffs are typical Buffalo River bluffs—a sheer face of solid limestone, painted with shades of gray and black and white, disappearing down into the forest below. Makes me wish I had wings.

The trail begins to drop off the hill a little, swings to the left, and then back to the right at 7.7. At this corner there is one last SSS view of the bluffs. From here the trail continues to drop down the hill, crosses a small creek, then runs up a short hill and turns to the right.

At 8.2 the trail goes across a dirt road and continues into the woods, veering off to the right some. A vast field comes into view off to the left, and the trail stays in the bottom for a while. There are a couple of unusual, eroded areas next to the trail. At 8.7 the trail TURNS RIGHT up a gravel creek bottom, then leaves the creek and heads up the hill to the left.

It climbs up the hillside, swings back to the left, then back to the right. The last part gets steep, but during leaf-off a view opens up to help you manage the stress. The trail runs along the top of the ridge, veers away from it for a little while, then back to it. The trail runs just on the left side of the hill, and the views keep getting better.

At 9.2 is an SSS view that it is a historical spot too—the "Tie Slide." Way back when, as the mighty white oak trees in this area were being cut down to be made into railroad ties, this spot was used to "slide" the logs, down along a cable, to the gravel bar below. It must have been an impressive sight, but I sure do like the way things look now. If you need to take a break, wait just a few more minutes.

Right past the Tie Slide, the trail hits a road—TURN LEFT on this road. You will be on this road all the way to the Tyler Bend area. The road swings to the right, away from the River for a short distance, then rejoins the edge of the hillside. And at 9.7, there is a cleared trail spur off to the left—this is where you need to stop and take a break—for it is a terrific SSS area!

In my humble opinion, this is one of the ten best views on the River. Craggy bluffs, twisted cedars, the River and valley below stretching out forever. Yea, its an SSS alright. A place I plan to return many times. And down below, somewhere among the crags, is Peter Cave (closed from March 15th to October 15th to protect endangered gray bats). Enjoy this view, 'cause there aren't many more views of the River for a while.

From here the trail remains on the road, and runs along level. During leaf-off, you may be able to look out to the right and see the Calf Creek drainage. You'll be crossing Calf Creek in a few miles. At 10.3 the

road forks. The left fork will take you down towards Cash Bend on the River. You want to take the RIGHT FORK for the main trail. There are several lesser roads that intersect with the one you are on— stay on the main road.

By 11.3, the trail hits bottom and begins a long, level walk through several grown-up farmsteads. There is a pond on the right. In the late and early spring the honeysuckle perfume makes this a very pleasant hike. There is a hill and bluff off to the left that come into view—you'll be climbing up that hill shortly. The bluff is up on the River View Trail at Tyler Bend.

You'll pass the remains of the Arnold house at 12.0. Then Calf Creek appears below the road on the left. You get a good look at the hillside you're about to climb up to. At 12.3 you cross Calf Creek. This is a wide, gravel-bottomed crossing, that is usually about mid-calf deep (but can get much deeper).

Past the creek, the road winds through a wonderful field. This was the last section of trail that I did for the first edition of this guide. It was late in the day, in mid-May when I did it. The sun was low and golden. The field was full of purple flowers, and bright green hay, and the air was alive with a hundred of those small butterflies. It had been a long day, indeed a long several months of gathering information for this book. And I think that the field knew that my hiking was coming to an end (for now). It wanted to bid a fond farewell, and this pastoral scene was just the trick. I just had to pause, and soak up all the beauty, one more time.

But you're not finished hiking yet, so lets continue through to the end of the field. Just as the road enters woods again at 12.5, the trail, and I do mean just trail, TURNS LEFT, and heads up the hillside into the woods. It climbs on *up*, and there is one great view of the Calf Creek Valley. At 13.0 it comes to the Collier Homestead, and connects with the River View Trail, which goes 1.5 miles to the Tyler Bend Visitor Center. To continue with the Buffalo River Trail, TURN RIGHT.

The trail goes over to the Collier Homestead Trailhead (this part is wheelchair accessible) at 13.1. You are now in the Tyler Bend area. There are four short trails in the park, and all of them connect to the Buffalo River Trail. For a complete description of these trails, see page 114.

From the trailhead, the Buffalo River Trail crosses the paved entrance road to the park, and continues out into the woods. It intersects with the Spring Hollow Trail at 13.5 (turn left for it). The main trail GOES STRAIGHT. It gradually climbs up to and around the head of a hollow, and comes to the Buck Ridge Trail at 14.1 (turn left for it). The main trail TURNS RIGHT and heads across the head of another hollow.

At 14.6 it comes to the Rock Wall Trail (again, turn left for it). The main trail GOES STRAIGHT, and heads down the hillside towards Hwy. 65. Before it gets there, it makes its way down the hill some, pass-

es under a powerline, then drops down to and across a small stream twice, and finally comes out at the end of the Hwy. 65 bridge over the Buffalo. The main BRT/OHT continues through a giant culvert under Hwy. 65 (if frozen BE CAREFUL!!!—perhaps detour up to the highway and down the other side). From the culvert the trail runs mostly level out to and across the Grinders Ferry access road and Trailhead, ending this section of the trail at 15.0.

The BRT/OHT continues downriver on the following pages to Dillards Ferry at Hwy. 14.

Another possibility for a hike in this area is to combine the trails at Tyler Bend, the BRT, and the Calf Creek Horse Trail that connects the Hwy. 65 bridge to Calf Creek along the north side of the Buffalo River. Begin your hike at the Amphitheater Trailhead at Tyler Bend, hike up to the BRT on one of the trails there, then take it to the Hwy. 65 bridge. From there you can hike on the horse trail over to Mill Creek, then follow this little creek downstream to the Buffalo—you will have to wade the Buffalo River here, so it is best to do this hike in the summer when it is low. This will take you into the day use area at Tyler Bend, and then back to the Amphitheater Trailhead.

You can also follow this horse trail further on upstream on the Buffalo, past Calf Creek, then connect with the BRT there, and return to Tyler Bend from the west. This would be a longer hike of course, and you would still have to wade the Buffalo.

The horse trail is drawn in on both the Tyler Bend (page 115) and BRT (page 123) maps. Check with the good folks at the Tyler Bend Visitor Center for other possibilities.

NOTES:

Buffalo River Trail—Grinders Ferry/Hwy. 65 to South Maumee Road (17.3 miles)

Trail Point	Mileage Downstream	Mileage Upstream
Grinders Ferry/Hwy. 65 TH	0.0	**17.3**
Long Bottom Road	1.6	15.7
Illinois Point	1.9	15.4
Amphitheater Falls	2.7	14.6
Gilbert Overlook	4.1	13.2
Bear Creek	5.8	11.5
Zack Ridge Road Trailhead	**6.6**	**10.7**
Brush Creek	7.7	9.6
Red Bluff Spur Trail	8.5	8.8
Red Bluff Road Trailhead	**11.1**	**6.2**
Rocky Creek	13.0	4.3
Little Rocky Creek	14.3	3.0
Pileated Point	14.5	2.8
Hoot-Owl Hollow	15.7	1.6
Saw-Whet Owl Falls	16.0	1.3
South Maumee Road TH	**17.3**	**0.0**

This is a continuation of the Buffalo River Trail (BRT/OHT) from the Grinders Ferry Trailhead (Hwy. 65) to the South Maumee Road Trailhead (completed in 2020). There are lots of amazing views, several nice waterfalls, and a few steep climbs that will make ya wish you'd cut that toothbrush in half! There are also a couple of large creeks to cross that could be dangerous during high water so plan accordingly—Bear Creek and Brush Creek. Blazed white, NO DOGS.

The trailhead is located just off of Hwy. 65 between Marshall and St. Joe (and just down the road from the Tyler Bend area). Grinders Ferry is also one of the major canoe access points on the River so you'll find a lot of traffic there. GPS 35.98420, -92.74422

The trail leaves the parking lot to the RIGHT of the rest rooms, heads up a short spur trail that leads to the main trail, then TURNS LEFT onto the BRT/OHT. It heads off mostly level through the woods and passes a small food plot on the left. It keeps going straight, and then at .1 we merge with an old road that comes down from the right. We just continue straight ahead, easing down the hill along the road next to the food plot/old field.

The old roadbed swings around to the right just a little bit, and at .3 down on the left is the foundation of the Grinder's home site (the folks who operated the ferry in the 1800's). From there the trail is still on the

Buffalo River Trail (Grinders Ferry to S. Maumee Rd)

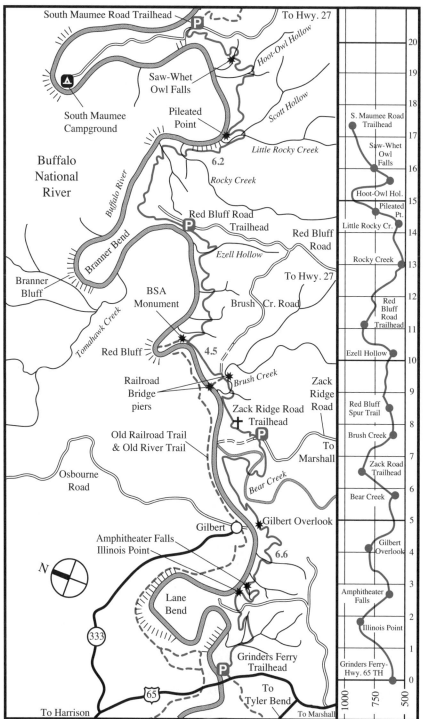

South Maumee Road Trailhead
To Hwy. 27
Hoot-Owl Hollow
Saw-Whet Owl Falls
South Maumee Campground
Pileated Point
Scott Hollow
Little Rocky Creek
Buffalo National River
6.2
Rocky Creek
Buffalo River
Branner Bend
Red Bluff Road Trailhead
Red Bluff Road
Ezell Hollow
Branner Bluff
BSA Monument
To Hwy. 27
Brush Cr. Road
Tomahawk Creek
Red Bluff
4.5
Zack Ridge Road
Railroad Bridge piers
Brush Creek
Zack Ridge Road Trailhead
Old Railroad Trail & Old River Trail
To Marshall
Osbourne Road
Bear Creek
Amphitheater Falls
Illinois Point
Gilbert
Gilbert Overlook
N
Lane Bend
333
Grinders Ferry Trailhead
65
To Tyler Bend
To Harrison
To Marshall

S. Maumee Road Trailhead
Saw-Whet Owl Falls
Hoot-Owl Hol.
Pileated Pt.
Little Rocky Cr.
Rocky Creek
Red Bluff Road Trailhead
Ezell Hollow
Red Bluff Spur Trail
Brush Creek
Zack Road Trailhead
Bear Creek
Gilbert Overlook
Amphitheater Falls
Illinois Point
Grinders Ferry- Hwy. 65 TH

20
19
18
17
16
15
14
13
12
11
10
9
8
7
6
5
4
3
2
1
0

1000
750
500

road and continues to curve back to the right and begins to work itself downhill slightly and up into a side drainage. Pretty soon the trail levels, passes a small pond on the left and then continues on over to and across a creek at .4.

The trail follows the little creek up into Goodhue Hollow, crossing small forks of it a couple of times as it works up into this side drainage. By .8 the trail is easing up the hill a little more aggressively, above the creek that's down on the left. At 1.0 we turn to the LEFT and switchback across the creek.

From the creek crossing, the trail eases uphill and swings to the right towards the top of the ridge, passing through a thick grove of cedar trees, and leaf-off views begin to open up a bit. We continue across the ridge to the right and then back to the left, straighten out, and cross Long Bottom Road at 1.6. (This road goes to the left down to Lane Bend, and to the right back out to Hwy. 65 at Silver Hill.)

The trail continues on the other side of the road and levels out along the left side of a ridge. During leaf-off you get some real nice views back to the left towards Lane Bend, and also out to both Pilot and Boat mountains in the distance. It's really steep below you, looking straight down towards the River—this stretch is kind of a moving SSS. And then we come out to Illinois Point overlook at 1.9, a great SSS looking both up and downstream and across towards the community of Gilbert. (A group of volunteers from Illinois built much of this section of trail, hence the name.)

From the overlook, the trail switchbacks to the RIGHT and begins a descent across the steep hillside down into a hollow. At 2.0 the trail levels off and swings to the left around the head of this small drainage above one of the small prongs (usually dry). It crosses a small road and continues over to the edge of a major powerline right-of-way at 2.3 (you can look all the way down to the River). The trail switchbacks TO THE LEFT just before you enter the opening and heads back into the hollow you just left.

The trail drops down the hill and works its way back into the hollow (across the little road again), and at 2.4 it crosses the hollow in two spots. If there is a lot of water flowing then you're in for a nice treat at the bottom of the hill. The trail swings back to the right and continues to cut across very steep hillside working its way quickly downhill above the little creek below to the right. The trail gets a little closer to the creek and at 2.5 down to the right is the top of a waterfall. It's extremely dangerous there, so stay away from the top—the trail will take you to the bottom in a few moments for a much safer view!

The trail continues down and comes to the edge of that same powerline. TURN RIGHT and head downhill and curve around away from the powerline and soon you will arrive near the bottom of the waterfall at 2.7, which is located just over a little gravel hump on the right. This is

Amphitheater Falls, 47', a major SSS. Hum, time for a snack break.

From the bottom of the waterfall, the trail swings away to the LEFT and follows the creek downstream (you'll be in the creek or just up on the right hillside—the trail may be sketchy through here), then back to the powerline, which may be pretty grown up. Go across the powerline and at the end of the right-of-way the trail leaves the creek to the RIGHT on good trail and heads upstream on another side creek—Boone Hollow. Follow this until it crosses the creek at 2.8 at a little limestone slide. There's a nice little waterfall and you cross just above that.

On the other side, the trail curves back to the left, mostly on the level and follows the creek downstream towards the Buffalo River. The trail swings to the right and goes across a steep hillside. The trail drops down the hill just a little into the bottom near the River on a little bit of a bench to 3.0. At this point you are just upstream from Gilbert.

At 3.1 we bump up the hill just a little to a small bluff on the right, then the trail switchbacks to the RIGHT just below that bluff and heads up a side drainage and away from the River, slightly uphill. Soon the trail crosses that creek, switchbacks to the left, and begins one of the more difficult climbs in this first section.

Switchback to the right. Switchback to the left. Switchback to the right. Continue pretty steep. Switchback to the left, continue up but not quite as steep. In fact, it kind of levels off a bit and goes around the nose of the ridge where you can see Gilbert, also it's straight down to the River. At 3.5, still up on the hillside and mostly level, we turn away from the River and work up into another drainage.

By 3.7, the trail has worked its way downhill just slightly to and across a little creek and there's a neat little stair-step waterfall there. And then the trail switchbacks to the left going back uphill, though not nearly as steep as the last drainage. We come up to the nose of a ridge, curve around to the right, slightly uphill. At that curve you have another good look across at Gilbert. Then we work our way back to the head of a little hollow and level off at 4.0.

The trail continues, actually easing on down the hill just a little bit across a steep hillside. Then we come out to the nose of another ridge and curve around it. It's a pretty good view from up there, especially during leaf-off—Gilbert Overlook. At 4.3 we're continuing mostly level across a very steep hillside, dropping down the hill just a little bit. Pretty nice, easy trail, good views.

At 4.5 we intersect an old road and we continue going STRAIGHT down the hill on the roadbed. It gets pretty steep going downhill. But just a couple a hundred feet down the road intersects with another one. TURN LEFT heading downhill (still on old road). There's a bunch of yucca plants on either side of the turn.

At 4.6 the road makes a sharp switchback to the RIGHT and down the hill. The old road bed that goes straight ahead is where the old

River crossing via ferry was, but we want to switchback to the RIGHT. The Buffalo River is kind of right in front of us and down below, and we're headed back downstream. Quickly the road levels off, and we stay on this roadbed in the bottom straight and level.

At 4.9 there's a historical landmark in the middle of the trail/ road—an old washing machine tub! Just beyond the tub we head uphill on the old road bed. At 5.0 we're still on the roadbed. It's kind of easing up. Continue on the road, slightly uphill, then it levels off.

The Buffalo River has been off on our left, out through the trees, but soon the trail/road gets rocky, and we turn away from the River to the right, and begin to head downhill just a little bit, eventually leaving the old road behind. We begin to work our way up the Bear Creek drainage, and come alongside this beautiful stream at 5.3. Some nice big boulders along the edge. SSS for sure!

We continue along the bank of Bear Creek on the level sandy trail through a thick stand of river cane. At 5.5 the trail veers to the RIGHT away from the creek and cuts across the flat and into the woods. It eases uphill a little bit, goes up and over a little rise, then starts to drop down back to the creek next to a small bluff line on the right, soon leveling off back next to Bear Creek. At 5.8 we come to and cross Bear Creek on a diagonal.

Most of the year this a wet crossing, so plan to wade. In the summer you might be able to find a spot to cross dry but it's pretty wide. During high-water events this would be extremely dangerous and you are best to turn back, especially if you can't see the bottom of the creek.

Once across the creek follow the trail on up over to the edge of a pasture, where the trail turns LEFT and goes around the pasture. The trail curves around to the right off the end of the pasture, then starts to head up the hill, leaving the pasture behind.

The trail crosses a small creek then continues through the woods uphill and to the right, then up against a fence (private property) at 6.1, where it curves to the LEFT. It continues up and around and past the fence, crossing a very steep hillside during a sustained climb. As the trail climbs it's a great SSS view during leaf-off looking out over Bear Creek and beyond. If you get off the trail here you might roll all the way down to the creek, so be careful!

At 6.4 the trail levels out for a moment at a switchback, and there's a blue-blazed side trail that goes to the left and downhill a bit to a wonderful SSS overlook of the Bear Creek Valley called Crane Bottom, and beyond. The main trail cuts back up the hill to the RIGHT, and climbs steadily until it reaches the Zack Ridge Road and Trailhead at 6.6.

To get to this trailhead from Harps on Hwy. 65 in Marshall—head north on Zack Ridge Road and go 7.0 miles to the trailhead on the right (paved, then dirt). GPS 35.99087, -92.69601. *Currently the trailhead is only a wide spot in the road with limited parking, but there will be a

real trailhead here soon we hope.

Once across the road, the trail heads back into the woods on the LEFT, and runs mostly level and passes through a cedar thicket to the right. There's a pond just beyond and the trail goes to the far end of the pond and turns left and follows along the top of the pond, then leaves the pond bank to the right and back down into the cedar thicket again—kind of a neat little swing around the pond.

You'll notice some old piles of rock along the trail for a while— sometimes farmers piled rocks while clearing fields instead of building rock walls. The trail drops on down to a second pond at 6.85, and it follows along the pond bank again, heading off into the woods on the other end still following those rock piles (if these rock piles were for direction they would be called cairns).

We ease up a hill just a little bit, and at 6.9 we curve around to the RIGHT and actually go around Horton Cemetery, a tiny pioneer cem- etery with only a few headstones left.

From the cemetery the trail continues straight and actually begins to ease down the hill past 7.0, levels off a bit then a gentle grade. You veer over to the edge and see the Buffalo River directly below, and a real nice SSS view looking upstream. In fact SSS views for a while, up and downstream.

At 7.3 you can see historic concrete railroad trestle piers just down- stream. The M&NA—Missouri and North Arkansas Railroad, AKA "May Never Arrive"—was built and ran in the early 1900's, and was dismantled in 1949, leaving the towering piers behind. They're about 35 feet tall and were totally submerged during a big flood in 1982.

The trail at that point curves around to the RIGHT and begins to work its way into a side drainage and away from the River. It drops through a rocky little bluffy area and then it switchbacks back and forth to the bottom and at 7.6 we come to and cross the creek, with a small waterfall there. Once across the creek, the trail turns to the LEFT and follows the creek downstream.

From that point we intersect with a road, an old overgrown road coming in from the right. We just keep going straight ahead, passing the remains of a little old rock shelter. Just beyond the shelter we come to Brush Creek at 7.7. This is a pretty big creek crossing and obviously dangerous during high water! The trail crosses on an angle upstream to the RIGHT (should be a white blaze on a tree).

Once across the creek head RIGHT/upstream until you intersect with a jeep road. Go LEFT on that road, which goes up the little hill (don't turn right and cross the creek again). This is Brush Creek Road, and it gets kinda washed out and rough, curves back around to the right, then levels off.

At 7.8 if you look below you to the right there's a short pair of concrete piers, one on either side of Brush Creek, where there used to

be a trestle for the railroad. And on the left is the old railroad bed that's marked with blue blazes—this is a spur trail that goes about a quarter mile over to a set of those much taller and impressive piers standing tall in the Buffalo River. Worth a side trip and maybe lunch!

The main trail/road tops out at 7.9 and the trail leaves the road to the LEFT. Go straight along a line of cedar trees on the level, then soon the trail veers away from the cedars to the right, and joins with an another old road bed, then intersects with a jeep road. TURN LEFT onto that road and follow it downhill past 8.0.

The River is out there a couple of hundred yards through the woods and we're hiking mostly level and straight. Just as we're getting a little closer to the River at 8.3, the road swings to the left towards the River, but trail continues STRAIGHT AHEAD as plain trail, on the level. (A horse trail marked with yellow blazes shares the same route for a while.)

The trail goes up through a small bluffy area and on top of a small bluff. As we climb up here there's a bigger bluff above us to the right. We level off a little bit. Nice views looking down to the River to a big gravel bar.

At 8.5 we come to a trail intersection. A blue-blazed spur trail goes to the left to a Boy Scout monument built in 1972, and that's also the horse trail. That side trail also goes about a half mile over to the Buffalo River near the base of Red Bluff (great gravel bar for camping).

Back on the BRT/OHT, it TURNS RIGHT at the intersection and goes back through a neat little rock wall, then we curve around to the left past it on the level. The trail winds around a bit through an old homesite area and along an old road trace in parts, rocky in places.

At 8.8, we come to and across a creek with a small SSS waterfall. Then the trail follows along beside what I call a wave bluff. It's only 10 or 12 feet tall and it's like a wave frozen in time looming over you. The trail continues along an ancient road bed, eases up the hill, crosses a glade area with a cactus or two, and lots of ferns with rich and lush but shallow dirt.

We continue up this old road trace out of the glade area into the woods past 9.0, then leaving the road we swing to the LEFT and cross a little drainage. The trail eases on up the hill through the woods, a little steeper now winding through moss covered boulder fields and rocks. It swings around to the left, levels out a little bit.

At 9.2 as the trail is crossing a steep hillside around the nose of the ridge, there's an SSS view down to the River, especially looking downstream. Real nice spot. The trail eases across that steep hillside and SSS views continue.

The trail begins to ease on down the hill a bit into Wolf Hollow, and then down at a pretty good clip. We're at 9.4 and we are heading away from the River into this hollow so we've lost our great view. We come

down to the bottom and creek at 9.5 and we turn LEFT. The trail follows an old roadbed for a little bit, and eventually heads uphill away from the creek.

It continues uphill on trail only through rocky hillside, and lots of mossy rocks and ledges. Levels off for a little bit. During leaf-off there are more nice views down the River. At 9.7 the trail makes a run up the hill along the face of another really steep hillside and beautiful SSS view during leaf-off, with the River right below us. Levels off through more rocks and great views downstream and upstream, then we start to ease on down the hill across the same steep hillside. The trail curves around to the left, away from the River. It goes to a little rocky area, makes a switchback to the left and then to the right, switchbacking down through a moss-covered rocky area and then straightens out.

From there the trail eases on downhill a little bit, winds around through a rocky stretch and comes to 10.0. By the way, we're back away from the River here in a little hollow. At 10.1 we continue to drop downhill and go through a small bluffy area. We're getting down close to River level, but we're in heavy woods away from it, then hike on the level through canebrake. Most of the time when you walk through canebrake like this you know the River's not too far away, although sometimes the longest way to get there is to go straight through the canebrake.

As you are roaming along the bottom, the trail swings to the right beneath and through some nice big trees over next to a creek, Ezell Hollow, crossing it at 10.2. You cross it on a diagonal and then follow the creek upstream just gradually going uphill. Get ready for one of the steepest climbs in this section where the trail has to climb to avoid private property.

The trail continues uphill, up into the drainage, climbing away from the creek. We're at 10.3 now. Still climbing. The trail at 10.4 continues uphill, kind of steep, crossing pretty steep, rocky hillside. Then we come up against a small bluff and the trail switchbacks to the left and goes up a series of ledges. Straight up. And then it curves to the right and levels off for a moment, then continues up through this ledge-rock steep hillside, heading upstream away from the Buffalo.

The trail switchbacks to the left in the middle of the steep part, continues up a couple of more quick ziggy zaggy, straight up the hill, left and right. More ziggy zaggy up through 10.5. It keeps going up. Finally the trail straightens out a little bit, still uphill, and this time headed back towards the Buffalo River. The worst part is over.

At 10.6 we pass a property corner on the right. We're still headed uphill through the woods, parallel to the River, but out of sight. At 10.7 we level off on that steep hillside, come up to a small bluff on the right, and a good leaf-off view down to the River into the hills beyond. The trail brushes against the bluff and then eases uphill a little bit. SSS

views in this area both upstream and downstream.

The trail runs level again, then slightly downhill across the same steep hillside with great views downstream and of the big pasture across the way. By 11.0 it has leveled out and looking downstream you can see Branner Bend in the River ahead. The trail runs slightly up the hill to an intersection with a spur trail at 11.1—up to the RIGHT is the Red Bluff Road Trailhead.

To get to the trailhead from Marshall—go north on Hwy. 27 for 4.0 miles then TURN LEFT onto paved Trout Farm Road (Howard Hensley WMA sign), go 3.0 miles and TURN RIGHT onto Red Bluff Road (gravel), then go 2.3 miles and TURN RIGHT onto Red Bluff Road/CR#49, go 1.5 miles to the trailhead on the left. GPS 36.0162, -92.6571 *Currently the trailhead is only a wide spot in the road with limited parking, but there will be a real trailhead here soon,we hope.

BACK out on the BRT/OHT, the main trail TURNS RIGHT and continues level along a very steep hillside that gets thick with old twisted cedars. A hundred yards from the trailhead is a nice cut-out SSS view looking down to the River, pastures and hills behind, with Pilot Mountain in the distance. It's all just beautiful!

You'll also see the upstream side of an acute bend in the River just ahead, Branner Bend, and the prominent 170 foot tall Branner Bluff at the far end of that bend across the River. Both were named after John C. Branner, Arkansas State Geologist, 1887–1893. Dr. Branner led a team that included future US President Herbert Hoover (then a student at Stanford) that documented prominent geological features in this area, including several major fault lines that cross the Buffalo River and BRT/OHT (Tomahawk Fault and North Rocky Creek Fault). Dr. Branner's accomplishments while in Arkansas have been largely ignored in the history books but he certainly deserves credit for moving our geological history and facts giant steps forward. Interestingly, he was kind of run out of the state in 1893 after he exposed a $100+ million dollar scheme by gold prospecting companies after he announced that there was no gold in the Ouachita mountains. He moved on to become the President of Stanford University. And now we have Branner Bluff and Branner Bend to rekindle some of that history.

One other note about the Branner Bend area—it was one of the first known bald eagle nesting sites along the Buffalo River in modern times, discovered by Jim Liles (Liles Falls is named after him), and his bride, Suzy. Jim designed and built a lot of this section of the trail to South Maumee Road. (Jim was the former Assistant Superintendent at Buffalo National River, and Suzy the former historian.)

Beyond the scenic overlook, the trail is still on the level, then it curves to the right away from the River, so you just lost your view. It cuts across a steep hillside then slightly downhill, passing under a powerline.

The trail continues and crosses an old roadbed, then drops down to and across a road at 11.4. This old road goes down near the River and is closed to public vehicle use, but open to hiking so it might be a great side trip to the River (hum, and maybe a great gravel bar campsite?). So just keep going straight across the road into the woods slightly downhill. The trail wraps around a hill to the right, across the face of a ridge and another old road trace, and works its way slightly downhill away from the River and into a hollow.

At 11.7 the trail comes to a wet area with huge ferns (glade ferns and Christmas ferns depending on time of year). During wet weather there's a waterfall on the right branch and one on the main branch. You cross the creek there. It's very lush and tropical and I'd say a nice little SSS area.

The trail crosses another old road trace and continues along the same hillside, easing up at a steady pace. Trail is on a steady grade up the hillside. At 12.0 we're in the middle of that climb, then eventually the trail tops out and levels off on top of a small double-deck bluff. Kind of a neat spot during leaf-off, an SSS area. Time to slow down, look around, nice view upstream, lots of moss and stuff, and a gigantic cedar tree.

At 12.3 the trail switchbacks to the LEFT down off the bluff and down through it. It's just a short switchback left a couple of steps, and then switchback right, continuing down in between bluff lines. Then it levels out for just a minute below one of the little bluff lines. Along the lower bluff line you can see some calcite formations dripping underneath it. It's actual calcium carbonate clay formations, little stalactites on the wall. But just past that little bluff, the trail switchbacks sharply to the LEFT and downhill. As we head on down the hillside it switchbacks to the right again, almost onto itself, continues down the hill, winding down through rocks and small bluffs and nice big trees.

Then we get down below the bluffs and it levels off a bit and straightens out through thick brush. A little ways beyond 12.5 the trail switchbacks to the left, continues downhill a little bit, then runs level. At 12.6 it turns to the right and drops down to and across a creek.

From the creek we head uphill on an old road bed, then turn to the LEFT onto a jeep road of sorts. We're on that road for a hundred feet and then we turn to the RIGHT, leave the road and we're on plain trail going through heavy canebrake. We know the River is nearby when we see all this river cane, and then shortly the trail turns to the RIGHT away from the cane and eases uphill just a little bit.

This trail just eases uphill and, oh my goodness, it is a jungle! Thick vines. It takes a lot of volunteer maintenance to keep this corridor open—you've got to thank the volunteers! (and perhaps adopt a section of this trail to maintain) It takes lots and lots of cutting back every year to keep the corridor open for hiking. The trail levels off, swings to

the left on an old road trace and then the trail leaves it to the LEFT and drops down in the woods at 12.8.

We get down near the bottom of the hill and land on a little roadbed that runs near Rocky Creek, then soon makes a sharp LEFT off of the old roadbed. That takes us over into a level open area right next to the creek—head out across the middle of this area going upstream (look for white blazes). There are some really big sycamore trees. As the valley begins to narrow, the trail turns LEFT and crosses Rocky Creek at 13.0.

Once across the creek the trail turns to the RIGHT and goes underneath one of the world's largest grapevines! Just past the grapevine it switchbacks to the LEFT and climbs up the hill back in the direction of the Buffalo. At 13.2 we swing around up through a little point of a ridge with small bluffs and there's a set of Buffalo River rapid's right below us. Good place to stop for a minute to take in the beauty.

From there, the trail curves back to the RIGHT and continues uphill away from the River. More uphill and we swing to the left. And then at 13.6 we hit a Jeep road. TURN RIGHT onto that Jeep road. Watch for this turn if coming from the other direction. The jeep road runs level, then starts to head STEEPLY up the hill for another tough climb.

The road turns back to the left (there's a big old slab of rock holding up the tree up on the right), and then it's switchbacks to the right as it climbs up the hill. Switchback to the left, go up steep again. Then at 13.5, as the road switchbacks to the right again, the trail leaves the road to the LEFT on the level, you can celebrate here, and continues into the woods as plain trail. Whew, good job!

As you head out on this level trail across a steep hillside you'll have nice leaf-off views looking downstream and to the River. This stretch for a while is all an SSS. Very nice trail. But be CAREFUL—the trail runs along the top of a bluff close to the edge, and if you do happen to fall in this section, lean *into* the hillside. (Just sayin'!)

Soon the trail heads downhill and works its way up into a drainage away from the Buffalo. At 13.8 we intersect with a logging road. We turn LEFT and follow the logging road downhill. Soon there's an intersection and the road turns sharply to the RIGHT and we switchback downhill to the right, then go swiftly downhill now into a small hollow on a rough old roadbed to 13.9 (this used to be Grandview Road).

Continue across a small stream and flat area—there's a short waterfall just below on the left, and a bluff up to the right. Then leave the old road STRAIGHT AHEAD (the old road trace swings to the left—we'll rejoin it soon). The trail eases up and over a small ridge that's below the bluff, then makes its way down to and across a small drainage and rejoins the old roadbed at 14.0—TURN RIGHT and follow the old roadbed upstream. Note that small creek you just crossed—there's a nice SSS waterfall up on the bluff to the right— no name, unmeasured, but it's worth a taking a break to go see if the creeks are high!

The trail is running upstream alongside Little Rocky Creek and crosses the main fork that comes in from the right at 14.3. Continue to the LEFT across a second fork, which is Scott Hollow— there's a nice little hole of water there—all of this is a nice SSS. Go STRAIGHT across, and the trail continues on the other side.

From the creek, the trail goes up in the woods and turns to the LEFT, and starts easing up the hill, going back downstream towards the Buffalo River. The trail climbs steadily till 14.5. Just as you're about to come out on a point, it switchbacks to the RIGHT and continues uphill. (If you go **off-trail straight ahead** at that switchback there's a spectacular SSS view of the River upstream and downstream, called Pileated Point. Maybe you can spot or hear the giant bird that was the inspiration for Walt Disney's famous Woody Woodpecker character.)

Back on the main trail however we are headed for another pretty tough climb up a very steep hillside that is just kind of rocks, small bluffs, and more rocks. The trail zigzags up and up and up. No need to hurry—the hill will wait on you to catch our breath. By 14.7 it is still uphill but you leave the worst of the rocky area and climbing behind.

At 14.9 we come to the end of the climb and to a saddle where the trail intersects an old road, which is a great place to stop and breathe after that climb! (At this intersection there is an old road back to the left that makes a loop around the hill—I'm told this was where log trucks used to be able to use the loop around the hill to turn around.)

From the trail intersection in the saddle, TURN RIGHT and head uphill on an old road. You can't really tell it's much of a road, just following the center of the narrow ridge. A little bit of view to the left during leaf-off, looking downstream. If your car is parked at the South Maumee Trailhead, that's where it's going to be—up on top of that far away ridge over there.

Near the top of that saddle at 15.0 the trail veers to the LEFT. You don't really notice that you've left the road, but you have. And you join another little road that you will follow going downhill. As we continue down this logging road at a pretty good clip you can look out during leaf-off and see the River on the left. Pretty nice view. At 15.3 the trail leaves the old road bed to the LEFT and cuts below the road bed heading downhill.

The trail drops on down past a set of short bluffs, then comes to a neat big block of stone that is sitting on the left at 15.4 (Ken Smith calls it Dog's Head Rock). Please don't push it over!

Then the trail levels off and continues above the bluff—be careful where you step and don't go over the edge. At 15.5 you cross a slippery little creek on the steep hillside, and just past a couple of boulders the trail takes a HARD LEFT and it goes straight DOWN the hill. Potentially a very slick area so be careful.

Pick your way down the hill, then the trail veers over to the RIGHT

and becomes actual trail again. The trail levels off at a moss covered rock slide that's a beautiful SSS. This area is called Christmas Hollow, and when the water's flowing well look above to see Christmas Hollow Falls, a beautiful SSS! (Jim Liles, unmeasured)

Once across the creek, the trail continues heading downstream and then levels off and swings over to the RIGHT and heads up into Hoot-Owl Hollow. Small hollows like this dry up quickly in the summer, although I was saved one hot August afternoon when I arrived with no water (having started the day at Grinders Ferry)—crystal clear magical stuff bubbled out of the ground from a tiny spring in the creek—I sat on the ground and drank a full liter of cold spring water! (filtered of course)

Soon the trail swings to the LEFT and crosses the creek at 15.7. From the creek the trail heads uphill and just about a hundred feet up the hill it goes past a pit dug by a mineral prospector. The trail continues uphill through a rocky stretch and eventually comes alongside the base of a small bluff.

At 15.8 there are nice boulders scattered along the trail and a larger bluff rising just above the trail on the right. The trail is level for a little while but soon it rises up to the base of the bluff, which is much shorter now, and switchbacks to the RIGHT. It goes up through the bluff and switchbacks to the LEFT on top. It begins a nice, beautiful, mostly level hike along the top of the bluff.

Soon, the bluff below begins to break down a bit and even disappears and the trail eases uphill a little bit, then back level as the bluff appears again below. At 15.95 we cross a little creek and there's a 23' unnamed waterfall below. Then a little ways beyond, we come to a little creek at the top of Saw-Whet Owl Falls at 16.0, which is a really nice waterfall and is 43' tall. Definitely an SSS, but CAREFUL if trying to get a view along the edge! (It is possible to reach the bottom of the falls by backtracking on the trail to a spot where you can get down through the bluffline and scramble back to the base of the falls.)

Never heard of a Saw-Whet Owl? Me neither. Jim Liles reported these owls in the area while building the trail in the fall and it seemed like a fitting name for the waterfall. As I was working on this part of the guidebook I was also trying to learn how to oil paint. Quite by accident one of the first learn-how-to-paint books I got had a painting lesson of guess what—a Saw-Whet Owl! Small owl, interesting call. Take a break or two through this area and listen...

From the top of the falls, step across the creek and the trail TURNS RIGHT and follows the little creek uphill, then RIGHT across the creek, then heads uphill across another little creek that feeds the waterfall. The trail continues to climb and then swings back to the LEFT and goes up through a rocky area above the little drainages, (usually dry). The trail continues easing uphill, winding around through exposed limestone

boulders and chert (limestone gravel).

At 16.3 the trail is still climbing and rounds a bend. During leaf-off there are SSS views through here looking down at the River, upstream and downstream (I saw a flock of giant trumpeter swans on the River from here once). By 16.6. the trail is almost level for a bit and the views keep getting better! This is a nice pleasant walk along a beautiful trail.

Soon the trail swings to the right, leaves the view and the hillside, and drops down into a small ravine. The grade gets a little steeper as the trail winds around on up the hill past 17.0.

The trail turns away from the River for the last time and swings around to the right. You can see a road straight ahead through the trees—that's the road past the trailhead that goes down and dead ends at the South Maumee campground. We head up the hill at a pretty good clip towards the trailhead and come out to the road at 17.3.

To reach the trail from Hwy. 27 at Morning Star (between Marshall and Harriet), turn onto CR#52/South Maumee Road (signed) and go 5.0 miles and park (this is about .5 miles past the Buffalo River boundary sign). GPS 36.0234, -92.6169

The trailhead is currently just a wide spot in the road with limited parking, but there will be a real trailhead there soon, we hope.

The trail continues on past across the road and heads to the Dillards Ferry Trailhead on Hwy. 14 (see next pages for map and description in the Lower Buffalo Area Trails section).

LOWER BUFFALO AREA TRAILS

Buffalo River Trail—S. Maumee Rd. to Hwy. 14 (11.3 miles)

Trail Point	Mileage Downstream	Mileage Upstream
CR#52 (South Maumee Road)	0.0	11.3
Maumee Falls	.9	10.4
Spring Creek	3.3	8.0
CR#99 (Spring Creek Road)	5.3	6.0
Kimball Creek	8.7	2.6
Hwy. 14 (Dillards Ferry)	11.3	0.0

This is one of the most spectacular sections of the Buffalo River Trail (completed in 2010), with several waterfalls and lots of great views down to the River from on top of tall bluffs. NO DOGS on trail.

To reach the trail from Hwy. 27 at Morning Star (between Marshall and Harriet), turn onto CR#52/South Maumee Road (signed) and go 5.0 miles and park (this is about .5 miles past the Buffalo River boundary sign). Limited parking. The trail begins on the RIGHT. CR#52 dead-ends at the Maumee South primitive campground and River access. (A bit of confusion here—the trail begins along **South Maumee Road**, but the nearby campground and River access area is called **Maumee South**.)

The trail heads out on the level across a steep hillside. You can look nearly straight down towards the River, and the leaf-off views are great. At .3 the trail veers away from the River and dips down and back to the right a bit, then curves back to the left, down through a small bluffline. The trail levels out and follows the top of a bluffline (past two wet-weather waterfalls that pour over the bluff below), over to a really nice SSS waterfall at .75 (53' tall). At .9 you come to Maumee Falls (67'tall), a wonderful SSS. You are hiking on top of all these waterfalls, but still have good views as you approach.

From Maumee Falls the trail crosses the creek, turns to the right, heads uphill, and follows the creek upstream. During high water there is probably at least one waterfall pouring over a smaller bluffline above to the right. The trail veers to the left and comes to the base of that bluffline, an SSS with perhaps another waterfall during high water, and lots of moss-covered boulders too. A beautiful little area.

The trail continues uphill, then eventually levels off a bit. It swings around a very steep hillside for the next half mile (mostly on the level), and there are some good leaf-off views along the way. At 1.7 you cross the end of a small pond, then curve away to the left, back towards the River. The trail winds around a bit and eventually lands on top of another bluffline, and comes to a nice wet-weather waterfall (45' tall) right at the 2.0 mile point, an SSS for sure!

The trail continues along the top of the bluffline, joins an old road-

Buffalo River Trail (S. Maumee Road to Hwy. 14)

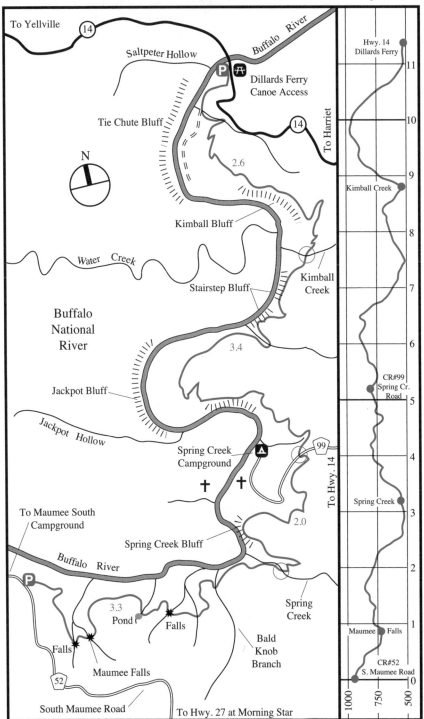

To Yellville

14

Saltpeter Hollow

Buffalo River

P

Dillards Ferry
Canoe Access

14

To Harriet

Tie Chute Bluff

N

2.6

Kimball Bluff

Kimball Creek

Water Creek

Stairstep Bluff

Kimball
Creek

Buffalo
National
River

3.4

Jackpot Bluff

Jackpot Hollow

Spring Creek
Campground

99

To Hwy. 14

To Maumee South
Campground

Buffalo River

2.0

Spring Creek Bluff

P

3.3
Pond

Falls

Spring
Creek

Falls

Bald
Knob
Branch

Maumee Falls

52

South Maumee Road

To Hwy. 27 at Morning Star

Hwy. 14
Dillards Ferry

11

10

9

Kimball Creek

8

7

6

CR#99
Spring Cr.
Road

5

4

Spring Creek

3

Maumee Falls

2

1

CR#52
S. Maumee Road

0

1000

750

500

145

bed and runs mostly level for a while, then eases downhill. At 2.3 the trail/road TURNS LEFT and heads down through the broken bluff at a pretty good clip. It swings to the right, then left, levels some, then back downhill again. The forest turns to bamboo, and at 2.7 crosses Bald Knob Branch. From there the trail/road eases uphill just a little bit, then swings back to the left and levels off. Lots of bamboo in some areas, and the old roadbed disappears and it is back to normal trail again. At 3.1 the trail passes through an old homestead area, then eases downhill a bit (the Buffalo River is just off to the left).

At 3.2 the trail comes alongside Spring Creek and turns right and follows the creek upstream. A beautiful SSS area, lush, with flowing water, a small bluff, and just delightful! The trail crosses the creek at 3.3 (probably a wet crossing), follows the creek for just a little bit and then TURNS LEFT, up and away from the creek. It switchbacks to the right, still heading uphill, then passes under a wet-weather waterfall just above the trail on the left at 3.5. Then the trail switchbacks UP to the left and then continues on the level along the top of the bluffline, passing through several limestone-cedar glades.

There are some nice views along this stretch of trail where each glade opens up the trees a bit, even better during leaf-off. The trail eventually turns away from the top of the bluff and heads uphill. At 4.1 the trail comes out to a spectacular SSS view from on top of Spring Creek Bluff. You've got a terrific open view down to the River, looking directly to the west for a sunset.

The trail curves around to the right and away from the River, mostly on the level, and goes across lush hillsides that are covered with ferns in the summertime. There is a neat sinkhole right next to the trail at 4.7. Just past this is a good example of an "N" tree. The trail eases uphill a bit, then back down, to mile 5.0, where you can begin to see Spring Creek Road below through the trees. The trail comes out to and crosses CR#99/Spring Creek Road at 5.3 (it is 1.7 miles out to Hwy. 14).

From the road the trail heads on down the hill a little bit, crosses a small stream, then runs downhill alongside the stream to a neat little waterfall at 5.5. The trail levels out a bit, then eases uphill through a nice glade that was full of wildflowers, butterflies, and cactus when I was there. More winding around brings you to a steep hillside above the River, with some great SSS views beginning at 5.8. Lots of old weathered, twisted cedars. The trail remains mostly level to mile 6.0, where it curves away from the River, but soon returns again for more great views looking directly down on top of the water. Oh, if only to be a bird!

The trail does a bit of up and downing until 6.7 where it TURNS LEFT onto an old road trace and heads down through a bluffline at a pretty good clip, switchbacks to the right, then not quite as steep, still on the old road. The road splits, but just stay straight and on the level (easy to see). By 7.3 the trail has worked itself down to the bottom and runs near the Buffalo River.

At 7.5 the old road turns right and follows a small creek upstream and away from the Buffalo River, then the road kind of disappears and you are back on plain trail again—a neat little area when the water is high, crossing the creek at 7.75. The trail heads to the left and uphill,

soon coming out above the Buffalo and leveling out a bit after a pretty good climb, past mile 8.0. The trail veers away from the River, crosses a small stream, climbs up a bit and returns to leaf-off views above the River, going across a steep hillside. At 8.3 you come to a wonderful SSS view from the top of Stairstep Bluff.

The trail swings away from the River and drops on down to and across Kimball Creek at 8.7. This begins the toughest part of this section as the trail switchbacks up and *up* and UP steeply through limestone rock gardens—lots of natural and man-made steps, but the terrain is all UPHILL! The steepness eases up a bit and you are back to normal trail, although still going up. There is a really nice SSS at 9.2 when the trail comes to the base of a nice bluff.

From the base of the bluff the trail goes on a little bit, then climbs up and switchbacks to the LEFT and then runs level on top of the bluff (heading back towards the River), where there are many great leaf-off views up and down the drainage. And then at 9.4 you come to a beautiful SSS view from on top of Kimball Bluff (the tallest bluff in the area).

The trail remains mostly level with more great views for a little while, then begins to head downhill and away from the River. At 10.3 there is a nice rock garden and then the trail switchbacks down a couple of times before crossing a small creek, and then it crosses the same creek again just a little ways downstream. The trail bottoms out and goes through a bamboo stand and comes out of the woods and hits a road at 10.9—TURN RIGHT and follow this road (uphill at first) through some old fields, and all the way back to the trailhead that is right next to (and almost underneath) the big Hwy. 14 bridge at 11.3.

At some point (we hope!), this trail will continue downstream through the Lower Buffalo Wilderness area and connect with the Ozark Highlands Trail Spring Creek Trailhead (all being part of the Trans-Ozark Trail). From there the trail will extend all the way to the Missouri border, and then connect with the Ozark Trail that's being built across Missouri and end up near St. Louis! I'm gonna need a new pair of hiking boots...

Big Creek Access (no official trail)

From the Hwy. 14 bridge over the Buffalo River, drive south on Hwy. 14 for about 4.5 miles. TURN LEFT at the Rock Creek Community Center onto a county road. It is paved for a little while (about 2 miles), then turns to a gravel road. You'll pass the Cozahome Church 3.3 miles from Hwy. 14. TURN LEFT .2 miles past the church onto a county road (gravel). Continue straight on this road for 1.8 miles. The road will sort of fork, with the main road heading up a hill and straight ahead. TURN RIGHT onto the lesser road here—there should be a hand painted sign that says "Somerville" at this intersection.

You'll pass a couple of driveways, and after .7 miles, the road forks—take the LEFT FORK, which is the main road (it gets a little rough in here, but most cars should be able to make it). This road is rather steep—probably not suitable for buses and RV's. At .4 miles from the fork there is a pulloff area on the left. The road gets rougher after here and ends just a tenth of a mile beyond at a cable gate. If there is more than one car in your party, be sure to stop at the pulloff 'cause there isn't much room at the cable to park or turn around.

There is an interesting feature near the cable gate—"Wobbling Rock." There is a natural spot to walk out onto several large rocks to get a look around the area. One of these rocks will move back and forth, or "wobble." Hey, some of us enjoy cheap thrills!

The Big Creek trail begins on the old road past the cable. It isn't marked, but just follow the old road *down* the hillside (500 ft. drop) into the Big Creek drainage. You should get a copy of the Big Flat quad map to take with you to make sure that you can find your way around. Big Creek runs into the Buffalo. There are lots of wonderful things in this area to see and do—be sure to plan an entire day or weekend to explore the area. Loonbeam and Cold Spring Hollows are down in there and worth some time too. The area beyond the gate is part of the Lower Buffalo Wilderness Area—no vehicles or motors of any kind allowed.

Leatherwood Wilderness Area Access

This 16,956-acre wilderness area is in the Ozark National Forest (office in Mountain View). It is connected to the 22,500-acre Lower Buffalo Wilderness, and together they form one of the largest wilderness areas in the eastern United States. It is a rough, rugged and remote wilderness. The Ozark Society has a great map of this area (that also includes a 32-mile section of the Ozark Highlands Trail that skirts the outside of this wilderness). Most of the wilderness area is also shown on the *Trails Illustrated* East map (#233) of the Buffalo River. (to purchase go to www. TimErnst.com) And the quad maps that cover it are Big Flat, Norfork, Norfork SE and Buffalo City. DOGS ARE ALLOWED.

There are no official hiking trails in this wilderness area, but there are a lot of old roads that provide good access. This is another one of those "park and find your own way" places. See the wilderness map noted above, and also the *Arkansas Waterfalls Guidebook*.

Big Creek Access (no official trail)

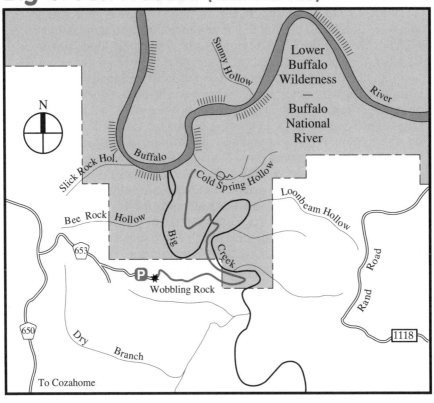

N

Sunny Hollow

Lower
Buffalo
Wilderness
—
Buffalo
National
River

River

Slick Rock Hol.

Buffalo

Cold Spring Hollow

Loonbeam Hollow

Bee Rock Hollow

Big Creek

Rand Road

653

P ✸
Wobbling Rock

650

Dry Branch

1118

To Cozahome

Indian Rockhouse Loop Trail (3.0 miles)

Buffalo Point was once a State Park, and there are a lot of facilities that were developed there at that time—including a restaurant and motel. It is one of the major public areas on the Buffalo River. Besides a Park Service visitor center, there are several campgrounds, cabins, a restaurant, picnic areas, River access, and a number of hiking trails. Most of these trails just connect facilities, but one, the Indian Rockhouse Trail, is a wonderful three-mile loop into a scenic area, and visits one of the largest bluff overhangs that I know of in the Ozarks. A side trail leads up a steep trail to Bat Cave, and adds an additional 2 miles to the hike.

Buffalo Point is located off of Hwy. 14, between the turnoff to Rush, and the Hwy. 14 bridge over the Buffalo River. Follow the signs—the road is all paved. The main trailhead parking area is located just past the visitor center. There is a separate trail guide for this trail that is available from the Park Service Visitor Center, or you may be able to find one at the trailhead. It describes each of the subjects of the signs that you'll see along the trail. NO DOGS on this trail.

The trail begins *across* the road from the trailhead, and heads down an old road. The return trail comes in from the left just as you start down the hill. Near the bottom of the hill, the trail turns to the right and follows beside a small creek. The first sign that you come to is "Poison Ivy." That is fitting, since a lot of you that hike this (and any other trail for that matter) will get poison ivy—so be careful—there is a lot of the stuff out here in the woods. Please excuse me for chuckling—I'm not allergic to it!

The next sign is "Ferns and Mayapples." You should come in late April and May to see these. The trail continues on, and passes a small bluff to the right. "Smooth Sumac" is next, and in late September and early October this stuff turns a wonderful color. Just beyond, the trail leaves the old road bed that it has been following and is plain trail now.

Next is the "Sinkhole Icebox" on the left. A nice spot to be in the heat of summer! Be careful not to slip in. This is an SSS. The trail continues on fairly level out through and past our next sign "Hardwood Forest." Then the trail begins to drop off down the hill just a little, past the "Cedar Glade" sign. Just after, be sure to TURN LEFT down the hill on a slab rock. And the trail keeps going *down* for a little while, and swings around to the left.

Then we encounter another SSS, a wonderful waterfall. The trail actually crosses under it, then swings back to the right. This is one of the largest waterfalls in the area. The bluff that forms the waterfall is pretty neat too, and the trail follows it to the "Bluff Mammals" sign.

The trail heads on down the hill, past the bluff, and comes alongside the small creek that formed the waterfall. Then we pass "Abandoned Mine," and you can see the remains of a small zinc mine. Down to

Indian Rockhouse Trail

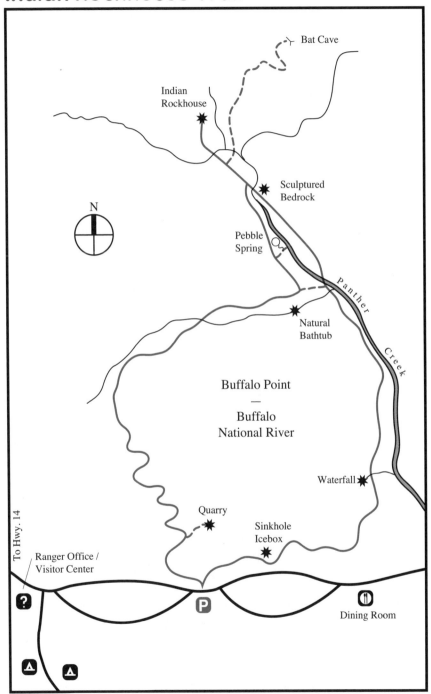

Bat Cave

Indian
Rockhouse

Sculptured
Bedrock

N

Pebble
Spring

Panther

Natural
Bathtub

Creek

Buffalo Point
—
Buffalo
National River

Waterfall

Quarry

Sinkhole
Icebox

To Hwy. 14

Ranger Office /
Visitor Center

Dining Room

Panther Creek we go, as the trail turns to the left and begins to follow the creek upstream. This is a nice little creek, and we'll see a lot of it ahead.

There are lots of bluffs around, on both sides of the creek. And you, in fact, pass the "Moist Bluff" sign. But the real treasure in this area is the creek. This is probably one of the best streamside walks in the state. But not for long, as the trail soon eases up the hill to "Small Cave," another SSS area. It's a neat little cave, with a sinkhole coming into the ceiling at one point. If it's hot, this is a great place to hang out and cool off.

Just past this cave you come out onto an old paved road—TURN RIGHT on this road, and you will come to an intersection. The main trail continues STRAIGHT AHEAD on the old road, but if you are getting tuckered-out, you can turn left and head up a pretty little side stream for a short cut to the return loop.

The main trail crosses Panther Creek, and heads up a hill (still on the old road), then levels off and looks down onto the creek. You will pass Pebble Spring, which you'll visit on the return loop. Just beyond, you'll cross a rock slab, which is nice during the wet season. Then the trail passes by the "Calamint" sign, and another trail intersection (it's another short cut over to the return trail—stay STRAIGHT AHEAD to get to the Indian Rockhouse).

At the "Sculptured Bedrock" sign you'll encounter another SSS which is worth a closer look. Just past this area, the trail crosses Panther Creek. The "real" return loop takes off to the left here—continue on STRAIGHT AHEAD for the main trail (still on the old road). It will head up another short but steep hill, level off, then drop down again, to a trail intersection.

(There used to be a trail over to Bat Cave here, but the trail has been closed.)

The main trail goes STRAIGHT AHEAD at the trail intersection, crosses Panther Creek, and heads up to the Indian Rockhouse. This is a marvelous place, a major SSS. There is a large sinkhole in the roof to the right, a creek running through the back of the overhang, and just lots of neat stuff for you to explore. There are even some genuine cave formations here—the "stalactites" point down from the ceiling, "stalagmites" are growing up from the floor, and there are "curtains" and "flowstone" along the wall. Plan to spend an hour or more here. And if you don't do anything else, just sit down against the back wall and absorb the place a little. It's one of the Arkansas's great thinking spots.

After a good rest, you're ready to head back to the trailhead. Begin by going back the same way that you came, across the creek and past the trail to Bat Cave (that's the trail that has been closed). Just before you cross Panther Creek again, TURN RIGHT at the intersection,

and follow the trail upstream. It crosses a bridge, and comes to the Sculptured Rock area that we saw from the other side. Then it meets up with a short spur trail that drops down to Pebble Spring, another SSS. The main trail swings to the right, up a small hill and then levels off. After a little ways you come to another wonderful sculptured rock area on the creek—this area wasn't seen on the trip in from the other side, and I would definitely rate it as an SSS! A cool spot to spend some time.

Just beyond is a trail intersection. Back to the left is the way that you came in. TURN RIGHT at this intersection to continue with the main trail out. This is the "Natural Bathtub," another SSS. The trail follows this small stream up the drainage through a cedar glade. It crosses the stream at a pretty little spot, heads *up* the hill a little, swings back to the right and levels off.

It continues to go up the drainage, keeping the little stream down off on the right, past the "Watershed" sign. Here it gets a bit more serious about climbing up the hill, and in fact does just that—*climbs*. Up several switchbacks it goes, up to an intersection. The left fork goes over to the old "Fossil Quarry," a short walk. The main trail TURNS RIGHT and continues up the hill on an old roadbed past the "Dogwood" sign and some large pines.

As the trail tops out, you pass through a wooden gate, cross an old road with another wooden gate off to the left, and continue into the woods on level trail (you are now alongside the paved road that you are parked on). You will shortly come out at the trailhead where you started. What a great hike!

Be sure to check out the large trail sign at the trailhead—it will show all of the other short trails in the park. I would recommend that you at least do the overlook trail. Be sure to stop off at the Ranger Station for additional information.

Rush Mountain Loop Trail (3.6 miles)

Rush is an old mining town, a ghost town if you will, that was first opened up in the 1880's when zinc ore was discovered. The community that was built up around the mines endured until the 1960's. Some of the buildings still exist today, and two different trails visit the area. One of them, the Morning Star, is a short loop. The other, that is called the Rush Mountain Trail, is a longer trail that goes past many of the old mines, loops around and goes *up* and over Rush Mountain. NO DOGS.

A word of caution: *Do not enter any of the mines.* Many of them are *very* unstable. The mine entrances are usually fenced off, so be sure to stay out of them. Most of the old buildings are too.

To get to Rush, turn off of Hwy. 14 between Yellville and the Hwy. 14 bridge over the Buffalo River (it's well marked) and follow the paved road to the entrance to the Historical District (road turns to gravel). There is a campground and picnic area there, and the last major canoe access in the Park. The River downstream flows through the Lower Buffalo Wilderness Area.

As you enter the District, you'll pass a row of old buildings off to the right, and just beyond on the left is the trailhead parking area. If you continued down this road, you'd come to the campground, picnic area and canoe access.

KEY TO MAP: 1) Smelter This stone structure is the oldest in Rush, built in 1886. **2) Livery Barn**. Built in the 1890's. **3) Blacksmith Shop 4) Morning Star Processing Mill.** These are the foundation piers of a remodeled mill that was built in 1911. **5) Mine level. 6) Tailings Pile 7) Taylor-Medley Store. 8) Rush "Ghost Town."** The houses in this row date from about 1899. **9) Hicks Store.** Built in 1916. **10) Boiling Springs.** Before the mining era, a grist mill operated below here on Rush Creek. **11) McIntosh Mine.** There used to be several buildings here, including a hotel. Remains of the processing mill are in the overgrowth. **12) "New Town."** This was a booming village during World War I when the mining operations were at their peak. **13) Red Cloud Mine.** Some of the mill piers still remain. **14) White Eagle Mine.** One of the earliest mines in the area, built in the 1880's. **15) 1960's mining.** A processing mill was set up here to process ore from several reopened mines, but was short-lived. **16) Ore Wagon Road.** Ore from the Rush mines was transported by wagon to the White River where it was loaded on barges (all of this is in the Lower Buffalo Wilderness Area). **17) Monte Cristo Mine.** Active in the early 1900's.

From the trailhead, the trail heads up the hill as a nice wide, graveled path. It winds its way up through the ruins of the Morning Star Processing Mill. Just beyond this area the trail levels off and then forks. The Morning Star Trail goes straight ahead, and the Rush Mountain Trail TURNS RIGHT and begins to climb up the hill.

Rush Mountain Trail

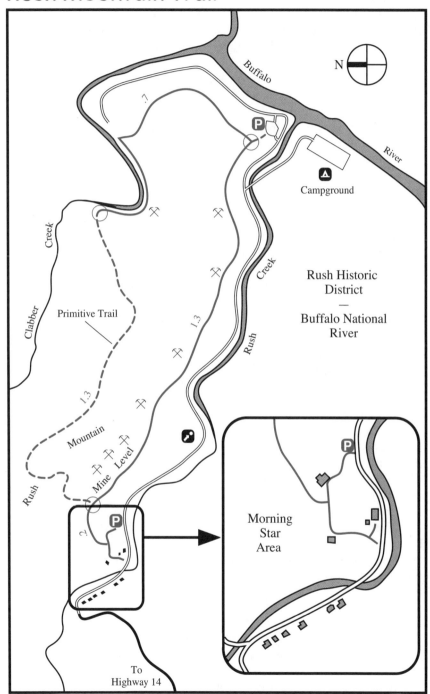

N

Buffalo

River

P

Campground

Rush Historic
District
—
Buffalo National
River

.7

Creek

Clabber

Creek

Rush

Primitive Trail

1.3

1.3

Mountain

Mine Level

Rush

.2

P

P

Morning
Star
Area

To
Highway 14

The Morning Star Trail goes past the blacksmith shop (nice colored wood building still standing) and turns left. It then drops down the hill to the oldest structure in the area—the stone smelter built in 1886. It stands all by itself back behind the livery barn, which is right on the road near the parking lot. From here you can either head up the road to the right and visit the line of buildings that was the town (which are fenced off), or head back to the parking lot. We'll go back to the trail intersection and head up the Rush Mountain Trail.

This trail goes up the hill on an old road that leads to the "mine level." On the way up is an unmarked intersection of a trail that turns to the left—this is the return loop of this trail, and I recommend that you hike this in a counterclockwise direction. In this area too is a path that takes off to the right and goes out to a tailings pile—the rocks left over after the ore was removed. It's kind of a weird sight to see such a pile of rocks right in the middle of all the forest.

The main trail continues up the hill at a steep pace, but not for long as it soon levels off at the mine level, and turns right. You can see entrances to the old mines scattered all about here. As I mentioned before most of them are gated and have warning signs on them. Just as you pass the second gated area there is a spur trail that goes off to the right and runs out on top of another tailings pile.

This entire hillside is pretty much dotted with mine entrances and usually small tailings piles. The views up and down the valley below are quite nice, especially in the early morning during leaf-off. At about .5 there is an old mine car that is off to the right of the trail. This is the type of car that was used to bring the crushed rock out of the mines.

The trail leaves the road and becomes just trail at one point, then returns as an old road again, passing a few more mines. Near the entrance to one of the mines are the remains of a wooden structure. It eventually heads down the hill and leaves the mine level behind. As it's on its way down, the trail leaves the old road TO THE LEFT and continues on as just plain trail. If you stayed on the old road it would come out on the main road that is visible off through the trees.

The trail sort of up-and-downs a little through a forest of scrub trees, and at about the one mile point it runs along on top of a small bluff—the main road is visible just below. Beyond this a ways the trail swings to the left and begins a real steep (but not too long) climb up the hill. It passes several more tailings piles and spots where it looks like mines were started, but never really developed.

The trail levels off, then begins to drop down the hill and comes to a trail intersection at 1.5. A right turn here will take you a short distance to another parking area by the River (& toilets). TURN LEFT to continue on with the rest of the trail to Clabber Creek, the Monte Cristo Mine, and the loop back to the main trailhead (up and over Rush Mountain). The remains that you see from this intersection are those of the White

Eagle Mine—this is one of the earliest mines in the area—dating back to the 1880's.

From the White Eagle Mine the trail heads uphill just a tad but mostly level. During leaf-off you can see the Buffalo River down below. The trail swings around the hill to the left. At this point you've got a good view of the River valley downstream, and you leave the River, and begin to work your way up the Clabber Creek drainage towards the Monte Cristo Mine.

The hardwood forest is wide open, and the trail passes by a hand-dug hole off to the right. Soon after, the trail drops down to and intersects with an old road at 1.9. TURN LEFT on this road, which heads uphill just a little, to the base of a bluff that overlooks the creek.

And at 2.0 you come to the Monte Cristo Mine, which appears to be the most developed of any of the mines—at least it has more dugout entrances than the rest! There is an old engine that sits in front of the mine that dates from a 1960's mine reopening. This area is definitely an SSS—the bluff and the view of the creek below are great.

Past the mine the trail continues on the level and swings around to the right. You can see another bluffline up above the trail to the left. At 2.2 the trail leaves the road TO THE LEFT. The road does continue just a little further and then enters private property. The section of trail from this point back to the trailhead was never really built. It is a rough, *steep* little trail that I would advise only those in good shape to try (shown on the map as a primitive trail). If it's not for you, then simply turn around and backtrack to the trailhead.

The trail climbs up the hillside and at 2.5 actually goes up through a break in the bluffline that I mentioned earlier. This spot is a minor SSS, and is a great spot to stop and catch your breath.

Once through the bluff, the trail continues uphill steeply, but soon levels off and continues along a fairly level bench for quite a while. Lots of good views through the trees during leaf-off. All too soon this bench peters out, and the trail climbs up again and heads for the ridge.

At 2.9 the trail reaches the top, AND TURNS RIGHT and begins to follow the ridge. From here you'll have views off of both sides of the mountain. By 3.0 the trail is going uphill some, and the road from the highway down into Rush becomes visible off in the distance.

As the trail swings around to the left of the ridge, it takes off to the left and begins its descent back down to the trailhead. This gets real steep at times, but usually is just heading down through a rocky, cedar glade. And it is usually easy to follow. The trail lands on an old road and follows it for just a hundred feet or so—be sure to TURN LEFT off of the road—and continues downhill through a rock wall.

After going through a nice tunnel made by a thick cedar grove, the trail lands on an old road at 3.5—this is the end of the loop—TURN RIGHT, and you will drop back down to the trailhead at 3.6.

MAPS

Trails in the Buffalo River area are generally not shown on topo maps (see compulsivehiker.com for online topo maps). Many of the trails are however shown on two Buffalo River maps published by National Geographic/Trails Illustrated (East and West maps), and also on the Ozark Highlands Trail North map (Underwood Graphics). Maps for the Upper Buffalo Wilderness, Richland Creek Wilderness, and Leatherwood Wilderness are also available, although these ares are mostly trailless. You can find all of these maps, plus other guidebooks, maps and interesting books online by scanning the QR grapic below, or going to our web site address below:

www.TimErnst.com

HIKING CLUBS, SHUTTLES, CABINS

We have a lot of great outdoor clubs in Arkansas, and many of them have helped build and maintain the trail system and do other volunteer duties at Buffalo National River. Joining a local club (or chapter of a national organization) is one of the best ways to learn about and enjoy outdoor recreation with like-minded folks—*highly recommend*! To find web links for many of these groups, go to the "links" section at **www.TimErnst.com**.

SHUTTLE SERVICES

For a list of the current concessionaires who are licensed by the park service to provide shuttles at Buffalo National River, see their web page— **www.nps.gov/buff/index.htm**.

CABINS and B&B's abound in the Buffalo River area. Go to the "links" section at **www.TimErnst.com** to find many listings.